Seas Outside the Reef

Seas
Outside
the Reef

A Novel

Rosalind Brackenbury

2000
JOHN DANIEL & COMPANY
SANTA BARBARA, CALIFORNIA

Published by John Daniel & Company
A division of Daniel and Daniel, Publishers, Inc.
Post Office Box 21922
Santa Barbara, CA 93121
www.danielpublishing.com

LIBRARY OF CONGRESS CATALOGING-IN-PUBLICATION DATA
Brackenbury, Rosalind.
 Seas outside the reef : a novel / by Rosalind Brackenbury.
 p. cm.
 ISBN 1-880284-41-3
 1. Aliens—Florida—Key West—Fiction. 2. Cuban Americans—Fiction.
3. Key West (Fla.)—Fiction. I. Title
 PR6052.R24 S33 2000
 832'.914—dc21 99-050882

for A.L.M.

Seas Outside the Reef

Part I

LIGHTS dropped their reflections into the Miami River, plumbing its darkness. Streetlights, office building lights, the lights of passing boats. Close to here, the river opened out into the ocean, as it always had, always would, no matter what was built up around it. Here, sitting low and close to the water, you could watch the river traffic, ignore the skyscrapers and streets that ran through the air propped on huge stilts, turn your back on the vacant lots under the highway where wire kept vagrants out and the beams of police cars' lights searched the corners. Here, you could behave as if the whole city had not been built, or thought of. Old Florida, wooden houses, palm trees, lay underneath the modern city, a layer in its archaeology. You could sit and watch it, its slow-moving tropical self devoid of air-conditioners and speeding cars, innocent of towering bank buildings and sealed offices. Boats, fishermen, people ignoring the whine and whir of the city above them. Cats, waiting for scraps. An old house under the bridge, hibiscus budding in its abandoned yard, its tile roof slipping sideways, jungle and wire, a fence that gave way to let someone slip behind it. Tugs on the river. A bridge opening, raising its arms to let a tall ship through. And the boats that went out backwards, downstream, because the river was narrow, with no way to turn.

Emily sat in the restaurant that had once been an old fish house, and though she was listening to her brother, her eyes were on the river and its traffic. Boats being loaded with mattresses and old bicycles to go to Haiti. *St. Innocent, Man O'War, Miss Yelena.* Old fishing boats turned into cargo boats, moored down there beyond the bridge that opened. Men of that dense blackness of Haiti, as if there were too much heat there to be reflected. Men with skins you could warm yourself at. But she was drifting, unable to concentrate, playing with her wine.

Pedro said, "It'll probably be about two weeks. If the weather

holds, and we don't get any storms. There'll be a boat going out to meet them. Have you fixed somewhere to stay?"

"Yes. I booked a hotel. I might as well get a vacation out of this."

"You sound as if you don't want to see him."

"Well, I don't know. How can I know? It's been so long, it's impossible to imagine. It's like going to meet a ghost."

"It may seem more real when he arrives. I hope so. Anyway, you will have done what you had to do."

"What I had to do. Yes."

"Shall we order?"

"I'm having the yellowtail. Oh, and ceviche to start."

The young waitress took their order. "My name is María," she said. Where was she from? Nicaragua, Colombia, Brazil? Maybe even Cuba.

Emily said, "Isn't it strange, how down here you can see what Miami was. A trading post, a fishing village. A collection of shacks around the mouth of a river. While Havana was a city, for centuries. Don't you think it strange, that they all come here?"

Pedro said, "It's what people want."

"It's what they're told they want."

"It's often better than what they have."

"It's illusion," she said. "Glittering illusion. A bauble, to draw children from all over the world."

"Easy to say, when you live here."

"To be American, in this century. Everyone's supposed to want to be American. To deal in toys and illusion, like a magician."

The dim lights swung above the Haitian boats, their paintwork, the stacks of bicycles tied down with rope. White plastic chairs, suitcases, lamps, bedsteads: the debris of this city which somewhere else, people would want. The world swung this way and that by wanting, by the imperiousness of desire for what it did not have.

"Emmy, *cara*."

"What?"

"Don't worry about it. It's gonna go fine."

"I'm not worried. But it brings up stuff for me, you must see that. Old feelings, uncertainties."

"It'll be just for the formality. Then you will be free."

"How do you know? I was made free, perhaps I'll be made unfree again. Anything can happen, when you start digging up the past."

"It's paperwork," he said, "bureaucracy. It's just to have everything in place. It can't be done without you."

"I know that. It's okay."

"Then you'll just come right back, no problem, and go on the way you were before."

He leaned across the small table towards her, a bite of white fish spiked on a fork close to his mouth. He popped in the mouthful, washed it down with wine. The wine in the bottle was yellowish in the streetlights, the lights from under the highway. They were sitting in a restaurant where no restaurant should be, but people are sitting by rivers, in working ports, to eat their dinner these days; it's chic, it's for tourists, it makes a change.

He was young, that's why it seemed so simple. To go to meet a man you used to be married to, whom you have not seen for fourteen years. He couldn't see any complication. It was for the paperwork. For the authorities. A marriage in name only, to be abandoned at once. A fiction, a story become a lie.

She lit a cigarette and watched his dark thin face, the way he chewed, the way he was impatient with her, wanted objections out of the way.

"You're not eating that?"

"Not hungry anymore."

His fork reached across, stabbed up her fish. Her little brother, still taking food from her plate.

"It's important that you're doing this. It makes things so much easier."

"Yeah, I know. Same old story, she'll do it for the family, for the clan, for history. At least nobody's telling me this time I'm doing it for the revolution. You'll call me? Here's the hotel number. I'll be in most evenings, late."

"Most evenings?"

"You don't expect me to sit in a hotel room all night just doing nothing? I'm going to have a vacation, I told you."

"Just so long as we can reach you."

"We?"

"Okay, I."

"Look at the river," she said. "Look at that man down there tying up his boat, putting it to bed for the night. See the cat on the dock? Look how she's yawning, she's just been fed."

"Yeah? What about it?"

"That's what men do on small boats all over the world. See him tying the knot? Slow and careful. Doesn't know we're watching him. Probably thinks only God sees him, or the cat. You know, we could be anywhere, anywhere in the world, so why are we here? What are we here for, *chiquito*?"

"Wow, you're in a mood tonight. We're here because, sister, this is where it's at. This is where we live, and nobody bugs us, nobody gets in our face. You can just arrive here and be invisible, and that's worth a lot."

She said, "Invisible? We're invisible like that fisherman down there is invisible. Somebody's watching us, but we're not aware of it, we don't know who it is. God, or a cat, or a whole bunch of people we can't see, because they're on the other side of some one-way glass, and our little lives, our little movements back and forth interest them just about as much as ants' do, but they still have to step on ants."

"Are you scared?"

"Of course. But not of what you think."

"What then?"

"Oh, women's fears, little brother, ones you wouldn't understand now you're such a big man, such an American. Don't worry. I'm going to do it and I'm going to do it well."

It was easy enough when you had your own business, to say you'd be away for a couple of weeks, taking a vacation. Jeanne and Dolores would manage it all. In summer, anyway, business was quieter; fewer tourists came and some of the regulars were on

vacation up north. You could fly down the Florida Keys in a rental car or a small plane, you could transport yourself back in time and space, be in a known place where nobody knew you, because the person you had been there was gone for good.

She bought a plane ticket in the end, opted for the thirty-five minute hop that was half like a bus ride, half like a fairground treat. Flying low over water like milky jade with the summer thunderstorms creeping around its edge, the glimmer of sheet lightning all around the sky, clouds like castles. The little plane, casting its shadow upon water. The earth tipped sideways as you skimmed above it in a little cylinder like a cigar holder, staring down. The water deepening in color as you came closer. Blue, purple, emerald, pale jade. Water color more brilliant as the sky grew darker, drew curtains that closed you in. The small patches of sudden blue, where a cloud broke open. The channels in the ocean, deep emerald, an unbelievable green, to show where the arteries were, the passageways of the marine world. Sandbars, pale as cream; shallows, brown and red, streaked with weed. Land that might be cloud shadow. Cloud shadow that might be land, islands, banks coming up out of the water, earth coming up through the ocean crackling and alive, to be submerged again by the next tide. Down there was all shifting shallow land, water, one thing endlessly becoming another, no edges, nothing fixed or defined. Maps of those places had to be drawn and redrawn, as the mangroves crept out into the water, their messenger fingers going out to put down roots. Land created and recreated itself. There were no boundaries, no fixed landmarks, only the roads in the ocean, the emerald depths, that showed from up here clear as veins, but down there had to be navigated with stealth and care.

She leaned, cheek to the glass, ignoring the stewardess' offer of peanuts. Drawn to the slanting earth, the rounded ocean, the curve of the horizon clear as a breast, the glitter of sun suddenly making water solid pewter, a dash of rain spattering the plane wing, cloud swimming up fast as fog. The island chain stretched below her, and there at its end, like a lizard with its blunt muzzle pointing outwards, Key West. The plane bucked and shook and began a

sudden descent. It swung out wide over the ocean, came in again. Immediately below, houses in rows, boats moored in rows, boats like dots out upon the ocean. The wrinkled skin of water. The edge of land, a beach like a frill. The bonfires of royal poincianas blazing up at her, the summer giants. God, what memories were here. And here she was, catapulted down into them one more time, August 1994: a bump and shudder upon blacktop, the plane's wings shaking, and ten other people, legs and heads bent in the cramped space, going out before her into the heat of day, like so many unfolded flies. She saw palm trees, the line of ocean, chartreuse stirred with milk. The warmth touched you like a damp cloth as soon as you moved, as there was no air conditioning in the little airport and the doors hung open. A pink cab waited across the road, with a young man yawning and stretching his arms beside it. And still the lightning flickered on, off, like a bad electrical connection, and the storm might pass them over this time, let them go.

The cab driver motioned her to get in beside him, as the back seat was full of stuff, so she sat and talked, not answering his questions. Yes, a vacation. The Pier House. Yes, she knew Key West, had been here before. She stared out. There were tourists in the streets, even though it was summer. They wore white socks and sneakers and sun hats and took pictures of trees. The trees themselves were as vast as she remembered, banyan and mango, women's tongue, jacaranda, and the flower of summer, the hot red canopies of royal poinciana. They drove through Old Town, and everything looked painted and bright, compared to the stained worn wood of her memory. It hadn't looked like this. Key West had not been pretty. There hadn't been paint, or glass for windows, or expensive imported shrubs, or swimming pools. According to the signs planted outside, most of the houses now seemed to be for sale.

The Pier House, her destination, had not been built; she was shocked to see its size and bulk, how all the old waterfront was now a cliff of hotels, with private beaches, parking lots. Yet still in the streets there was the lazy dusty summer look, because you couldn't air-condition streets or control who came down them. There were

shaggy guys with bottles in brown bags collecting on the small beach down the street from the hotel. A man stretched out either asleep or dead, right on the sidewalk. A dog ran out, accosted another, smaller dog, and began fucking her right in the parking lot.

The cab driver grinned at her. "Welcome to Key West."

Out on the pale green water, between her and the islands, moored sailboats rocked on the tide. She sat in the bar, ordered a margarita, held ice to the inside of her wrist where a mosquito had bitten her already. It would soon be sunset, but the sun tonight was invisible behind rolling dark clouds. A schooner passed between the dock and the moored boats, small figures on deck hauling up ragged sails. A black schooner, passing like sleep, like dream. She watched it go, out past the hotels and into the ship channel.

She wondered how long it would take.

RAIN, and the music of the tango—that's what I remember most from that summer. Rain sluicing boat decks and filling yards, running down my face and arms as I worked, rain making lakes in the street. And the dance music, the tango. One particular tune, played over and over, in a closed room with the ocean outside and the clatter of seagrape leaves in the rain.

My name's Martha. I'm a deckhand on the topsail schooner *Black Cat* and we go out for a sunset sail each night, there and back, where the Atlantic Ocean meets the Gulf.

I saw her first from the deck as we sailed out, close to shore. Most people wave at passing boats. She didn't wave. She just watched. As we moved out past the hotels towards the crowd on Mallory Dock, I saw her put up an arm to shield her eyes so she could follow us with her gaze. I wondered who she was. When you're sailing, thoughts flit through your mind and you let them go because your mind's on the job, has to be, or nothing would work. It's kind of like making love, or music. You have to be all there.

Going out of port, this particular night I'm up taking the bow watch. We run the engine to get out of the narrow harbor mouth into open water, where we set the sails. She's seventy-four feet, this boat, with a draft of six-five. She's steel-built and rigged the way a schooner would have been a hundred years ago. We're sailing the hard way here, no shortcuts or gadgets, just heavy old sails and a bunch of lines to haul and old-fashioned belaying pins set in rows to make the lines fast. We go out with a boatload of tourists and show them the sunset over the Atlantic, where it joins the Gulf of Mexico, and we sail back in darkness. Then, the sky's a soft bowl of stars and our passage through the deep channels is so quiet. Even the noisiest tourists go quiet then. Even with booze in them and the noise from the bars on shore and the dart of boat traffic

across the bow. It isn't ordinary, it isn't what people get to see and feel in the rest of their lives. They have neon and the blue light of TV, and the only water comes out of the faucet. They want this other thing, this passage through deep water. You can see it in their faces, even if they're only asking for another beer.

So, I've come down from my position in the bow, and we've been out into Man-O'War anchorage and set the main and the foresail, and we tack back shoreward before heading for the islands and the setting sun. I'm leaning on the lifelines on the port side, coiling up a last line while the other crew member, Janie, goes to open the coolers. Harry, the mate, is beside me looking shoreward too. So we see her together, the woman in the Havana Docks bar. She looks up. We pass, close as people in two passing trains. She doesn't wave, but stares. She takes a drink. Harry's beside me, staring back. Sharon, our relief captain, calls out an order and we have to listen up then, not be gazing back to shore. I run aft as her voice carries on the wind. The boat picks up speed. We're sailing. I glance back to Harry for orders, but he looks blank for a second, as if he's had a shock. But I don't have time to ask, what.

<hr />

The island settles back onto its old bones in the summer months. Work is scarce. Everything depends on tourists, now that the shrimping industry is dead and the cigar makers long gone and even the fishing diminished. We all fish for humans instead. We want them in droves, all going the same way, with full pocketbooks and plenty of credit. They are easily scared away, these human fish. News of a hurricane will do it, or Cuban militancy just across the water. But the brochures and TV programs never show these things. They simply show blue water and blue sky, young nearly naked women and bronzed muscular young men, and white sand, and sailboats. These are the pictures we use as bait for the pale passengers of the north.

It was a week or so before the Havana Docks woman came down to the booth and booked in. I worked in the booth on the dock three days a week, and other mornings I cleaned the boat. Cleaning the *Cat* was hot work in the metallic morning sun, scrubbing the decks and polishing the brasswork, with all the carpets from down below hung out on the lifelines to air, and water from the hose cool on my mosquito bites, and the sun hitting me over the head.

That's what I was doing the morning she came down to the booth. Harry was in the booth. The job there is to catch tourists as they pass, so you have to make up some stuff about pirate ships and all the champagne you can drink and sunset over the water. Sometimes we play music, and there's one guy, Mo, who works in the booth who sings and plays guitar. The tourists like that; they stop to listen and sometimes book to sail.

I was on the boatdeck, swabbing last night's wine stains off the cream-painted metal with a long-handled mop. I'd done the cabins and the hold and cleaned out the head and belowdecks were looking pretty good. I had only the weather-decks to finish and the carpets to put back. It must've been nearly midday. The sun was up overhead like a furnace and the clouds were piling up on the horizon, out there over the water, the way they did most afternoons this time of year. There'd be afternoon rain and then it would most likely clear before evening. I stood up straightening my sore back, leaned on the mop handle and watched the woman in clean white pants and a black top come down past the Schooner Wharf bar, stepping over the bumps and cracks in the street, and walk towards Harry in the booth.

Harry didn't call out or joke or say any of the usual things. He just leaned on the counter in his white shirt with the sleeves rolled and watched her come. He waited for her. He looked like he'd been waiting all his days. I couldn't hear what he said, because there was a foot of water between us and the radio was playing from the bar and the high-up breeze was rattling the halyards. I just saw him

bend to write carefully in the book and take the money from her outstretched hand.

She saw me watching. "Hi!"

"Hi!" I called back.

Her black hair swung forward like a wing, below her chin. She took off her dark glasses after she'd waved to me, and she had high curved cheeks, pale brown skin, large dark eyes. She was beautiful, that was it. I sighed, suddenly feeling tired. That was why Harry was so quiet, and why his shoulders were set high that way, and why he avoided her gaze. Oh, you see beautiful people, so-called, all the time down here, the ones with the swept-up blonde hair and long brown legs and a look of contempt on their faces for all the people who aren't them. But when you see the real thing, you know in a minute. It's unlike anything you've seen before. It's totally personal. There's no blueprint, in spite of what the magazines say.

The woman stood there, leaning on the counter top, intimate and confident, or so she looked to me. Harry spread his hands on the counter, his arms braced, his blond head with its ponytail slightly bent. There was something hopeless in the way he stood. I give up, it said. I give up before I've even begun.

The boat rocked gently towards the dock, pushed by the current. The main boom shifted an inch and creaked. The thunderheads grew on the horizon. The sun was as fierce as ever. The woman picked up her purse and turned her back after saying some last thing to Harry, who shrugged. She walked away between the Schooner Wharf bar and the trailer park, picking her way back in heeled sandals between the potholes. She wasn't on her way somewhere, she'd gone back the way she'd come. She'd come especially, to find us.

"Emily de Soto," Harry said. "She's sailing with us tonight."

I WATCHED her settle in the stern with that calm, alone look of hers as if she didn't need a thing. The way she was, was like the sunset or the way a heron stands in the shallows to fish, unaware of what he looks like to humans. She wore a scarf tied over a straw hat, and blue jeans, and a striped sleeveless top. Her arms were long and slim and slightly tanned. Her cheek curved up high beneath her sunglasses and her body was lithe and comfortable. I came down from the bow to clear the lines and then went to offer her a drink. There were only six people on board that night. The heat and the clouds of August were putting off the tourists. There was a rumor too that something or other was happening in Cuba. And there were the hurricane forecasts. They form on the coast of Africa, come down across the Atlantic, pass by the Caribbean islands or the Bahamas, or Cuba, and curl back our way, towards the Gulf and the Florida panhandle. So far, they hadn't touched land this year.

She looked up and took off her glasses. Her eyes were a light green and her eyebrows raised.

"What do you have?"

"Budweiser, Bud Lite, white wine, champagne, Pepsi, ginger ale, Sprite."

"White wine, please. With ice. Do you have ice?"

"Sure."

"That'd be nice. Thanks. Hey, you're the one I saw yesterday, cleaning the boat, aren't you?"

"Yeah, that was me."

She smiled, and I understood the look Harry'd had when she spoke to him, the way he'd hung his head. I went to pour the drinks while Harry set the jib. There were just Harry and me as crew that night, with the captain, McCall, at the wheel. The other parties were a German couple with a subdued teenage daughter in white

socks and a young couple from Louisiana or maybe Alabama, who were heavily into the beer. The Europeans don't drink much, usually, and are more ready to be awed and ask questions than the Americans. So I spent some time with the Germans, telling them about the islands and why Australian pines grew there and what the birds were and what the channel markers meant. They spoke good English and were kind of earnest. They were interested in ecology. They wanted knowledge, it seemed, for its own sake. The tall skinny girl they had was like a stalk on her thin legs. She just sucked soda out of a can and looked at me with her pale eyes. I talked to them for a while and then went to work as the captain called out, "Ready about!" There was a bit of wind tonight, coming in from the south. We went about. "Let go and haul!" I hauled, my legs stretched out to brace me on the deck, and made the line fast. We were sailing. The woman in the stern sat motionless with her drink in her hand, just staring out to sea the way she sat and stared out from the hotel deck when we passed. I stopped thinking about her, busy with the routine of the boat. Then I saw Harry go aft to her and say something. She shook her head. Maybe he was just offering her a refill of wine. But she raised her head and looked into his face and just gave a little side-to-side shake as if refusing him something in an intimate way. I saw his face as he stumbled back past the mainsail and down the steps from the aft deck. Normally Harry is very deft on board and moves easily, not stumbling or sliding even if the boat's rolling. Tonight, he stumbled. His face was reddened by more than the setting sun.

We go out towards the reef, give them a chance to photograph the sunset, and then turn back. Somebody usually says something about the green flash. They watch for the green flash, talking about luck, and love. The sun goes down fast towards the burnished water and becomes a soft red egg. As it gets close to the horizon it sometimes goes square at the bottom, so that its path on the water is squared off too. When it isn't going down in a drift of cloud you can watch it inch its way down, poised just above the surface of the ocean, changing shape, dropping like gravity. People are amazed by

this. Where they live, they don't see sunsets. Any more than they see birth, or death. It's one of the basics of life, and they want it, sure, but not too often, not every night, the way we who work on board get to see it. They exclaim, call out, and take photos. That night, the German man was taking photos, one a second, with a big old camera. He didn't photograph his wife or daughter, just the sun. The sun doing its thing in the tropical waters, to be captured and taken home. The two Americans were taking pictures of each other, waving their cans of beer. They knew what they were supposed to look like on vacation, on board a ship. They posed and showed their white teeth and shifted their hips to look sexy, for the folks at home.

Home to Tom, to the apartment we share on Olivia Street, with the cemetery at the back of it and our neighbor's TV blaring at us all day and most of the night; a little temporary makeshift home, but it's home. Home is where the light shines that you bike towards through the darkness. I unchain my bike and bump off over the ruts towards the empty lots covered in oyster shells that crackle under my tires, cross Caroline Street, wave to my friend Joe who keeps his store open late, and cut across town towards the cemetery. The cypress and the eight tall palms of the cemetery all point up to the night sky. When I get to the cemetery gates I can see whether Tom's in from the light that shines out from the back of the house. We have one room and a balcony up there, and when I see that light my heart does a jump and I pedal faster and more carelessly, singing as I go home. I'm already home, going up the rickety wooden stair at the back of the house to find him smoking on the balcony or lying across the bed, reading, or watching the on-off crackly black-and-white TV that only gives us snowstorms and sound. I'm in his arms again, I'm pressed up close, I'm feeling his wide lips on mine. Safety. Home. Every night, as the darkness closes around the islands.

He's a sailor too, he works on a huge gray steel hulk of a ship that's built for Atlantic waters, out there where it's deep. It's a Navy boat, used for research. Sometimes he's away for weeks or even a

month or so, and that's when I don't see the light from across the dark cemetery as I bike home, and my heart doesn't do its little jump of pleasure. Then, I go home slowly. I call by to see people on the way. I take my time, because going back to that upstairs room when it's empty just isn't the same at all. We're like new lovers still. That's how it is.

But this particular night, he's there. They haven't made him work late and he's not out on a trip. He's his slow-moving half-surprised self as he gets up to greet me and we stand for a moment at the top of the stairs, embracing. There are the dark spikes of areca palms and cornplants and the thickets of aurelias beneath us, and before us the dark finger of a cypress, pointing up. The air is warm as our skins. There's only a slight shift in it, after sunset, a slight cooling. But it breathes on us from across the graves. The stones in the cemetery are white and gleam at night, and we like the quietness of this place.

"Well…. The sailor's return. Are you hungry? I made spaghetti."

He sets out our two bowls on the table under the stars and puts a steaming pan between them. We pull up our two chairs to eat. I want to tell him about tonight, about the woman in the stern, and about Harry's face, and about the way she turned and looked at him with a slight twitch of a smile as he handed her down on to the dock at the end of the sail, the way we have to. But when I think about it, nothing really happened, not the way it should if you tell a story; there isn't anything to say. So I help myself to spaghetti and just think about it, wondering what happens out of the way of storytelling, like something moving underwater, in the darkness, out of sight.

MOTHER of God, Emily thought. Being here again. Sailing out past the Navy buildings, the Truman Annex, where all the boats had come in. A Friday, that had been. A calm day, hardly any swell. Hours, a day at sea. A flat blue horizon, on which small bumps grew at last, like baby teeth.

She stared out now, lulled by the onward movement of the sailboat. Past the docks and bars, the new hotels. How buildings shrank back as you went out to sea, how flat the land seemed. The white buildings were like old bone. The Customs House, its red roof a shriek of color. The low white Navy buildings, the docks where they'd all stood in line to phone, go to the rest room, hear something, be found. The Navy base, now a wasteland of cracked concrete and growing weeds. There'd been showers, phones, people rolled in blankets, buses coming in.

Waiting, she thought, a condition of our lives. What we know how to do, is wait. For whatever is coming from the outside. From history, from geography. For whatever it is that comes to find us and move us about like pawns on a board.

She'd stopped thinking about him, or only thought about him about once a week. Others kept him alive for her. Asked her where, when, how they would be reunited. That was another part of her history, of all of their histories, the other part of waiting. You waited enough and then everything was possible. It was your patience and faith that made this so. You were uniquely gifted in patience and faith, for there was so little else to go on. She thought, we are a people whose skill is waiting. We live off signs, and hope.

A boat moving out of harbor, for instance. The gap between land and boat that lets you know, suddenly, that you were moving. Dark blue water. A calm day. Seventy-five degrees, they said, and the

wind out of the south. Boats blocking the harbor edge, hundreds of them, some very small. A man with a broad hand, reaching to take hers. The yellow buses on the dock, turning and gunning their engines. Faces pressed to the windows. Weeping faces, hands stretched out. The paper in her hand. Blue smoke from the outboard engine. Then, the gap between the boat and the dock, and a gap at her side where he wasn't and wouldn't be again, a gap quickly filled by another man who pushed roughly at her and shoved her towards the bow, to make room farther back. Mariel: the land receding, buildings shrunk back to stumps. Flat water, the desert that was the ocean. And then, new stumps, growing out of the island to the north.

And if you were married, you were married. She kept her affairs to herself, because secrecy was the only safety, always had been. But she'd had to fill that gap. You couldn't be twenty years old and alone, carrying that opened space inside you through the world, where a man had been. She didn't tell them, a way of having everything, and nothing.

She saw the sailor's glance, as she settled into the boat's rhythm and began her own lookout. Men's eyes did that, they looked at her and then looked away. And then back again, in case she wasn't looking, but she was. She'd developed a way of staring directly back, to unsettle them. She watched him look, and then away. And then back, and his roused, unsettled face.

She said, "Haven't we met before?"

"I don't think so."

"Were you ever in Fort Lauderdale?"

"Sure."

"I wondered if we met in Fort Lauderdale."

"I'd have remembered," he said, giving himself away.

"Not Fort Lauderdale, okay."

"You here on vacation?"

"Isn't everybody?"

"No, some of us work."

"Yeah, I'm on vacation. What about Tampa, were you ever in Tampa?"

"I used to sail a boat out of Tampa, yeah."

"Maybe it was in Tampa." *The Dolphin*, Tampa. Gold letters on the side of a white hull. A new boat, a sportfisherman, big engine, the crossing'd be easy, they said. A man reaching out of it, a captain, with a broad hand. American, with a baseball hat. Get down there, out of sight, or they'll throw you off. I gotta take this riffraff on first. She'd crouched in the bow, still watching the yellow buses full of people that were not, any of them, him. Sorry, ma'am, seems your husband's not coming after all. And the dark blue water stretching in the gap between boat and shore.

This man, the sailor with the sleek tight blond head, leaned and looked down on her, as the boat passed the different shore. Rocks, a beach, a harbor mouth. Trees. The open sea. Lights, channel markers, islands. A way out, a way in.

He said, "Maybe it's just, all sailors look the same." And went to pull on a rope and fasten it, ending the conversation, letting her know he was still in charge.

She watched him, narrow back, lean waist and hips, blond dripping head, large hands capably covering distance. There was a tension in him. At the end of the trip he raised his eyebrows at her and grinned as he handed her ashore, but she felt the tightness in his fingers, what he had to contain.

Back in the hotel, she turned on the radio and listened to the weather forecast. Forty percent chance of rain. Highs in mid-nineties, lows in high eighties. Seas inside the reef, two to four. Seas outside the reef, four to six. Bay waters, moderate chop. She turned it off. Anything could happen here, anything. A hurricane could grow on the coast of Africa or on the Yucatan Peninsula, and be here within days. Out over the Atlantic, the storms boiled up, dissipated, began again. Maybe all you could do, once again, was wait, and pray. There was the big story that was outside your control, but there was also your own small part in it, the thing you were uniquely able to do. She unrolled a sea chart across the bed, one

she'd found in a marine equipment store on Caroline. For a long time she studied shorelines, depths, locations. It was a map of her life, she thought. It was a chart of the gap between here and there, this and that, past and future. She read on it wind patterns, currents, sudden changes in depth, the names of small islands that were probably no more than mangrove roots clustered in salt water. Then she rolled it up again and put it back in a cardboard tube and stood it in a corner; but only when the lines drawn on it were drawn again inside her eyes and in her mind, where her brain stored it for future use, a new line, a new configuration, that might make sense of what had already been. She lay across the wide taut bed, where the chart had been. Her arms behind her head, eyes drawing lines on the ceiling. Sweat lay in the hollows of her back and between her breasts and prickled under her arms. Outside, a ship's whistle hooted for departure.

AFTER that first time, Emily de Soto began coming out with us every night. McCall, the captain, was polite to her and when he took her hand to help her on board, he looked like he was going to kiss it. As for Harry, he blushed and frowned and went to work quicker than usual. She didn't even come down to the booth to book anymore, she just walked towards the boat a few minutes before sailing time and handed in her money and stood apart from whoever else was there, waiting. She waited as if it were all she did in life. She'd gotten it down to an art. And when she was up there in the stern again, her legs folded under her, she just stared out to sea the way she had stared at us from the dock. Not as if she were looking at things, but through them. I began thinking that she was acting a part. She just didn't behave normally, or at least not like anybody I'd ever met. There was something so passive about her, so numb.

We didn't talk much, apart from me offering her drinks. Once we've set the sails, we open up the coolers and serve free drinks, while sailing the boat at the same time. I stopped wondering about her, because there was too much to do. When somebody just sits around looking stunning, and you're working your butt off, you can get kind of irritated with them, too.

Harry and I worked together cleaning the *Cat* one morning. I usually do it alone, but this time he came down with a new gallon of boat soap and stayed, I think because he wanted to talk.

"Looks like we've got a new crew member," I said, as he said nothing.

"You mean her?"

"Her. Madame What's Her Name. De Soto?"

"Sure. I had to write it in the book. Emily de Soto."

"Emily. I thought it would be something more exotic."

"De Soto's exotic."

"Sounds like a husband's name to me."

Harry began tidying stuff in the cabin. He slept down here most of the time, since McCall said he could. That way he was like a night watchman for the boat, and he got a free berth. The bed down here was wide and comfortable looking, and Harry said it was quiet at night and the boat hardly rocked. Sometimes he was surprised by someone coming on board, but they were usually looking for McCall or so drunk they didn't remember why they'd ever come. He put his few things in a zip bag and stowed it out of sight when the passengers came aboard.

After a while he said, "She isn't wearing a ring."

"Ex-husband then. Why do you think she's here?"

"I dunno. Why is anybody here?"

"No, I mean, why stay at the Pier House for weeks on your own, and why come out with us every night?"

"She wants a vacation and she likes sailing?"

"You know what I mean."

"No, I don't. Here, have you done the head today? We need more paper."

But he was there, ready to welcome her aboard again that night, and it looked to me like he and the captain were competing to take her hand. Harry was wearing a white shirt that ballooned out above his pants like a pirate's and his hair was combed back gold and smooth. The shirt was more or less open on his chest. The captain was wearing white too, an ironed white shirt and white pants, with his captain's hat. Something was going on here. Janie, who was down on the dock coiling rope out of the way and preparing to catch the lines we throw her, grinned up at me. She saw what was going on. Our passenger was wearing a short black linen dress tonight and her knees shone as she curled herself into the place in the stern. I went aft to cast off the stern line. As I unwound it from the cleat, I felt her presence behind me. Normally, McCall won't let anyone up there until we were underway, but there she was, like the ship's cat. We did have a ship's cat once and it was black and white

and licked its lips just the way she might after a good feed, and sat exactly where it liked.

I was beginning to feel annoyed with her, I could tell.

"Cast off the stern!"

"Stern's free."

"Cast off the bow!"

Harry was up in the bow tonight. We threw our lines shoreward and Janie and Mitch from the booth caught them. The black ship turned sharp out from where we were moored, and we motored gently out between the posh yachts from up north and the sailboats that clattered their halyards in a slight breeze, passed where the Navy boats are moored, where Tom was still at work, and turned out towards the channel opening. A day like any other. A sail like any other. Only they never were the same, even if you went out day after day at the same time, because of the changes in weather, wind, tide, and current, and because no two sunsets are alike.

"Ready on the throat?"

"Ready."

"Ready on the peak?"

"Ready."

"Haul away."

We haul, Harry and I, and Jeb, that night's musician on board, begins a sea chantey which somehow strengthens our muscles and gets us hauling the way it's supposed to, and the wind takes our big ragged sails and fills them, and we turn in the space between the island and the shore. Clouds pile up all around the edge of the ocean as we go out. They lie around like big cats at a drinking hole, growling and stretching and threatening action. There's a lightning flash from time to time so fast that you think you haven't seen it, a shiver of electricity that makes you blink. The wind freshens and we're sailing into it, the squall that takes the light away and makes the surface of the ocean dead-looking, metallic. The captain changes our course, takes us out towards the Lakes, on the other side of the islands, and we head towards the Sand Key light. The clouds are coming in from the north. The sea begins whipping up in mean little crests and slapping us about. The passenger up in the stern shivers

and wraps her arms about her. Harry serves drinks as usual, but he's thinking already about getting people below. It isn't a night for sleeveless dresses or taking pictures of the setting sun. The storm comes up so fast that the whole world changes into a stew of water and wind. Even the captain wasn't expecting this. He braces his feet and flips the wheel and a cigar sticks out clenched between his teeth. Harry and I skid about tidying lines out of the way, making things fast. The other passengers are a large family with three kids from Oklahoma, large in size rather than numbers, and a man from Fort Lauderdale who comes here every year. They all huddle together on the main deck, rather like cattle do at the end of a pen when something's about to happen. The thunder gives its loud crack, making everybody jump, and then the rain begins, thin rain coming in sideways with the wind. In a minute, the captain and Harry have their white shirts plastered to their bodies. Harry goes for slickers, but it's too late. I'm wet to my armpits as I trim the staysail and hang out waiting to be told what to do next. The passengers all push towards the companionway but have to wait while the large lady from Oklahoma lowers herself down. She takes a year getting to the bottom, so everybody else is soaked before they even get down there. Harry and the de Soto woman are behind them. He's holding one of the yellow slickers around her, the one he was going to put on himself. He's got his arm right around her and she's shivering against him, although it isn't cold, this rain, it's warm as life. Maybe she's afraid. Her hair is in black rattails on her neck and her eyes without the dark glasses are naked-looking. The rain runs down her face and she puts out her tongue to lick it away and as she does this Harry turns towards her and his eyes look fierce and dark suddenly, almost as dark as the ocean around us. Normally, they are blue. Normally, nobody on this boat grips a passenger to them this fiercely, as if they'll never let go, but this is what Harry's doing tonight. Then there's a space. The youngest Oklahoma kid goes down with a waggle of her fat little butt in too-small shorts, and there's room for Madame de Soto to go next. But suddenly she shakes her head. She grins at Harry. She wants to stay on deck. She's into being a sailor now, and taking what comes. Acting again, is what I think.

The storm passes over in half an hour, and the sun comes back just in time for sunset. So everyone piles out again and gasps or shouts and the cameras come out after all. It wasn't much of a squall, in the end. Just enough to soak everybody and give them something to remember. Just enough for Harry to get where he wanted to go.

He scooted off fast once we'd put the sail covers on and divvied up the tip money, and down in the cabin he'd rubbed his hair dry with a towel and changed his clothes. I was left with checking everything over and turning out the lights. I didn't mind this, as having the boat to myself is always a pleasure, and I knew Tom was working late because they were preparing for a trip. So I slowed down and finished work, still wet but not unhappy. I knew she was waiting for him somewhere and he'd join her with his still-damp hair and his face shining from the rain, and something would happen, something would already be going on.

"Tom," I said to him, late that night when he was lying close against me in the bed we share, and both our ships were moored and closed up for the night, "Tom...."

"What, baby?"

"Nothing. Just hold me."

And he did. He wrapped his arms around me and held me so that no storms could shake me loose. I thought, love is an anchor, a safe mooring, and then I slept.

We met back in the late eighties, Tom and I. I'd newly arrived here and he was in from sea for a week. In those days he was out most of the time, because the boats got more government contracts and there was money for research into sonar buoys and defense stuff of all sorts. They used to anchor for weeks at a time off Andros Island, or out in the Gulf off the coast of Mexico, or around Canaveral, picking up debris from the shuttles.

I was doing the Power Squadron course in safe boating, and looking for a job. We both used to hang out down at Schooner Wharf, and I was already in love with those schooners. I used to watch them go out at sunset from the Ocean Key House dock or Mallory Dock, and then one day I just went down to where the *Black Cat* was docked and asked McCall if he'd give me a job. It was in that same week that I met Tom. I guess my luck was right in, like one of the crazy spring tides that were happening then, with the moon full and the ocean coming up higher than you could have imagined, like a great magnetic power was pulling everything into shape.

I knew as soon as I saw him. Big, gentle, solid, a man with dreamy eyes. We shook hands at the beginning of the evening, and kissed at the end. He was a Conch, third generation, he told me, which meant his family was from here. He'd been to school here and then away, and he'd come back in the seventies, to do what his father and grandfather had done, work on shrimp boats. The corporate world was not for him any more than it had been for them—islanders, seamen, guys who'd worked their whole lives on the water when there was a shrimping industry and who now lived in Ocala on memories and the money they'd made from selling out to incomers from the north. Tom had this apartment on Olivia. Within a couple of weeks, I lived there too.

I told him with pride, I was a sailor too. I'd just gotten this great job, sailing the most beautiful boat on the island. I was twenty-nine years old and in love with this place I'd come to, in love with the life of it, and the schooners, and the tropical sun. It was easy to fall in love with him too. I was born in England, I told him, so I had this great seafaring tradition behind me. I was a child of Nelson and Drake. I exaggerated all this for him and made him laugh to egg me on. I told him about going to Canada when I was nine, and then how my parents had moved to the States when I was twelve, and about my sister who died when I was three, and about always being an immigrant, always on the move. I told him about English high tea and our house in the Lake District and sailing on Windermere, and about school in Ontario and the frozen winters

there, and my father's work as an engineer, how he had to go where the money was, and my mother never getting over Marie's death, and my dog I left behind, and my English major, my teaching in an elementary school in Albany, and at last, my decision to run away to Key West. In fact, I gave him my life history as we sat there sipping our beers at the Schooner Wharf Bar, where Brenda who worked behind the bar was an ex-girlfriend of his, but I didn't care, because I was young and so much in love with everything that no one could resist me. He laughed at me and said, well, I've sure got your credentials now, haven't I? and we walked out of there with his arm around me and something understood already, although it had never been said. I was his girlfriend. He'd had them all over town. At one time, everyone I met seemed to have been Tom's girlfriend. But he told me, gently, this time was different. Maybe he always said this, I don't know. But here we were together, five years later, and we were still like new lovers, and neither of us so much as looked at anybody else.

There's something about Conch men. They don't say much about their feelings, though they may spend hours shouting to each other about outboards, trailers, or the weather. They're pack rats in their houses and live among all the stuff they just can't bear to throw away. But they're steady. They've been through a bunch of things in their history without budging, without getting off this rock where they've come close to starvation and gotten rich and poor again and still kept on going. And I'd had enough of moving around. I wanted a home.

HE stood at the lifelines to help her step ashore. She took his hand and gave him a small smile. He felt the hand, smooth and warm in his.

"Watch your step. Goodnight. Thanks."

She'd placed a couple of folded dollar bills in the tip bucket that hung on the rail, or maybe they were fives. Harry had scooted up to unhook the rope as soon as they'd docked. You had to make sure nobody tripped. You had to hand them carefully ashore, because of the insurance. If somebody tripped, McCall could be sued. And it was part of the mate's job. So they all trooped ashore, some of them drunk and some of them sober. He despised the drunk ones. Couldn't they enjoy an evening sail without getting toasted? The sober ones remembered the tip bucket, too, while the drunks just roared off in search of their next drink and dinner.

That black-haired woman seemed to him to take his hand for just a fraction longer than necessary, unless he was imagining things. He wanted to say, meet me for dinner, wait for me. But no words came out. She must be used to men gawking at her, she was that pretty. You ought to look out for pretty women, he told himself, they're trouble, you just end up being one of the poor goddamn flies around the honey pot. But this one, he thought he recognized from somewhere else. When all the passengers were gone, McCall went ashore to make a phone call and close up the booth and take the cash box to the office. Harry watched his white shirt move away into the dusk past the Schooner Wharf bar. McCall was okay. A bit mean with the pay, but goodhearted. He'd had this schooner afloat before any of the fancy boats arrived, the catamarans and fancy yachts and the gambling boats that looked like Mississippi barges. Harry went to help Martha roll the sails and put on the sail covers. The two of them worked together companionably in the dark. Then he divvied up the tip money. Yes, the dark woman had put in two fives folded together,

so tonight the takings were good. They grinned at each other and tucked the money into their pockets. Harry went below to check that everything was stowed and turned off the electricity.

"Okay, Martha, goodnight. Good work, thanks."

He like the way she worked, dogged and quiet, and the attention she gave to detail. She didn't complain, either. Sometimes it was a pain in the butt, working with women; they behaved like wimps and tried female wiles on you and all the time insisted they should be treated like men. Then you were stuck between a rock and a hard place, either putting up with shoddy work or being accused of sexism every time you opened your mouth. Some of them couldn't stop answering back, they just didn't get it that it was the mate's job to tell them what to do, no matter what sex he was or they were. They'd just about take it if McCall yelled at them, which was rare. But even then they'd sulk. There'd been one in particular, a big broad from up north somewhere, loud-voiced, full of herself, Jennifer. He'd wanted to say dyke, but you couldn't even say that these days. Damn, she used to get him going. But these two, Martha and Janie, were okay. When you worked with them, they hardly seemed like women. It was weird.

Martha unlocked her bike and clattered off across the parking lot. The boat rocked behind him, black in the black night. The water was full of pools of gold from all the ships' lights. He went to the men's room at the bar and washed his hands and face and smoothed back his hair and fastened it back again with a rubber band. When he came out, there she was sitting on a bar stool.

"Why, hello."

"Hello again."

"I must have walked right past you."

"Yeah, you did."

"What're you drinking?"

"O.J."

He thought, she could have had as much of that as she wanted on the boat.

"Want another?"

"No. You have something?"

"I'll have a ginger ale." He spoke to the woman behind the bar, Brenda. She washed glasses and grinned at him. "Hi, Harry, how you doin'?"

"Good." The ginger ale glass slid in front of him, filled from a hose. The de Soto woman watched. It felt like she'd been waiting for him. But you couldn't be sure of things like that. He thought less of a woman who'd wait for him, somehow. So he didn't hurry talking to her, or taking any notice.

"You don't drink alcohol?"

"I quit. Used to be too fond of it."

"I understand."

No, he wanted to say, you don't. You don't understand a thing. So wait until I damn well tell you, and don't even pretend to understand. But he said nothing, and sipped his ginger ale.

She said, "I wanted to see you."

"Why?"

"Because."

"Because why?"

"I like you, that's why."

"What is there to like?"

"I guess quite a bunch of things. No?"

He didn't look at her, but straight ahead across the bar. His face burned. Again, he didn't speak, but words ran through his head. Don't guess, don't presume, don't think you can play with me.

"Why are you angry?"

He turned sideways and looked at her then. She didn't look like she was mocking him. Then he stared out past Brenda across the bar and into the darkness where the water was.

"I dunno," he said at last. "Maybe I'm not really. Maybe I'm just in a bad mood."

"Should I go?"

What was that accent? Just a trace of it came and went in her speech from time to time.

"No. No, don't go."

They sat in silence, both glasses empty. She took out a pack of cigarettes. "Mind if I smoke?"

"No."

She lit up and smoked in silence. For the longest time, neither of them said a thing. It felt like the longest silence he'd ever had with a woman. Normally, they couldn't stand it and started to chit-chat. It went on until even he was starting to get nervous. Could you sit and have a drink with someone and have them smoke a whole cigarette and stub it out and keep on sitting there, and no-body say a word? Brenda shot him a glance as she passed, carrying glasses. He'd known her for years. They'd even had a fling together once, back in his drinking days when he could hardly remember one woman from another and his whole life had consisted of wait-ing for the next drink or the next screw. No hard feelings, though. They were old friends, in the casual way you could be old friends with someone, when you'd both forgotten what it was you did to-gether exactly, but it was something. Now he could see her think-ing, cat got your tongue, Har? Damn if his mind wasn't empty as a pocket with a hole in it and there wasn't a single thing he could think of to say. The woman at his side didn't seem to mind.

At last, after what felt like hours, he said, "Would you like to have dinner with me?"

They crossed the Caroline Street parking lot, walking between the RV's and parked cars where people camped and slept. The oyster shells shone and cracked underfoot. On the street, they ran into Wanda. Damn, thought Harry. He tried to pretend he hadn't seen her, but she saw him.

"Hi, Har, how're you doin'?"

"Hi, Wanda, good, how're you?"

"D'you wanna hear some poetry? I got some new stuff, it's real hot, you'll love it. I got a new line. Erotic recipes. Listen. This one's with mango and stuff, it's hot. Drive you wild. Is this your girl-friend?"

"Not now, Wanda. Some other time, okay?"

She stood planted in front of them, blocking the sidewalk. Her blouse hung open and she had a boob tube under it with large breasts trying to burst free. She wore a black beret on her spiky

short blond hair, big sunglasses, and her little skirt strained across her thighs. But she put the sheaf of papers away in her bag and stood aside after a minute.

"Okay, Har. You know where to find me. They're only ten bucks for a whole book. I've got some great new ones. You know that guy who split to the FBI? Well, they're after me. I've got a load of things to tell you. You wouldn't believe it. Well, so long. Have a nice evening."

"Who is she?"

"Wanda? She's nuts. Or mostly nuts and sometimes extremely on the ball. She writes pornographic poetry and sells it. Well, she tries to sell it."

"Erotic or pornographic? She said, erotic."

"Well, it's all the same, isn't it? Now she's into cooking and sauces. I can imagine what you're supposed to do with the sauce." He chuckled and then remembered who he was with, and stopped.

She said, "No, it's not the same. Not at all. I don't think so."

They went into P.T.'s and in amid the din and beer and the strident voice of television, ordered big platefuls of meat and vegetables. Harry thought, I should've taken her somewhere more fancy. But he was aware of the tip money in his shorts pocket and didn't want her to pay. She looked as if she could pay, but he didn't like women paying for him, however rich they were. She looked quite happy, sitting opposite him. They drank more ginger ale and smiled at each other. He breathed out. Maybe she really did like him. Something tight loosened in his chest. He spread his work-rough hands on the table and looked at them and she kept on smiling at him in that self-possessed but friendly way, and they ate hungrily as if they'd known each other for years.

Who was it that she reminded him of?

"You're staying at the Pier House, right?"

"Yes. I used to watch the boat, your boat, go out past the bar there. Then I thought, I want to go out on that boat."

Again, there was the trace of something foreign in her speech. French, Spanish, English? Just not quite all-American, he thought.

"So, where are you from?"

"Oh, from Miami. I'm just down here on vacation."

"Before that?"

"A bit all over the place. You know? I've kept on the move."

Okay, so I won't insist on that one.

"And you?"

"Pensacola, Florida. I was going for a job in Tampa, then I decided to come down here. I always wanted to sail, so here I am, sailing my butt off, for a living. That's the way it goes, huh? You go for something you want and you get more than you thought."

"But you like it still?"

"Yeah. I get a kick out of it. I can't imagine doing anything else. So what do you do for a living?"

"I've a business." She smiled at him carefully.

Okay, so no more talk about that, Harry thought. There was tension going on in him now and his hands were sweaty. His heart felt too big for his chest. What could you say to a woman like this? She'd eaten all her dinner and was smoking again. It was unfair the way smokers always had something to do, to make them look self-possessed. He folded his hands under the table.

"Shall we go?"

"Sure. Let me pay for this."

He'd seen that coming.

"No, this is on me. I invited you. You can do the next one if you want. Take me someplace fancy."

That was a good move. It meant there'd be a next time, and the responsibility was on her. He left his crumpled little pile of bills on the table and they got up to go. She moved ahead of him, out into the street. He took her arm. Like this, they moved back down Caroline Street, the lights and masts of Schooner Wharf and the Bight off to their right, the crowds on the sidewalk, the pitted pavement, the bums on the parking lot. The soft warm steamy breeze of summer enclosing them. It was all easy and obvious and going on forever, as if you could just go on this way, Harry thought,

moseying along down the street forever with a beautiful woman on your arm and no need to be anything or prove anything or achieve any goal to be accepted. You just drifted on to the next thing, and the next. But life wasn't like that. He dropped her arm suddenly as they came to the Curry Mansion. Life was rich and poor, tourist and worker, it was full of sharp contrasts and he'd be a damn fool to let himself suppose anything different.

"What's the matter?"

"I gotta go."

"You won't walk me back to the hotel?"

"Whyn't you get a cab? I'll get you one."

"Why won't you walk with me?"

Damn, she was nosy. Obstinate, too.

"I said, I gotta go. I gotta see to the boat. I'll see you soon."

She seemed to accept that, but she stood looking at him for a minute, frowning.

"Okay. I can walk, it's not far. It's only just around the corner. When d'you want your fancy dinner, then?"

"Gee," he said, "I'm sorry. I didn't mean to be rude. It's just, I dunno, I thought I ought to get back. McCall relies on me for a night watchman."

She looked at her watch by the yellow street light. The noise of music came up to meet them from a band that had just started up at the Bull.

"It's only ten-thirty. What time do night watchmen go on watch?"

"Yeah, but you know, the drunks from the bar hang out down there, they can easily get on board. Stuff goes missing. You know how it is down here. But thanks for coming out with me."

"Thanks for the dinner."

She held out her hand. He took it, then leaned forward suddenly and kissed her on the cheek. Her body against him, just for a moment, her breasts brushing his chest, her hand still in his, the clean smell and tickling touch of her hair. Her eyes open and close in that terrible yellow light. Damn, but it was a charge. He almost ran from her, back up the street, and he knew she watched him go.

A WHOLE bunch of things used to go on in this town that don't anymore. Tom tells me about them, and the way it used to be.

Among them are shrimping and the fishing industry. You see the shrimp boats out still with their outriggers lifted like the claws of strange-shaped lobsters. But the center, the heart, has gone. It's like someone's trying to do open-heart surgery now on this town and turn it from a slow, decrepit, laid-back little end-of-the-road nowhere into the kind of tourist town that the last decade of this century seems to want. There are buildings going up that belong somewhere else, and traffic pours into it down US 1 as if there were somewhere to go instead of right back up the causeway. The little cigar makers' houses and shacks and places that have belonged for generations to Conch families who never did more than nail up driftwood over the cracks and slap on some marine paint are now being gutted and tented and sprayed and refloored and reroofed and made into little copies of magazine houses, brochure houses, what people in real estate call "homes."

Sometimes it feels like being in love with somebody with a terminal disease. There are people here who do live with a terminal disease, but they tend to do it discreetly now, tucked away among the Jacuzzis and hibiscus plants that make their landscaped backyards a better place to die. But the island isn't dying. If I believed that, I'd be out of here. It's going through a stage that can't possibly go on the way it is, that's all. Everything shifts and changes here. Everyone who's ever tried to own this little rock in the blue sea kicked off the southernmost edge of the United States of America has come to grief. The hurricanes roll in, the tides come up, history changes course, and change is the only thing you can ever be sure of. We live at an edge. Perhaps at the edge of ourselves.

I wasn't here in the old days of long uninterrupted druggy parties and naked breasts on the street and cheap rents on Duval. Tom

tells me about them, the days when everybody was poor and shared what they had and loved each other. It's like hearing about any other golden age. It's the past of "once upon a time" and it's full of stories we love to hear, and ones that make us shudder, ones we won't forget. Now the drugs are hard, and in the hands of the police. Marijuana's out, and Prozac's what you're supposed to take if the pace of life gets too much for you with the two or three jobs you have to do to pay the rent and thousands of kids of all ages in white socks and sneakers coming to you to be endlessly entertained.

But the old island is there underneath, and we live there still like the cats that creep in under the houses to find their favorite little nests, and the chickens that dart about still between the cars. We have our exits and our entrances, our hideaways, our private lives. Tom and I have our treehouse apartment and a landlord who's unusual in not raising the rent to keep him in Cadillacs and sushi. We hide away in it, up among the palm branches with leaves blowing in across the floor and a bed like a hammock for keeping our dreams alive. When he's home and he's in it, he's my refuge. I put my head against his chest and hear his heartbeat and feel the warm furriness under my cheek and I'm safe. It may be an illusion, that human love can be this way, but I don't think so. I think, in these shifting times, it's what we need. Maybe it's what all those people out there are looking for, marching up and down the streets with their vacant stares. They call it paradise, this island we live on, and everyone wants a slice of that, because it was promised them, long ago. Now they've come for it. It isn't exactly what was promised them. But whatever is?

One of the stories Tom told me from the old days, before I came here, was about a couple who met at a poetry reading in a bar and fell in love. They married. And one evening, in front of the crowd that gathered at sunset on Mallory, he stabbed her right there on the dock. And what did everybody do? They watched. The police came of course, and the ambulance, and the two of them, one alive, one dying fast, were taken away. But they were down there right

where the entertainments happen, where the musicians and jugglers work and people tell fortunes, read Tarot cards, and sell falafel and popcorn and limeade. Where the cats have to jump through hoops, swishing their tails with annoyance, and the tightrope walker balances right at the edge of the dock, and the fire-eater eats fire. It's where people pass in the schooner, night after night. From our decks you can see the faces, mouths slightly open or munching on something, candy or popcorn or gum, waiting for the sun to set, for someone to fall off his perch, for something to happen. You get to the very bottom of this huge continent, and what do you see? A murder. Enacted before your very eyes, just as if it were on TV. One person who used to love the other one, or so they said, seen stabbing that other to death.

I'm not saying that nobody felt horror, terror, outrage, or any of those human emotions. Just that nobody moved fast enough to stop it happening. Nobody was there. Entertainment seems to numb you out. And these days, we're all either entertainers or audience. I pour the drinks and listen to the jokes, and smile, and say my spiel, and know that eyes are staring at my butt as I hoist the sails, and I think about that woman sometimes, the one I never met, who had to go down to Mallory Dock to be killed in public and become just a story to be told. She had a name. She was called Donna. I guess it matters to me, to know that.

When we sail out past that place again and again, and I look from the boat deck out across that strip of water towards the people who've come here from all over the world to watch something, to be told something, I wonder what part I'm playing for them as I take this boat out past their gaze. I'm scenery for them. I'm behind the scenes, a worker. What they see is a black schooner going out under the sign of the skull and crossbones, sailed by nobody in particular, disconnected from any reality they know.

I wonder, is it better to be murdered in front of hundreds of people on Mallory Dock, and remembered, than to die in some hole and be forgotten? Is it better to have the gossip go on—"But I thought he loved her," "They hadn't been married long," "Why do

you think he did it?" Does doing things in public make them stripped of any dignity they might have had? The jury was still out on that one. It was the future, not the past, that was going to let me know.

One thing I did know, though. Sailors, like acrobats and cats who have to jump through hoops, can't afford a clumsy gesture or begin to slip about. We used to fire the cannon sometimes when Gary the tightrope walker was getting up there and balancing his chairs, and he was such an old pro that it never made him miss a beat. But Harry, my shipmate, was getting clumsy. Not only that, he sometimes didn't hear what the captain was calling in the way of orders. Twice McCall had to tell him to cast off the springlines and he just stared into space. Another time, he forgot to set the staysail, and yet another time, he tripped as he carried the cannon on deck and nearly dumped the whole thing on a tourist's feet. In some professions, you can make mistakes and a slip-up can be just something you laugh about. Sailors and acrobats can't do this. I guess in some love affairs, lovers can't either. There are times when you have to be exact.

Captain Sharon got the measure of him one night when he either didn't hear her or forgot to take the watch.

"Harry," she called out to him, "when do we get your brains back? I hope it's soon, for everybody's sake, but especially yours."

They were together, that night after the storm, I'm sure of it. Harry was there on the dock already when I skidded my bike to a stop and chained it to the rack beside the booth. The morning was brewing up fast to heat and humidity the way it does here in summer. He was standing with his arms crossed and mouth pursed, staring out beyond the moored boats to where the horizon was milky and uncertain still.

"Hi."

"Hi."

"Anything happening?"

"Uh-uh."

My shipmate was usually a silent man, but not as withdrawn as

this. I undid the gangway and went on board. I'd come down to clean early, to avoid the heat of noon.

"I'm going for a coffee," Harry called.

"Get me one?"

I went below to the stifling airlessness of the cabin and began tidying. The bed had not been slept in. It was the way it had been yesterday, with the sheet folded. I found the broom and began sweeping. On board, I became house-proud in a way I never am at home. It was the ship that demanded it, it seemed. Shipshape is a necessity, whereas house-proud somehow isn't. Is it that houses, apartments, don't go anywhere, their personality depends on their inhabitants, whereas a boat, a sea-going boat, has a personality that demands attention? I took the carpets to hang out, and as I went up the companionway again, Harry came biking back with a styrofoam cup of *café con leche* in each hand. He wobbled and got off. Then he came on board and sat down on the foredeck and I went and sat beside him.

"I guess you've noticed," was what he said.

I didn't say anything. I'd learned in this town that when men, especially sailors, want to unload, you'd best just listen and say nothing. The island is full of silent men who chew everything over a dozen times before they spit it out. It's all that water, I guess, those spaces and long hours that they get used to, and the company of guys like themselves. They're a species apart. Harry was one of them, Tom another. I was learning to make a space for them that was something like the gap between a boat's rail and the water below, so they could stare down into it.

"I don't know what to do," he said.

Then, minutes later, "I never know what women want."

He sipped his coffee and looked at me over the rim, just a glance sideways, a flash of blue. He was a good-looking guy, not more than forty, maybe less. We knew nothing about each other, but because we worked close and in tune with each other, we knew each other's strengths and weaknesses and where we could depend on each other and where it was better to go alone. He never waited for me to go up the rigging, for example. He knew without me saying that

I was scared, so when the captain ordered the topsail set, he just went up there, climbing the swaying rope ladder without a word. I never expected him to scrub the head out either. We knew each other's fatigues, fears, triumphs, so it was not necessary really to fill in the rest. So I knew about him and the de Soto woman in this way, as if we'd been lovers; in the way of knowing from the inside.

"I never know what women want."

Was he asking me? We'd never been in this territory before. I sipped the foam from my milky coffee and ran my tongue around the edge of the styrofoam. The boat was still and only the shore-lines creaked as they tugged a little at their knots.

"Well," I said, "it looks as if she wants you."

"Yeah, but there's something more. She didn't come here for me, she came here for something else."

"Everyone always does. They don't know why they've come, they have some idea in their head, like it's paradise or nirvana or something, they see the ads, they act like lemmings."

"Lemmings go to the ocean to drown themselves."

"Oh, yeah, so they do. But what's the problem?"

"I guess," he said, "it's that she's rich and I'm poor. She lives in a different world. And I don't know what it is she wants."

"Well, didn't you talk, as well as—"

"Sure. Well, not much, not really."

"She wants you. Your cute ass. Isn't that it?"

He looked at me, still puzzled, and leaned to toss his cup in the garbage. His hair gleamed golden in the sun, the hairs were gold and wiry on his arms, and yes, I thought, looking at him properly for the first time, he was quite a hunk.

"Go for it," I said. "She won't be here long. She wants a fling. So enjoy. Why not?"

But I knew as I spoke that there was more to it than this, from the way he stared down, puzzled, into the water between the schooner and the land, into the question I hadn't been able to answer.

As I sluiced the decks, I thought, what *do* women want? Different women want different things. Men act like they've been

given a riddle they have to solve. Around puberty, someone gives them this puzzle and they spend their lives trying to solve it. Like the old Rubik's Cubes, or a math problem. Here you are, here's your quest, your impossible task: Find Out What Women Want. You only have a lifetime to do it. Begin, boy, and don't give up. You can't ask any individual woman what she wants at any given time, that's not in the rules. You have to figure it out on your own. This made me think about Emily de Soto herself. The fact that she was beautiful seemed to make her into a puzzle, but perhaps she was just shy, or having a bad time. It didn't seem to have occurred to Harry that he could ask her what she wanted; he was too busy trying to be the knight-errant trying to figure out the terms of his quest. So I thought I might try. Nothing so crude as asking her straight out, just getting to know her maybe, just hanging out.

But that night we had a charter, so she wasn't on board. Forty people who all worked for the same company in Fort Lauderdale wanted to go out, so the boat was packed, and they were so busy getting down their free drinks that there was hardly time for thought, let alone conversation. I slid about the decks with beers in both hands, I opened champagne bottles, aiming the corks out over the water so as not to hit a tourist in the eye, and I put up with jokes about women on board ships, ones I had heard a hundred times before, and remarks about how cute I looked hauling on ropes. Janie was working with me and we were busy all the time. It was a night for a third crew member, but Harry was off. The weather was calm, that was one thing. It was simply very warm and humid and the *Black Cat* moved sluggishly through the water. That was lucky. If we'd had to sail as well as be barmaids, we'd have been pushed. McCall at the wheel was doing his thing with pirate stories and calls of "Avast!" and "Ahoy!" and "Heave ho, me darlings!" and telling his jokes about drunken sailors. Mo, the other musician, was getting them to sing along. The Buds were going down fast, the champagne ditto, and by the time we turned at sunset, most of them were toasted. Janie and I slithered along decks wet and sticky with spilt beer, gri-

macing at each other. None of us liked this kind of sailing, if you could call it sailing. But it was good for business, so I guess McCall was happy. It wouldn't be good for tips, because they'd all be too drunk to notice the tip bucket on the way back ashore.

I was pouring more champagne for one of the wives while Janie was setting the jib, when I thought about Harry being off tonight. Emily de Soto wasn't on board either. I almost missed her, up there so quiet and calm in the stern. I'd mind if she didn't come out again. She meant something to me, with that face, that way of being that was so rare, like some graceful animal about to become extinct. And I was interested in the effect she was having on us all.

Janie said to me as she passed, "Can't wait to get this bunch back on dry land. How're you doing?"

"Okay." She's much younger than I am, but she's a better sailor because she's been doing it from childhood, somewhere up on the coast of Maine. She's first mate tonight, this skinny young woman with round brown eyes and the ease of a monkey as she swings around on the lines and hangs out easily over the ocean in the foot net where we furl the jib. She's in love with a boy named Sergey, who used to be in the Red Army, a Ukrainian deserter, who's broken his arm on a construction site and is out of work. He speaks in a thick choking voice that only she understands, and sometimes at night, she tells me, he lashes out and hits her, but only by mistake. He has bad dreams. He's a casualty of Soviet imperialism. They caught him young, made him shit himself with fear in an army full of men born thousands of miles away from him, who didn't understand him either. Now, he wants to be an American. Same as everyone else, including the Cubans who creep in through this back door here. It's not such an easy thing to be anymore. If he marries Janie, he's in. She's thinking about it, what it might mean to be married to a man from the other side of what used to be called the Iron Curtain, who cries in his sleep and thinks he's in Afghanistan. I like Janie. She's tough and yet tender. Sometimes she cries too, but mainly from exhaustion. She works all hours, she's saving for a place for them both to live, and I only hope that this big sad dark-faced incommunicado guy with his paw in plaster like a wounded

bear will make it okay for her. That's love. It catches us in strange ways and makes us bedfellows with each other's scariest dreams.

When we'd gotten them all safely ashore again, Janie and I slowed down to put on the sail covers and stow the cannon that had made them all shriek with terror when we'd fired it on "enemy ships" as McCall liked to say. We heaved the coolers ashore and coiled the line ends into neat little mats and closed down the hatches and then sat down next to each other on the hatch to the fo'c's'le.

"Boy, I'm bushed," Janie said. "I hate it when it's like that. Running around getting more booze down them when really you want to tell them to quit, they've had enough. Why can't they just enjoy sailing? Why do they have to get tanked up like that? I don't know if I'm just getting mean or what. Sergey's drinking too much again. It pisses me off. I hate it, I really do."

"Me too. It's a pain in the butt. What d'you say we get some food and eat it on board? I'm starved."

"What about your guy, isn't he home?"

"They're working late. They're going out in a day or so. I'm pissed about that. He has to get up at five A.M. suddenly because they haven't left him enough time to get the stores on board, and then they keep him late in the evening too. He gets dinner on the ship, these nights. No overtime, of course."

"Of course."

I walked across to the Schooner Wharf bar and filled two plate-fuls of the very good dinners they hand out to local sailors for two bucks. We sat on the dark boat with the water glittering black around us and ate mashed potatoes and stew with plastic forks.

"What about Harry, then?" Janie said.

"Him and that woman, you mean?"

"Mm-hmm. Yeah, he's really hooked, wouldn't you say? Keeps forgetting things. Like coming to work, for instance."

"I thought he was off tonight anyway."

"McCall asked him to come out, though, we were shorthanded, with that bunch on board. Said he was busy, had other plans. Hunh."

"Well, I guess we know what the other plans are." I wondered if he went to her in her bland room in the hotel, where the bedside lights would turn everything pink and he could lean out the window and watch himself not sailing the boat back in. Did she seduce him the way women did in old movies? Did they have an intimate dinner by starlight first?

"I'm worried about him," Janie said.

"Why? It could be fun."

"You didn't hear about his heart?"

"No."

"He didn't tell you?"

"What?"

"He's got something wrong with it. It misses a beat or something. He went to the doctor. I'm surprised he didn't say. It seems a lot more serious to me than falling in love with a rich tourist."

I thought, hearts are strange things. Tough little muscles, pumping away so regularly year after year, and then suddenly not so difficult to break.

"What did the doctor say?"

"She said he should rest. Which of course he can't. And take vitamins. And get some tests done, which he can't afford. So it all looks kinda depressing."

"Poor Harry. I didn't know."

But there he was, in my mind's eye, wearing a white shirt and leaning over a dark woman who smelled of gardenias, somewhere in a room with a hidden orchestra playing. I couldn't feel too sorry for him, not yet. I wanted to know the story from the inside first, the one we all want, however sane we think we are.

IT was weird to be sitting eating dinner on the Pier House deck while the *Cat* went out past him to sea. It was like having double vision, or two lives, an inside and an outside one. He watched the boat come back down from the anchorage near Christmas Tree Island, towards the shore. They had the sails up and there was a decent southwesterly breeze. The little figures on the deck moving to and fro were Martha and Janie. He could see, or imagine, McCall at the wheel, a cigarette in his mouth and his shirt sleeves turned back at the wrist, his captain's hat on the back of his head. It was like looking at your own life from the outside.

The young waiter brought their order. Shrimp, then yellowtail. Emily was drinking a glass of wine. He had his usual ginger ale, with so much ice it tasted of nothing but ice water.

She said, "This is where I sat when I first saw you going out. The boat, I mean."

"Looks great from here, doesn't she? But it's a weird feeling, me being here and not there. Like, you know people say they have out-of-body experiences? They go up to the ceiling and watch themselves? Look, they're coming in close. McCall's going to fire the cannon in a minute, just to give those folks on Mallory a thrill."

One minute later, the cannon fired and a little puff of smoke floated between the ship and the dock. The little figure bending to light it and then jumping back was Martha. He knew how it scared her each time, firing that thing.

"Feels kinda strange to me, sitting here with you."

"Would you rather not? Would you prefer to be there?"

He looked at her, dazed. What sort of a question was that? "Guess not. But you know, it's kinda familiar, that's all."

Silence. She was good at staying quiet, he noticed. He liked that. She sipped her wine and they both began to eat. Harry had never seen the point of eating as a hobby, or recreation. It was what so

many people wanted to do these days. Eating in restaurants was supposed to have some point to it that wasn't about just getting food down you, but he hadn't yet figured out what it was. You were supposed to make conversation. In movies and ads, people gazed into each other's eyes. They got close. Or they pretended to. More likely, they just got drunk. She'd asked him did he mind if she drank wine, and he shook his head. He liked watching her drink it, as if it were some sort of rare thing. It wasn't like watching other people drink. Other people just tipped it down and got obnoxious. She seemed to be breathing it in and letting it do something to her that was only pleasure. She ate like that, too. Not like a person who was simply hungry, although she said she was, but like she was really tasting everything. And when she lit up cigarettes, it was with attention, like all she was doing at the time was smoking. He watched her, to see what she would do next. It looked like she didn't ever do anything without thinking. It was deliberate, like her way of walking. He wanted to watch and watch her, see how she did everything, even how she used the toilet. Thinking this, he blushed.

"What are you looking at?"

"You," he said simply.

It was like having leapt clean over something. He vaulted easily into the next space waiting for him. It was the most honest he had ever been. She looked clearly back at him. Her eyes were green like the water. Being with her, you'd always be reminded of sea. Even inland, even in a room, even miles from all this water, it'd be with you. You'd never be stranded, far from what you needed. Even if that green was like diving into deep water and having it close over your head.

She looked at him and he couldn't look away. He felt the blush rising in him, his throat and face hot. Luckily he was so sunburned anyway she might not notice.

"We'd better eat our fish," she said at last.

The white flesh of the yellowtail fell off the bone. He forked it up and tasted the sauce, lime with peppercorns, fruity and sour at once. It was amazing what you could do with a sauce. He was used

to them coming out of bottles and tasting predictable. But this one was such a mixture of things you couldn't say exactly what was what; it was confusing, like a smell on the air that you can't quite catch. The waiter came close to ask them if everything was all right. He looked up, surprised. Why shouldn't it be? Emily was eating steadily but delicately, the way cats eat. She'd parted all the fish flesh from the bone, and the spine lay clean on the side of her plate. It was just what a cat would do. He smiled at the thought. It was okay being here with her, you could think crazy things and not say. He thought of Wanda and her erotic sauces, her wild incomprehensible words in which only the ordinary ones, *fuck* and *cunt* and *come*, told you what her poems were about. Wanda fucked men and wrote about it. Or she made it all up. Hard to tell. With her, you had the uncomfortable feeling of seeing straight into her mind, which was maybe a crazy mind but yet had its own logic. She walked about on the streets showing all the things women were supposed to keep secret, or not even think about. She'd stop you in the post office and tell you about her hot new lover and how he sucked her off and then you had to wonder who he was. He thought of her large breasts, always about to pop out of some flimsy halter top or bandage. Her thighs, which wobbled as she walked. He shuddered.

"What's up?"

"Oh, I was just thinking about something. About Wanda, if you want to know."

"That woman we met on the street?"

"Yeah."

The trouble was, with Emily it seemed impossible to lie. Whatever was the truth, you just had to come out with it.

"What are her poems like?"

"All about sex."

"I'd like to read them."

"They aren't—" He was going to say, they aren't what women are supposed to think about, and then checked himself. It was ridiculous. Wanda was a woman, wasn't she? Yeah, but she was crazy. So maybe that didn't count.

"I've got some, back on the boat, in my bag. I bought them, just to do her a favor. Whatever you may think of her or her poems, she's totally serious about them. She spends hours typing them up and getting them copied, and hours walking about the place trying to sell them to people."

"Do you find them erotic?"

"Well, I guess. Yeah, they're quite a turn-on."

Silence. The waiter came and took their plates away. The *Black Cat* was now a small toy boat on an ocean whose horizon had disappeared. The sun was a blur of pink, caught in a swirl of dark cloud like a poached egg in a pan. They watched it go.

"Do you want dessert?" she asked. She reached into her purse and brought out a new pack of cigarettes. He watched her light up. She was like someone in an old movie who used smoking to show some grace. He wouldn't ask if he could have one too. But he knew if he did he would feel like Clark Gable or someone, some other seducer out of the past. He felt scared, suddenly. What happened next? How, with a woman like this, or with this particular woman, did you get from *here* to *there*, from this place to where he suddenly most wanted to be?

"No. Do you?"

"No, I've had enough."

He heard her leave her room number for the check. He sat back, bereft of the need to find money, work out a tip, all those things you had to do if you took a woman to dinner. She was in charge here, she was taking him. They got up to leave the restaurant, walked through a room where a guy in a tuxedo was playing a piano, moved into a tidy mock-jungle of carefully reared tropical plants. Both moved at the same time, so that their hands met and joined. It was sudden, a shock. Hers was smooth and warm, as he remembered from the boat. He felt a jolt of desire. Then she pulled it away again after a moment's pressure. He followed her just as if there was nothing else he could possibly do, upstairs, along a corridor, past dozens of identical doors with numbers on them, to the very end of a corridor which was all pink and padded, where their footsteps made no sound.

Emily unlocked the featureless door and let him in. She felt him behind her, following her, close. This was the very last thing she should be doing. She'd brought him here, she knew what she wanted, she was here, now, alive and doing what she wanted. It was nothing to do with what should or should not be happening. Sometimes what you did didn't connect with the outside world at all. It was now, and then past. You locked all the rest of your life up in a closet and you stepped outside it; it was, as he had said watching the boat go out, like being outside yourself, watching. She came up close to him, this man she didn't know, and reached up into the darkness of his face and found his lips as if she were eating a fruit right from the tree.

After the kiss, he stepped back, away from her. Maybe looking for a last chance to escape. He was checking out something. Safety, perhaps? Then he came back to her. She smelled his body through his shirt. His hands were on her breasts. They were hunting each other out, finding out, finding what they had to know.

"You seduced me," he said, and rolled the sheet around him.

"I know. But you didn't mind being seduced?"

"I don't know, to be honest."

"It never happened to you before?"

"Well." He was silent for a moment. "I guess, I like to be the one who seduces. Or chooses, maybe."

She laughed. "Some men like to be seduced. That way, it isn't their fault."

Some men? How many had she had, for God's sake?

"Come back to me, Harry."

But something was nagging at him uncomfortably. He was tense, in spite of the pleasure of that relief. He felt grateful to her for that, but also scared, scared of something, he didn't know what.

"I gotta go. I gotta watch the boat."

He pulled away from her and dressed quickly, avoiding the sight of her disappointment. He pulled his belt in over his jeans. It

seemed ridiculous to be leaving, but he felt unable to do otherwise. He picked up his shirt from the floor and slipped it over his shoulders and buttoned the buttons slowly. She was watching him the whole time, looking puzzled but not upset. His body was singing with the pleasure of her touch, but it was like some alarm had been set, and mistrust was running him, it was getting him out of here, back to where he ought to be.

She sat up in the big pink bed where they'd wrecked the linen. Naked, she studied him as if he were a puzzle.

He said, "I'm sorry. I don't want to be rude. But I do have to go."

"Rude! What d'you mean, rude? What are you talking about?"

"I mean, leaving you like this." He sat on the edge of the bed, safer now that he was no longer naked.

"What are you scared of?"

"I don't know. I can't lie to you. Something." He kissed the warm angle between her neck and shoulder, then caressed her cheek. "It isn't you, it's me. I'm not used to this sort of thing. You are wonderful. It's—" He shrugged and breathed out. She reached to rub his cheekbone briefly, as if he'd had a smudge there. She looked at him, deeply, and he felt it again, the fear. An ache under his heart, a tension in the gut.

"I'll see you tomorrow," he said, "and thanks, Emily, thanks for everything. The dinner was great."

"*De nada,*" she said, and watched him go.

Harry walked back up Simonton and turned left on Elizabeth to go past the hippie shops, little shacks selling beads and hammocks from Central America. The *Black Cat* was a dark hulk straight ahead. All over the harbor, lights plummeted into the water and rippled in downwards spirals. The halyards ticked in the slight breath of air. He felt light and exhausted, as if he'd been up all night, and his eyes were sharp in the darkness, his step slow. His body felt hollowed out and his skin smooth and pleasured in a way it hadn't for years. He yawned as he walked. His hands swung loose at his side. It was a relief to be alone. So often when he had been with people he felt like this, relieved, freed to be his solitary self. How did anyone do it, live close to someone else? He couldn't remember ever having wanted this. Since childhood, as far back as he could remember, there'd just been him. Friends, yes, but they were just people to do things with from time to time, before you resumed aloneness. Women, yes, he'd had all the sexual urges anyone else did, but apart from that he hadn't felt the need for them. Always, when he'd had sex with anyone, he'd wanted to leave immediately afterwards, before they could find him lacking in conversation, commitment, whatever it was that women wanted after sex. But tonight, he wondered. Had that been just a stale reflex, this time? No, it made sense. He had the boat to see to, and if he'd stayed there he'd have fallen asleep with her. Now, out here alone under the stars, with the company of moored boats and the roar from the Schooner Wharf bar, he wasn't sure. The thought of sleeping close to her was appealing. He wanted to see her sleep, to see if she did that as thoroughly as she did everything else. He wanted to see her in the morning. He wanted to be able to bury himself in her again, with less desperation and speed, and to really feel what that was like, to be enclosed by a woman who wanted him there.

In the old days, he'd have gone straight to the Schooner Wharf bar, started on the beer, and picked up someone he wouldn't even have to talk to. Thank God he wasn't at that stage anymore. Maybe he'd been scared all along; maybe the alcohol had just masked that for him. The thudding in his heart subsided as he swung aboard the boat and sat amidships just looking around him, just breathing in the night air. It was good to be alone. It was safer. The other thing was always such a risk. Everybody pretended it worked, but it couldn't, not really. People were too different, too scarred. But he enjoyed the thought that he would see her tomorrow, watch her come across the space between the boat and the land, that narrow plank that joined the two, and see her settle in the stern. On board, she couldn't go anywhere or expect anything of him. She'd be sitting there for him to look at, and he'd be busy sailing the boat. Beyond that point, for the moment, he had no plans.

He went below and stretched out on the mattress and thought for a moment, looking straight up to the low ceiling of the cabin, its brown-yellow varnish. Then he got up again and went to the old suitcase he had stowed in a corner, under his few clothes. He opened it up and took several books out, battered hardback notebooks in different colors, all stained with sea water. He flipped open one after another until he found what he was looking for. Then he settled back on the bunk bed to read.

April 25, 1980. 15.00 hours.
Still in Mariel Harbor, after 10-hour crossing yesterday from Two Friends Fish Co. docks, Stock Island. Escort from Cay Sal by gunboats to Mariel. Flat calm, even on Gulf Stream. 75°, clear skies, light breeze this morning but turning cloudy now. Storm possible, but no warnings yet. About 1500 boats here, many of them shrimpers. There'd be chaos if wind came up, we have so little stability with outriggers up. Last night 300 to 500 boats anchored off Mariel, but now so many, another little cove has been opened up. New cove's separated from main harbor by peninsula with airstrip on it. Filled up fast by at least 500 boats.

On arrival, Cubans jumped on board, wanted ID, gave us a number they'd call when it's our turn. Two guys, friendly enough I thought, though Mungo grumbled about Commie bureaucracy and horseshit. Couple Cuban patrol boats came by twice this morning to see everyone's in their proper place. It's quite a logistical problem. An American charter boat came in last night, no one checked it or the crew's papers or found out who the relatives were.

Hope we can get out of here today. Last thing we heard was boats arriving Friday, that's today, face a 5-day wait.

Rum and shrimp for dinner last night. Food situation's getting tight. Cuban boats with "Turista" on them cruise round selling refreshments. 5 bucks for a ham and cheese sandwich. A Govt. boat selling chicken and rice for 7. You can get canned sausages, rum, cigars, and T-shirts at a price. Capt. Mungo bought 50 cigars.

15.30 hours. Several official boats prowling around. Crews have .38s and .45s but nothing heavier. Russians on shore have blue uniforms. A boat comes by, wooden 15 ft., the *Vietnam*. Film crew on board. Could be I'll be in a Cuban movie, who knows?

16.00 hours. Something's happening! The *Lissette* just steamed in, the Liberian freighter hijacked a month ago from Cuba. She's in front of the Russian power plant, flying a US flag.

Glad I'm here, seeing a bit of history. Mungo's getting 4 grand at least for this so even if we get fined we'll be in the clear. Makes up for rotten year shrimping, Mexican imports, fuel going up etc. 2 Cubans came to talk him into it Tuesday night and he didn't need much persuading.

Yellow buses on dock bring people in, overcrowded, poor fuckers waving out the windows, some even crying. Are they the "scum" the Cubans talk about? Or refugees, or families, or what?

14.20 hours. Nothing to do except write here. A brand new sportfisherman out of Tampa just docked, its number called. Must be worth at least 60 grand. If I was a Cuban, I'd impound it. 334 foot or so. Fat Cuban-looking captain. Two people walking down dock, getting on board. Young guy and girl. God, what a looker, black hair, white sweater, great tits, walks down that dock like a movie star. Looks scared though. Is the kid going too? Yes. Not a boyfriend, too young. A brother? I wouldn't kick her out of bed.

14.50 hours. Guys from the yellow bus getting into the sportfisherman. Captain looks like he's angry. Maybe they're trying to overload him. More boats coming in. You could step from one deck to another in place. Can't see the girl anymore. Wish I had a six pack, but they're selling them for forty bucks. Wonder when we'll get out of here, looks like it won't be tonight.

Harry scanned another couple of pages that had been written on in blue ballpoint, scrawled by his twenty-six-year-old self on board the *Anna Marie*, that afternoon when nothing had seemed to be happening and he'd been bored enough and sober enough to notice a young woman getting on board a boat. Damn, if only he'd taken a photograph. But the Cubans would've taken it, most likely. So all he had was a few banal words, the observations of that horny, beer-obsessed young shrimper he had been.

<center>~~~~~~~~</center>

Emily sat on in her wrecked bed for a few minutes after he'd gone, thinking. She pushed her hot hair up on top of her head with one hand and held it there, letting the AC chill her neck. Then she leapt out of bed and went to the shower. He hadn't even showered before he left, so he'd be wearing that stickiness and the smell of them together out into the world. She stood under cool jets, letting the water run all over her. She ran her soapy hands all over

herself and thought how she would have done this for him, if he'd stayed. It was strange how men did that. Pulled themselves away either mentally or physically in one abrupt movement and were gone. It wasn't the first time that had happened, and wouldn't be the last, but it was a shame. It made actual sex like a thing separated from what came before and after. There was no continuum. They did it—*it*, the only thing they knew how to want—and then they were gone. It was only when they were with you, inside you, that you had any real sense of not being alone.

She wrapped herself in a hotel towel and walked about the room leaving wet footprints. She sat on the bed feeling very wide awake and wondering what to do with the rest of the evening. Then the telephone rang.

"Hallo? *Sí. Soy Emilia.*"

It was Pedro, in Miami. He spoke fast, as if someone was waiting for the phone.

"What's happening? *Qué pasa?*"

"It'll be soon, Emilia. You'll need to find somewhere, something to rent."

"How soon, do you know?"

"Not exactly." He went on rapidly in Spanish, telling her possible days. "Listen to the weather forecast, okay? I will call you if I hear anything. But you should be ready, *cara*. You are well? Nothing is difficulty?"

"No, *nada*. All is well."

"*Adios, Emilia. Ciao, mi hermana.*"

"*Adios.*"

It was good that Harry had left when he did. She sat, the water still drying on her and chilling her skin. Until tonight, when they'd sat opposite each other and he'd looked at her so frankly and blushed and said the one word, "You," she had not intended for anything to happen. Or not this fast. But she'd known, after that, that she could have him. She'd been able to hold him, in that place where she needed so badly for someone to be. She'd felt peaceful when he lay, still inside her, even though she knew they should have used a

condom. She liked the wetness, the slippery ease. And he'd been scared by her, or by something. He'd gotten out of there as fast as he could. She knew how much this man could be hurt. She recognized it, and it scared her too. Tomorrow she'd leave the hotel, look for a house or apartment on the other side of the island. She had her work to do now. In the evening she'd step across that gangplank and go aboard, giving him her hand as she went, balancing between sea and land, because there was something about him that she wanted, had to have. That ruddiness on him, those sea-blue eyes. That clean wave, filling her up.

It was impossible now to remember how Raúl looked. She could evoke a hand, a foot, hair, a part of him, but not the whole. The whole of somebody could not be preserved in memory. That was good, it was how she wanted it. In fourteen years, he would have changed. That seemed to make her obligation to him less. She still saw the sailor's face above her, remembered his body all along hers, his fair sunburned skin, the flush of his arousal. His fear, that made him tremble as he came into her, his cold sweat on her afterwards. His leaving, like a thief in the night. She liked that. Her thief.

She imagined saying to Raúl, "I want a divorce now. I am going to marry an American."

She was at the end, the very end of her commitment to him. It was like being at the end of a long strip of land that reached out into the sea. You couldn't go any further. That was it. That was as far as you could go. Nobody in this country stayed married to a man she hadn't seen in fourteen years. Nobody clung to the memory of their first love, their teenage years, their first experience of another person coming inside you, opening you up. They moved on. Said, that's past. History did not exist here. My ex, they said, my first husband, my second, my third. But the husbands were only milestones, marking the stages of their maturity. It wasn't about one man owning you forever, like a piece of land with a claim on it; not about the mark of one hand on you, the imprint of one caress.

A man's entry into you meant only what you decided it meant. Nothing, or everything. It was a matter for interpretation, nothing in itself.

Now she was giving meaning to the embrace of a man who'd left her in a heartbeat, being too scared to stay. He was as scared as she was, that was the point. He wasn't making a claim. He was the one who pulled away. He was a man who lived on the surface, in the moment. Here and then gone, as soon as his need was satisfied. Her American. But tomorrow she would see him, for his ship would be going out, perhaps even as the other one was coming in, and she would be on it. The schooner, with its huge sails ballooning above her and the small crew like family making her safe.

Two men. They were like two ships passing each other in the same narrow channel, which was herself.

Part II

10

HE crossed the street, avoiding dogs and children. It was nearly dark as he left the Malecón and went up into La Habana Vieja, to the street called Loyalty, which is next to the street called Perseverance. All these streets named for virtues or heroes. He didn't know quite why he'd had to have a last walk along the Malecón, unless it was pure nostalgia, sentimentality, the sort of feeling he ought to have eliminated from himself by now.

The ocean was white and shining under the last of a watery sun. All along the ocean wall there were lovers sucking at each others' mouths, writhing into each other's bodies. The desperate, intimate movements, all privacy removed. He walked, and thought, and felt sad for these young people. Bikes on the rutted street, kisses instead of food, sex by the uncaring ocean, because there was nowhere else to go. Yet, had his own youth been very different?

He whistled in the twilight and a key flew down and landed with a chink in the gutter. It lay sideways at the edge of a puddle, shining so that he could see to pick it up. Overhead a window was open.

"*Hola!*"

"*Hola*. It's Raúl."

"*Ay, perdón!* Did I hit you with the key?"

"No, no."

He opened the heavy carved wooden door and went into the complete darkness. Three flights up, feeling his way, one hand to the curved and pitted wall. At the top, a dim light showed. Luz, his brother's wife, leaned over the railing, smiling.

"Stranger! Come in, Raúl. Julio is here. Mamá will be pleased to see you."

Luz and a woman friend were in the bathroom, up to their elbows in laundry. He kissed Luz and shook her friend's wet hand.

"Julio's brother," explained Luz.

The baby, completely naked, was running up and down the long corridor between the rooms at the back and the big salon at the front of the house.

"Hola, Julito!" Raúl caught him up, feeling skin tight over flesh, a wriggling armful. He must be, what, two? The little boy stared intently into his face, his eyes like raisins. His wrists were tight above his fat little hands, as if cotton had been drawn tight around them. Raúl carried him high, like a trophy. Behind an open bedroom door, he glimpsed his mother sitting on her bed in her nightgown.

"Mamá." He set down the child, bent to kiss her. Her cheek was like tissue paper over bone. She seized his wrist.

"Raulito."

Julio had said to him, don't tell her. It'll break her heart. So instead, he said gently, "How well you are looking, Mama."

"I am not well, I am old. How would you know what it is to be old? But you, look at you, you are gray, too! Here, and here." She touched his beard, one side, then the other. For some reason, he found this unbearably moving. He kissed her quickly again. *"Mamacita,* I must go and speak to Julio. I will come back, before you are asleep."

She was so small, with her long gray braid of hair and her sharp little features, like a bird. He guessed at the body under the nightgown. She was hardly there any more. Everything that was womanly about her had shrunk and gone. She was pure spirit, he thought. Perhaps she knew, without him telling her. Perhaps she already knew.

Julio was sprawled in front of the TV, which was not on. He looked as if he were asleep.

"Just tired," he said, smiling up at his brother. "It's a long day. And last night little Julio kept us awake. I think it was his teeth."

"Julio." He bent to whisper. "Just for you. I'm not telling the others. Mama needn't know, it's best."

"It's now?"

"Tomorrow. I came to say goodbye."

"They waited, because of the weather?"

"Very many have gone already. Diego came by this afternoon, told me they are ready. We're going from up the coast, it's safer."

"I won't ask you again why you are doing this."

Raúl gestured at the room, the baby who was now on all fours, the TV, the figure of his brother relaxing in his own home.

"For this, Julio. To have a home. It's been too long."

"Home? In that place?"

"You know what I mean, *mi hermano*. A home for the heart."

"Yes, you told me. Does she know?"

"Yes, the others sent a message."

"Goodbye, *mi hermano*. I say it to you now, so afterwards we can behave like everything's normal." Julio stood up and the two men embraced, each with tears in his eyes. Raúl noticed how in spite of food shortages, his brother had put on weight. Neither of them was a young man any more. He turned to the window, looked out through panes patched with cardboard, to where the sun had set over the city of Havana and all the rooftops were turning bone-white in darkness, as if this were a cemetery, and they, white graves. But the sun did not set, he thought. The earth turned. What you perceived and what you knew to be true were often not the same.

On the coast road in darkness, you saw all the little lights of the countryside and the people, grouped around them on their porches. Bonfires at the roadside to show the edge. Dark hills, muted bluish lights, unknown yet familiar lives. Then the sudden stink and leaping tongues of yellow flame from the oil fields. Disconnected balls of fire, like meteors in midair. Red swirls on the eyeball, after the fires had gone. The white looming shapes of a sudden herd of cows. Their heads low, their mooing into the dark. Ghost heads against lights of the car, the bump of their thin flanks as they passed. The smells of the countryside, kerosene and charcoal and cooler air, through the open window. Royal palms black against the sky. He watched, and felt no fear, as if all fear were long ago used up in him. It felt like he'd done this all before. Perhaps he had done this all before. It was familiar, a routine. It was what he had to do, and had not done until now, but over and over in his mind, he had imagined it.

You, who left Cuba, tell me
where will you find green after green
blue after blue,
palm after palm under the sky?

And who would he find to talk to about Guillén's poetry, ever again?

You, who have forgotten your language.

No, he spoke to himself, deep into his own heart, as the last miles of the dark coast road went by and Diego's old car coughed and bumped over the ruts and the two of them were silent with each other, each in his own thoughts. No, I will not forget.

"HI, I'm Bob Hechter."

"Emily de Soto. Hello."

The rental agent unlocked the door and stood aside to let her pass.

She had a look about her, as if she wanted privacy, so he didn't stay too close to her. You had to get it right with people when they were looking at places to rent. You had to make them feel right. If they felt right, they'd pay the asking price. Trouble was, it was different each time. You had to watch people, you almost had to hold your breath, you had to know when to keep your distance and when to come close, when to be formal and when to be laid back. You had to feel your way.

He knew this was why he was a good realtor. Buying was different, that was another part of it. Buying was more of a big deal, so they'd probably have done more homework first. There were complications to that, of course. But renting was often a matter of impulse. They weren't going to be here forever. A few weeks, a couple of months, just through the season. So they could pretend to be who they wanted. They could move into these houses, apartments, other people's lives, just as if they were going onto a movie set. Especially the ones with money. And this lady had money, he knew it as soon as he saw her. She'd have what she wanted, but maybe she didn't know yet what she wanted. Maybe he would mention a few properties, make a suggestion or two, give her something she hadn't yet thought of. He'd felt the temperature drop just a little between them, as he waved her through the door. Just a little coolness, just a little distance. So he stayed outside and walked slowly back across the yard, noticing where the grass had grown thin, where the gravel from the driveway had been scuffed up over the balding grass. He went around to the veranda, looking for a moment out to the ocean, which was bright emerald streaked

with aquamarine stripes. He'd leave her the time to look around on her own.

He wanted a cigarette, but thought that his smoking might put her off. She seemed a fastidious type. He'd noticed her shoes, in the car, and the cut of her blouse. You didn't get up close to women like that every day, you didn't get to drive them around town, have them sit just a few inches away, smell their perfume, expensive stuff, and have the gleam of their hair swing past your ear when they got out of the car, and it was kind of upsetting when you did. He parked his butt on the veranda railing, wood smoothed and bleached by the wind from the sea. He looked out. You couldn't see a thing from here but the ocean and the sky and the two leaning palm trees that framed it. No traffic, no tourists, no T-shirt shops, no brash hotels. He thought he wouldn't mind spending a few weeks here himself. He knew she'd take it when he saw her reappear at the dark wood-framed door. He knew it was too big, too expensive, too hot in summer, with all that exposed wood inside; but also that she wouldn't be able to resist the open balcony where she could sleep under the stars, the big open living room with its solid shipshape feel, Dade County pine all through, and the rivets of wood, the interlocking beams, so that it would creak like a ship at night and seem to be taking her somewhere, and the ocean out there like a quiet neighbor, so close.

She came out on the veranda, looking past him as if she were sleepwalking. She was a bit weird, as well as a looker. Perhaps she was a movie actress, he thought, someone like Greta Garbo, who always wanted to be alone. Well, if you could be alone anywhere in Key West, it was here. It was as if the rest of the island and all its clutter had simply disappeared.

She said, "Yes, I'll take it," as he had known she would. Then she asked, "Do you want a cigarette? You're a smoker, aren't you?"

Rob felt his pants pocket, then the one over his heart. "Guess I've left them in the car. I thought you wouldn't like it."

"Have one of mine. You can relax now. Now I've made my decision, and you don't have to show me anything else. Go on. They aren't too disgusting."

He took one, and let her light it. It made him feel uncomfortable. He perched back again, swung his foot. He was glad he was wearing long pants this afternoon, even though it was so damn hot.

They smoked on the veranda. She had a weird effect, he thought. Sometimes she seemed so distant you felt she didn't want anyone near her at all, other times she was so intimate it made him sweat even more than usual. He was glad he didn't have to show her any more houses. He sighed as he exhaled and felt her look at him. It was weird, it really was. It felt like it was her house, she owned it, and he was there for no reason at all, just smoking in hard little puffs like a sweaty schoolboy, wanting to escape.

"I'll drive you back to the hotel, if you want. Or do you want to see anything more?"

"Well, you haven't shown me around yet."

"Gee, excuse me, I thought— "

"No, I'm only teasing. You don't need to. I know where everything is. You see, I used to stay in this house when I was a little girl. It was my grandparents' house."

He drove her back to the other side of the island. They swung by the office on Angela on the way, so she could pay her deposit and sign the lease. He saw the secretaries staring at her as she walked through to his office. One of them said, just before he closed the door, "Wow, is that Demi Moore, or what?" Then he drove her back to the Pier House. As he turned at the bottom of Duval to go into the hotel parking lot, she said, "It will be so great not to have to be in a hotel. I really appreciate your finding the house for me."

"But you said you knew it already."

"I didn't know it was up for rent. That was quite a coincidence."

"Sure sounds like it. Do you believe in that sort of stuff? Synchronicity, don't they call it?"

"Coincidences happen. I guess you can always find different ways of explaining them. But anyway, I'm grateful. It couldn't have worked out better. I'm having to stay longer than I thought, and it's depressing staying too long in a hotel."

At three hundred dollars a night, he thought, anything could

get depressing. But she didn't have to worry about money, that was obvious. She'd paid the advance on the house rent without hesitation.

"Are you on business here?"

Since she'd said she had to stay longer, he thought, well, it would be okay, it would even be friendly, to ask.

She looked at him vaguely. Her eyes seemed the same color as the water today.

"Not exactly. No. I wouldn't say it was business." Then she was silent. She put her dark glasses back on and picked up her purse. Well, it was no business of his either, if she didn't want to say. She'd suddenly withdrawn into formality. If she hadn't sounded like an American, he would have thought she was European. Maybe being that good-looking made you cautious.

"Good to meet you," he said, and held out his hand. She took it and it felt as if this were more than just a handshake. There it was again. Intimacy, something assumed that had never been said. He blushed.

"Thank you," she said simply, and was gone. He hadn't even mentioned a rendezvous to pay the rest of the rent. He hadn't offered to drive her back to the house with her things. He watched her walk across the parking lot, between the palm trees, and disappear around the corner of the hotel.

If he'd followed her in, he would have watched her pack a few beautiful clothes into a small suitcase, check her make-up in the mirror, and then sit down to make a phone call in Spanish, a language he didn't understand apart from *café con leche* and *por favor*. He sat in the car, thinking about her. It was only a year since his divorce. His wife had gone back up to Naples, saying Key West was a hellhole and too dirty for her to live in, and he'd kept on in his job in the real estate office. It was getting hard to stay in real estate if you weren't gay, these days. He was earning good money and he hoped Barb would see the sense of that and come back. He wasn't really interested in other women. On the other hand, after a year.... He was only forty-one. But this woman had drawn him close and

then rejected him with one look and a handshake, and he felt upset in a way that puzzled him.

He could have said, "Look, let's have a drink. What are you doing later?" He could have driven her back to the house and helped her move in. They could have even had dinner. But there was that block, her beauty. How could you get past that? Women like that used men and cast them aside. What would it be like, to be used like that and cast aside? It gave him a sudden hard-on, as he sat there in the car. Used, huh? He imagined silk lingerie and a roughed-up bed and thought of the way she'd lit his cigarette. It was all stupid, it was old movies and out-of-date ideas. He lit up and breathed smoke in and felt the discomfort of arousal subside. What was the use? Yet the idea stuck with him, that he might just show up at the house one day and find her there off her guard, undressed even. But he wasn't that sort of man. And she was rich. Then he realized why he'd felt so uncomfortable when she took his outstretched hand. He'd offered it as an acquaintance and she'd taken it like he was a lover and then let him go like a servant. That was what had made him blush. What was a cross between a lover and a servant? A gigolo. And he was too much of a man for that. It was almost as bad as being taken for gay, or approached by another man. It touched him in some place that was shameful, that he didn't want to feel.

Rob started up the car, threw his cigarette out of the window, and accelerated too fast towards the white bar at the end of the parking lot that would let him out of there, into the traffic on Front Street that ordinary afternoon.

THAT this house, of all the houses he could have shown her, should have been the one.

She stood just inside the door that opened from the wide verandah, and smelled it. Wood, salt, mildew, the exact mixture of smells that had been there all these years, waiting for her to sniff it up again. She closed her eyes and listened to the house, its messages. Then realized that the realtor was standing a little way away from her, waiting.

Being here was like being in another time in her own history and that of the island. She'd been a small child when she first came here to visit with her grandparents. It was when they'd lived in Nassau, she and Pedro and Mamá and Papá. Her parents left her here while they went somewhere else, perhaps Miami. It was the beginning of her spending time with her grandparents alone.

Her grandmother used to sit in that wooden rocker, sewing clothes, embroidering, even though her eyesight was so bad. Her grandfather stood between the leaning palm trees, gazing out to sea. He was still there. She could feel him. The rocker creaked and thumped on the wood floor. They were both still here, just as the furniture was still here. What was a house for, if not to preserve its memories? It opened its doors to her and breathed out its breath of warm old wood and mildew and closed rooms.

"Yes," she said to the waiting man, "I'll take it."

She remembered the summers, long, gray, sticky days in which she'd lain face-down on the rag rug under the ceiling fan and thumped one foot gently up and down till her grandmother complained. Mosquitoes and moths crowded up against the screens and the seagrape trees scraped their limbs together and squeaked in the slightest wind. Thunderclouds gathered all around the rim of the horizon and the ocean boiled up in minutes to a seething gray broth that scared her, and lightning flicked over the afternoon skies, just a reminder—on, off, on, off—of what might come.

It came, what she was scared of. The freak storms of that coast. The twister came and threw boats off their docks so that wreckage floated for days on the swollen water outside their house. Her grandmother lit candles and prayed, and her grandfather died. They were always, to her, grandfather and grandmother, *Abuelo* and *Abuela*, no nicknames allowed, not like the others, her father's parents, in *La Habana*. A casual wrecking finger came in and destroyed their lives. They'd found him at the bottom of the stairs, just there. Her grandmother lifted a face of rage Emily had never seen before. A heart attack, the doctor said, very sudden; he wouldn't have suffered. He had been going upstairs to put the storm shutters up. But nobody said it was to do with the storm. Out there over the ocean, waterspouts grew still like columns that would suck you up to heaven. She thought that was how her grandfather might have gone.

A little girl, five or six, playing out there on the soft thin grass between the palm trees, behind the seagrape, making dens out of sight, strutting with her make-believe telescope. Keeping look-out always towards the ocean. A child in a white sundress with grass stains down the front. That was her in the photos of that time. All the photos her parents kept, of places they could no longer go.

She remembered the smell of herself, of her own arms, warm flesh in sunlight, damp with sweat. Sniffing them, there on the sea wall, loving her own smell. Eating mangoes and papayas, those fleshy fruits with their own warm skins. Her grandparents always there at her back, looking after her, the child entrusted to them, the one they hadn't seen. Facecloths to wipe the juice away, cool towels for her hands.

Then the sky went dark and the winds came. It happened over and over. The sea, bright green and striped like today. They listened to weather forecasts on the crackling radio and the frogs in the yard all sang and croaked. Rain came, blowing in sideways. The wind was like the hand of God. She and her grandmother prayed to Saint Mary, Star of the Sea. What else could you do? The grandfather went each time to nail big crossways battens across the windows, upstairs and down. The ocean went crazy, towered at

them like a nightmare. They lived right at its edge, facing all the storms that came. But the old house didn't collapse. Like the fairy story, the mean old wolf huffed and puffed and still couldn't blow the house down. Yet when it went, it left the grandfather, all life blown out of him, a shell of a man at the foot of the stairs. The grandmother had had to sell. It had been the last summer, till now.

She wandered through the house, unable to settle. The ocean tonight was still, golden with sunset already, at the end of the day. The schooner would be going out. She imagined the sailor up in the bow with his white shirt ballooning, the fine bronze patina of his skin, the seaward gaze of his eyes. She was in the stern, watching. She would always be there, from now on, the way her grandmother would always be in the house. In some places, at some times, people just imprinted themselves, because of the depth of their belonging there, if only for that time. Her place now was up in the stern of a schooner, heading out towards the reef, looking out past the body of her lover, towards something that was still out of sight.

He would come tonight, after he had finished on the boat. She had told him to come to the house. She wanted him here, to share the heritage of her ancestors, all the way from England to the Bahamas and Cuba, that complex mix of the people who had made her. She imagined saying to him, "This is my grandmother and this is my grandfather's house." She saw him in the semidarkness, the glow of his white shirt, the shape of his body, the gold of his smoothed-down hair in the lamplight. A suitor, a beau. But he had to come to her in secrecy, and he had no part in her life, not really. She had no room for him there. She would have to tell him, one day, "I have no room for you. History has filled my life quite full."

But these days, perhaps only a few days, perhaps more, would be theirs. She promised him this, in his absence. "For this time, in this present moment, I am completely yours."

She undressed in the wide upstairs bedroom, put on her bathing suit, and padded barefoot down the wooden stairs, across the floor, out through the glass doors to the verandah that wrapped itself

around the house Bahamian-style and led her easily out onto the hot grass. The concrete sea wall was too hot underfoot and she hopped fast to the worn wood of the deck. There was a simple ladder to the water. The water sucked and slopped at the foot of the ladder, which showed green slime at low tide. Her feet went down first into the water and she lowered herself down. The water was body-temperature, so you could hardly tell you were in it. It seemed to join your blood as you entered it, so your skin was only a thin irrelevant membrane between two liquids. It embraced you, warm and salt, lapping at your body.

She let go of the ladder, kicked away, and swam. Lying on her back under the golden sky, she moved her hands and feet just enough to keep afloat. The ocean carried her and she thought of how it might carry others to safety. There was no urgency. How could you feel urgent, with the house opening to you like this, opening all the rooms of the past, and the ocean carrying you, and a man coming to you tonight with all the ardor he possessed to give to you? Time slowed and stilled itself around you precisely so you could live this moment and give it its true weight.

She hadn't imagined such a thing happening. Of course, men did notice her, follow her, give her those stares which she knew were nothing really to do with her, just an automatic homage to the way she looked. It had been going on all her life. They came to her, and their bodies made her briefly satisfied. Beauty was an accident. It was not her doing. She lived inside it, like a hermit crab in a shell. Raúl was one who looked beyond the shell, found the inhabitant deep inside. It was for his perception of her that she accepted him; because he was capable of seeing who she could be. But now, with this other man, it was all reversed. His beauty stunned her, blond and so unlike her own. With him, she was on the other side of the mirror, looking through. When she looked inside his shell for an inhabitant, she had just a glimpse. His blue, opaque sailor's eyes only lifted their shutters for a second at a time. His silences excluded her. He was not telling, not giving himself away. So she lay in wait for him. She knew there was someone hiding in there

because of the way she knew herself. The inhabitant was there inside the perfect shell. When they lay together, after making love, as they had several times already, six or seven probably, she had a split second's chance to glimpse the inhabitant. The blue shutters lifted and he was there. She waited for this time. Through all the pleasure of their bodies, she waited for it. Each time, it came. It was like watching a crack open just a little wider, letting a little more light out upon the world.

When she had swum all the way down to the Southernmost Point and back, pushing against the oily warmth of the water with her hands as if pushing back veils, she climbed the ladder again. On the dock she shook water from her eyes and hair. She dabbed at her face with a small white towel. The house waited for her with its doors wide open. She'd forgotten to close the screens to keep the bugs out. The rooms would be alive with flying insects now as well as palmetto bugs, lizards, and even hidden cockroaches. It lived and breathed, this house, it was like a ship. She would lie on the upper balcony under the stars, and he would come to her, and then he would go again, come and go, come and go, like the ships that went in and out of the harbors of this island, and the tides, in, out, time passing, the present time quite safe in their embrace.

She crossed the grass, stood on one leg and then the other to brush sand and grass from her wet feet, and went indoors again, to make her own dinner, and then wait. Waiting could be a pleasure when you knew the person you were waiting for was on his way. It was only when there was uncertainty that it was painful. When she shut the doors tonight, it would be uncertainty she'd be shutting out. Her grandmother closing windows, shutting the heavy shutters, locking locks. Her grandfather, nailing the crossbraces. Her Bahamian ancestors had been used to locking out the wilderness all around them of ocean and wind. They were all with her tonight.

Dressed, she poured a glass of rum and sat indoors, as they had for generations, waiting for the boats to come in.

HARRY went to find a glass of water, leaving her sleeping in the wide upstairs room with the big ceiling fan turning above the bed and the screens closed to keep out the bugs. He walked naked through the moonlight to the bathroom and then heard the telephone ring downstairs. He went down the smooth wood stairs and across the floor to where the telephone was and picked up the receiver.

"Emilia? Emilia?"

He said, "Hello? Who is this?"

The line crackled, there was a pause. The man's voice said, *"Dónde está Emilia?"*

"Sleeping," Harry said. "Who are you? It's the middle of the night. Can I take a message?"

The phone at the other end clicked off, so he replaced the receiver quietly and stood thinking for a moment. Outside, the clouds passed across the moon. The trees were not moving. The ocean was black and there was only one ship's light, far out. He felt the sweat of the night running down his spine. The temperature was up in the nineties these days, with ninety per cent humidity too, and the nights were scarcely cooler. He went back upstairs, went into the bathroom, shot a hot stream into the bowl and took a cold shower, letting the water run into his open mouth, wanting it colder than it was. He was thoroughly awake now. He sat down wet and naked at the top of the stairs, where there might be a breath of air. He took one of Emily's cigarettes and smoked it. Too bad, you couldn't give up everything at once, whatever doctors said.

"Emilia? Emilia?" Who would call at this hour of the night? He went to check the time by his watch, which lay next to hers on the bedside table. He watched her sleeping. She lay half on her side, one breast squashed against her chest, the other tipped sideways, as if reaching towards him. The sheet just covered her hips. Her

waist, a shallow dip up which he could run his hand. Her tanned skin looked grainy against the moon-bleached white of the sheet. She breathed almost silently, and her hair was hot and tangled. He put his face close and smelled himself on her, mixed with the salty smell of her own skin. He was still astonished by her. It was amazing that she could lie there asleep and let him watch her. He could have done anything. When you saw a person asleep you saw how private they were. You mustn't do anything to disturb that privacy, he thought. Naked, she wore sleep as if it clothed her from head to toe. He stubbed out the cigarette in the ashtray and took a sip from the glass of water. *Emilia*. Did that mean that she was Spanish? Or simply that the person calling was Spanish, and so had called her by that name? It couldn't have been urgent, or the man would have left a message. Perhaps he was calling from somewhere overseas and didn't know what time it was here. Two-thirty. Damn, he'd have to be up again in five hours' time.

Emilia. He knew nothing about her, except for the way her body was. When they talked, it was about the present, nothing of past or future. No history, no commitment. Just this.

He wanted to say to her, come away with me, let's sail away, go to Guatemala, cruise the Caribbean, what about Belize? He wanted her alone with him, going somewhere. It was strange, other women had wanted him, wanted some commitment from him, and had ended up accusing him of that nineties crime of "not being able to commit." Commitment, it seemed, was the goal. It was the only way to prove you were a good guy. It was all women wanted these days. It was more important than money or looks or charm. You had to be able to look them in the eye and say it. Commitment. Commitment to an ongoing relationship, that was the phrase. If you couldn't do that, you could be Kevin Costner but it still wouldn't do. But here, asleep in front of him, was a woman who wouldn't even mention the future. When his mind strayed off in that direction, she would gently remind him that the present was all they had. But didn't human beings need some notion of a future? Surely, he protested, you couldn't wipe it out, just like that?

"Come to Guatemala with me. I want to get you on a slow boat to South America."

"What's the matter? Isn't this enough?" And she'd pull him down to her, opening her present self more fully than any woman ever had before, no strings, no ifs and buts, no maybes, and here he was wanting that strange thing, a commitment, a promise, something to go on, something he had never wanted before. He couldn't believe it was really happening, when he was not with her. He just did his work and sailed the *Cat*, sold tickets in the booth to the few tourists who were still in town, and went on as before, until suddenly the pain recurred. When it happened, it made him gasp and double over, this frightening lack that he had not known he had.

The doctor had laid a stethoscope over his bared chest and listened for the voice of his heart. She wanted him to go for tests. He had no insurance, he had told her, and worked for seven bucks an hour. People like him couldn't afford heart complaints, it just wasn't done, not in the nineties.

"Are you under stress?" the doctor had asked, her blonde hair smooth to her shoulders, her face sympathetic.

"Not more than usual," he'd said. But it wasn't true. He knew now that he wanted something that a working man couldn't want, couldn't allow himself to want, and it was the worst stress there was. To want a future. To want something out of reach.

"You don't drink?"

"No, I quit."

"Cigarettes?"

"Nope." Not until she had started him off again, smoking with that air she had, like someone in an old movie when the damn things were harmless still. "Well, only now and then."

"Well, don't. I'll give you some multi-vitamins and you should watch your diet, I'll give you a diet sheet. D'you do any body work? Yoga?"

"Nope. Unless you count work. That's pretty constant body work, sailing a schooner."

"No, I mean, for relaxation. Try yoga, why not. Or t'ai chi, if you prefer. What else do you do for relaxation?"

Screw a demanding woman, he wanted to say. But instead he'd just looked out the window and said, "Nothing. I just sleep."

"Do you sleep well?"

It was airless, down there in the cabin on the *Cat*. There was no AC, only a very small electric fan. Often he woke drenched with sweat, felt it running off him in rivers and soaking the single sheet, and he wondered if it were normal. It was the tropics, though. It was summer, only a couple degrees off the Tropic of Cancer, in the hold of a metal ship.

"Not really, no."

And there were the dreams he'd been having. Dreams about drowning, about going overboard and not coming up, about groping, fighting for breath.

"So shall I give you something to help you sleep?"

"If you like." He knew he wouldn't take it. What was the point? You took what was coming to you, in the end. You didn't try to avoid it. That was what they had told him. The only people who tried to avoid their fate were the rich, the owners. They could fool with fancy medicines and diets. The American working man was beyond all that. He imagined his father snorting at the idea of it, fancy diets, sleeping pills, tests. Then he remembered that his father, that tower of a man, had dropped dead at sixty, felled like a tree.

"Yeah, my dad had a heart attack. Least, that's what they thought it was."

"Ah. Well, luckily, these days there's a lot we can do. How old are you?"

"Forty."

"Are you in a relationship at present?"

That was the way they put it. Relationship, not love. At present, because everyone knew they didn't last.

"No," he'd said angrily, while the young doctor in her summer dress folded her arms in the cool air-conditioned room with the sun only coming in softly like a hint of what was really there outside. She had looked at him sympathetically.

"I'm in love," he had said, sounding harsh and angry.

"Oh well, that could be good. A man in a relationship has a statistically higher chance of recovering from heart failure, did you know?"

He'd paid the doctor's bill with the pile of green dollar bills saved from his tips on the boat, and thought he wouldn't go back. He swung out through the door into the burning afternoon.

What about a man in love with someone he can't have, who's gonna throw him away like a used condom, what about that? Is that stress, or relaxation, or what?

At the bedside, at nearly three in the morning, with her sleeping there so quietly, he felt like someone else. He was someone he'd never been before. It was different from being there at the hotel, where he'd felt uneasy, an intruder with his dirty hands and sea-stained, sunburnt face. Here, it was more like they both belonged. The house was kinder to him than the bland hotel had been. It let him in. It wasn't a snobbish house, it didn't mind a bit of sweat, a bit of dirt. It was a real place, not a playground for tourists. It had a life.

Emilia. Who the hell wanted to call her and talk Spanish in the middle of the night? Who was she, anyway? Was Emily de Soto her real name? What was she doing here? He leaned over, wanting to disturb her now, wanting her to be confused and speechless for once, woken from sleep. He put his lips to her breast and found it surprisingly cool. It was darker now; the clouds had blocked out the moon. There was supposed to be another front coming in, tomorrow or the day after. Perhaps they wouldn't be going out tomorrow after all. Perhaps he'd be able to catch a nap down there in the belly of the old boat. He pushed back the sheet and put his hand in between her thighs. She mumbled something and turned over on her back. Her thighs loosened, she opened to his fingers, he felt her warm and sticky like the ocean in summer. Even in her sleep, she turned towards him, wanting him in her. His penis stiffened and the whole of his lower belly grew hot. He moved over her. Outside, there was the first rumble of thunder, the murmur of another storm. He didn't know if he was inside or outside now, he

was in a liquid world, moving like a dolphin, leaping the wave. She opened her eyes and cried out with surprise and he felt her grip him, just as the first rain hit the roof.

Part III

14

THE front came in and we didn't go out on the boat that week. Tom was back from the Bahamas after their five-day trip into the deep waters off Eleuthera. We lay in bed late and listened to the rain on the tin roof and felt the wind shake the house. There was a gray cloud low over the island and the forecast was more rain. When the weather's like this in summer, you feel like you've been wrapped in a wet warm blanket that's never going to lift. Rain fills the streets up fast, first the holes in them, then the dips, then anywhere where it's close to sea level. At the bottom of our street the pools filled and then spread to lakes and if you biked through them the water slowed your wheels and sloshed around your legs. People moved about slowly, giving themselves up to the rain. They looked odd; bare legs with plastic waterproof slickers, hats with dripping beards, swimsuits with umbrellas.

All the boats were in port, tied up like patient animals in the wet. No tourists wanted to go out. The crew of the *Cat* stayed in bed or watched TV or got drunk. There was a feeling of vacation about it: sudden days off, sudden leisure. Tom and I slept, and reached out for each other, clasped each other's slippery flesh, took cold showers, read books. The apartment was our underwater kingdom, surrounded by big wet shining leaves, as if the world were upside down. Fish might swim up against our windows, weeds drift in. We closed the metal jalousies and lived in a womb in time. I didn't think much about Emily de Soto and Harry, not then.

On the fourth day, when the rain paused and the island was three-quarters under water, I put on my yellow slicker and biked through the sloshing lakes to work an hour or so on the boat. McCall wanted her swabbed in case we went out later in the week. The decks were shining wet and all the sail covers hung like dank, dark bundles. The water between the dock and the boat was full of

leaves and debris and maybe even drowned things. I stepped on board and began cleaning, moving quite slowly, because really there was all the time in the world. I'd been at it about half an hour when I saw Harry wheeling down between the puddles on Schooner Wharf. He wore a big dark-green poncho, with his bare legs sticking out underneath, and boat shoes. His blond hair was shiny wet and his face too. He parked his bike next to mine and locked it to the bike rack, then came up the gangplank.

"Hi."

"Hi, Harry."

"How ya doing?"

"Good. You?"

"Okay."

He came on board and went down the companionway to the cabin. "I just came on board to fetch something. Didn't think there'd be any work to do today."

"Captain just wanted me to clean up."

He came back up.

I said, daring, "How's your love affair?"

"Oh. Good, I guess. So far as it goes. How about you, Tom back yet?"

"Yeah. We spent the last few days in bed."

He grinned at me. "Good for you. Martha?"

"Yes?"

"I'm in trouble. Least, the doctor says I am."

"Janie said. Something to do with your heart?"

"She thinks I'm straining it. There's something wrong, I don't know exactly what. She wants me to go for tests."

"What are you going to do?"

"I can't do anything. Can't stop work, I need the money. Can't afford to go for tests. Just keep going, hope for the best, I guess. I'm going to try yoga, see what that does. I'm doing the vitamins and the diet, more or less."

"Whyn't you ask her, Harry?"

"Who?"

"Your girlfriend. I'm sure she could help you. With the money,

I mean. She looks like she could spare a buck; I'm sure she'd be pleased to help."

"No."

"Why not?"

"Just, no."

After a couple of years with Tom, I recognized this end-of-the-road statement. No good pursuing it now, wait till it comes up again. Male pride's a weird thing. What woman would risk having a heart attack rather than ask for help where it could be easily given?

"Okay."

"Look." He was pointing out into the gray water of the harbor to where a boat was coming in fast, towing another behind it. They passed in front of Christmas Tree Island and headed towards the Navy base where Tom's ship was moored.

"Poor bastard," Harry said.

"Who are they?"

"Cubans. You haven't heard? Wow, you have been out of it. They're coming in every day now. A whole bunch of boats got picked up, and people on home-made rafts, even tires, I've heard. It's like Mariel all over again. Look at that."

The towed boat was an old crate, straight out of some wartime movie, its hull down deep in the water, a little old outboard on the back. Probably six-horse, not more. The people on board stood and stared towards us. It was like we were invisible. They were looking for something else. What the hell must it feel like, to cross the Straits of Florida on a day like this, all through a night like last night, visibility nil, maybe not even a compass to tell you where you were headed, the Gulf Stream probably churning all around you like a massive Jacuzzi? Not knowing what was in front of you, just knowing that somewhere ahead there had to be this island, last in a string of tiny islands that dangled off the edge of that enemy land mass, the United States of America.

Having Cuba for a neighbor was like hearing someone coughing on the other side of a wall. I wondered how it was for them, to come out of their locked house and see the people who'd been their neighbors all along.

Together, we watched the two boats disappear round the corner towards Fleming Key.

"What'll happen to them?"

"I dunno," Harry said. "Guess we'll give them asylum. We did last time. I was over there to bring a bunch of them in. I hope they get a hot meal and a change of clothes. They'll probably be sent to some center somewhere miles from where they want to be. The media's in town, so they say. Holed up in hotels, I guess. The papers are full of it."

"I haven't seen anybody. Town seemed empty."

"That's because you've been in bed with your guy for days. We're on the map, baby. It's all happening. It's just that newshounds don't like rain."

The soaked, battered Cuban boat looked pathetic, dragged in like so much refuse behind the Coast Guard launch, and the rain-soaked darkened harbor was a poor welcome. But I guess if you'd been out for days and nights on the open Atlantic, you'd be simply relieved to arrive, whatever. I put the mop and brush away, closed up the hatches, and went on shore. Harry was still there, looking through the book where we write down bookings and receipts. Sometimes visitors write their home addresses down, like it was a hotel book or something. That's what Harry was looking at.

I teased him, "You mean you have sex with her all the time and you can't even ask for her address?"

"That's right."

"Whyn't you just ask her?"

"I can't, that's why."

"Okay, sorry I asked."

"S'okay. Hey, I'm sorry. Guess I'm a bit antsy these days." He closed the book and locked it away with the flyers about the boat. "Martha, could you do something for me?"

"What?"

"Try to find out? She won't tell me a thing about herself. It's like there's some pact, about me not asking. But I have to know."

"You want me to spy for you?"

"Oh shit, no, not like that. It's just, it's easier for a woman. Someone not involved."

"But I don't know her."

"She'll come out with us again, when the weather's good."

"Well, I guess I could give it a try."

"Nothing obvious, just, you know, if you hang out with her a bit, she might tell you something."

"Harry, what exactly do you expect me to find out?"

"Well, hell, I don't know. Something. Where she comes from'd be a start."

"Like, I could ask her for her card, or something?"

"Yeah. Something like that. You know, the way you always chat to people. You know what I mean. Women's stuff. Anything." He raised his shoulders with a helpless look. "You know."

"So, I have my mission, do I, if I choose to accept it?"

I was curious about her, not for the same reasons as Harry, but for something else. I guess I wanted to know that somebody who looked like that was still human. If you're very good-looking, you can seem mysterious when you're just plain depressed. That doesn't work for the rest of us. I wanted to know that she was like me, just another woman. To be vulnerable and have a sense of humor and be scared of things too.

I had my chance the next day, as I was standing in line at Fausto's on White Street with my bread and milk and hamburger and Cuban coffee. She came and stood right behind me. She had a can of Bustelo too, and some yellow rice and orange juice and a bag of onions.

"Hi," I said. "How're you doing?"

"Hi. You are from the *Cat*, aren't you? Martha?"

"That's right. I know it's weird when you see someone in a different place, isn't it? I'm usually either hauling on ropes or handing out champagne." I thought I'd be chatty, so she might talk in reply.

I fished in my purse for money, while the teenager with the

catatonic expression put my things in a brown bag. I felt my flesh pleasantly chilled by the air conditioning. Going outside again would be like going into a steam bath. What the hell else could I say to her? I tried to remember what Harry had said.

"So, where's home for you?"

"Miami."

"Oh, so no cooler than this. You must be used to it. Have you always lived there?"

Her purchases rolled through the checkout now. I thought how I'd make a good enough detective. Onions, O.J., coffee. Oh, and a quart of milk. She'd forgotten the milk.

"My parents live in Coral Gables. But I have also lived in Havana."

"Uh-huh. So, are you coming out with us tonight?" Her groceries were packed now. She had the brown bag under her arm. We walked out into the steaming street together, to where my bike was chained to the rail.

"I think so."

"You're becoming quite a regular."

"I like it. It is so peaceful."

"Well, mostly. Not when we get a storm like the other night, though." I packed my bag into my bike basket. She still stood with hers under her arm. I realized she had to walk somewhere, carrying that stuff. She looked pale and tired today, and a black strand of hair kept falling across her face, to be shaken back again.

I had the feeling that she wanted to talk to me. It was just that she wasn't moving briskly away, the way people do when they come out of stores and just pass the time of day with you and have stuff to do.

"D'you want to go somewhere, have a coffee? There's a lot of good places on White Street."

"No, really I have to go. Another time? Maybe I'll see you this evening, I can't be sure right now. Goodbye, Martha, nice seeing you."

So that was it. Miami, Coral Gables, Havana. She was Cuban. Was that what Harry wanted to know?

WHEN the rain stopped and the clouds lifted, Tom and I set out to bail out our own boat, which was moored out behind Houseboat Row. We have a little old cabin cruiser, seventeen foot, with a shallow draught, and when we first met we used to go out in her to spend days and nights in the backcountry and make love uncomfortably under the stars. The *As You Like It* is Tom's boat. He found her and rebuilt her and made her what she is. We'd been thinking about her as we lay cocooned in our treehouse these last days. Out on that stretch of choppy gray water where the current drags you out towards Cuba if you aren't careful, a small boat is vulnerable and can drift or even sink.

It was the day after that conversation with Harry, the day after I saw that Cuban boat towed in. He was right, the papers were full of it. I unfolded a limp damp copy of *The Citizen* and got the full story. The *Miami Herald* had pages and pages, with photographs. Even *The New York Times* had it on the front page. The Cuban Invasion, Part Two was on, according to some people. According to others, their lost brothers were at last shaking off the yoke of tyranny and reaching the promised land. But whatever way you looked at it, they were coming. In the hundreds, so the papers said. Into the Florida Keys, Miami, wherever they could land. The search parties were out for them, with helicopters, Navy boats, Coast Guard boats. Wet, hungry, lost, hundreds of Cubans were sailing in, on whatever kind of floatable craft they could find.

Tom and I biked up the coast, along Smathers Beach, the long soaked expanse of sand where no tourists played. The ocean had calmed to a metallic gray-green with a bumpy beaten surface. There were a couple of boats moored. We didn't see anything coming in or out. As we turned the corner by the airport, a truck overtook us, with a boat lying tipped on it. It was a small boat with red

paint peeling off it. As it passed, we saw the one word "HABANA" painted on its stern.

"There goes another Cuban boat!" Tom called back to me. We got off our bikes to chain them to a post on Houseboat Row and watched it drive away.

There was something so touching and so beaten-looking about that boat, lying on its flank, its sea-going bleached underside exposed, and that one word, both a name and a home. Here it was, being hauled like garbage. Where were its sailors, I wondered? Had they lived or died? What would happen to it now? We chained our bikes together. All the Houseboat Row boats, or houses, for they are all strange hybrids, had greenish muddy water sloshing between them and the land. There was nobody in sight. Probably everybody was still in bed, waiting for the sun to come out and dry their soaked possessions. The *As You Like It* was still afloat on her mooring, though she looked low in the water. Tom dangled himself down into our dinghy, which we'd chained to the wall and padlocked there. I handed him down our stuff, a couple of plastic milk bottles cut away for bailing, a bag with drinks and cookies for us.

"Damn oars are gone," he said almost absent-mindedly.

"What'll we do?"

"Get something out of the garbage back there? See if there's a plank or a piece of ply that'll do, we can make a paddle."

He's philosophical about stuff disappearing. I guess it's because he's been here so long. It makes me mad. That morning it made me madder than usual, having to go off and dig around in the garbage for some soaked old pieces of wood and then paddle out there looking like idiots. But you never find out who's stolen things out here. That's probably because they think of it as borrowing. Somebody comes back late and drunk and borrows your oars and then leaves them somewhere and forgets about them and that's that. Then they borrow something else. It isn't malicious, but it's annoying.

It was seeing that Cuban boat towed away like so much garbage that made me mad that day. When I saw it on the back of the truck I thought how when we're no longer around to love things and use them and leave our mark on them, they just become somebody

else's garbage. It's like saying a person's worthless, treating their boat that way. It made me mad that morning and I remember how it felt. Taking our oars made it seem like Tom and I didn't matter, and it made me think how those poor goddamn Cubans didn't either. I found a wet plank and a triangular piece of ply and took them back to Tom, to see if they would do.

As we paddled across to where our boat was moored, I think we both had the same thought. The cabin door was wide open, where we had left it locked. We couldn't see yet whether the outboard engine was still in there where we'd left it wrapped in an old foam mattress. We'd lost one outboard this year already, though it had been locked to the transom. An outboard motor, that's like the heart and lungs of a boat like ours and without it we're going nowhere.

Neither of us spoke. I could feel Tom worrying about his boat. A sailor cares about his boat, he says, like he does about his mother. Whether that's a lot or a little may depend, but in Tom's case it's a lot. He climbed on board and I followed. The outboard, painted green to go with the boat and the backcountry, sat under its cover still, like a parrot under a blanket.

Tom said, "So, the pirates haven't been aboard. Thank God for that."

We passed a can of 7-Up between us and got the bailers out. We still didn't know who'd been on board and who had opened the door.

I picked up a small wad of folded paper off the starboard bunk, where a pillow, our pillow, still lay with the dent of a head in it. I unfolded the wad and picked the damp papers apart.

"Hey, Tom, this is Jimmy's stuff." Here was James O'Dowd's Social Security card, an address scrawled in ballpoint, a card from a restaurant in town, and a folded pink paper from the hospital saying that J. O'Dowd had completed the course of treatment and been discharged. There was also a prescription for some antibiotics.

"He'll be needing this, wherever he is." I showed Tom.

"Let's see, what's the date on here?"

The hospital discharge paper had a barely legible date. It looked like the nineteenth. That had to be last month. We'd last seen Jimmy three weeks ago. And we hadn't been out on the boat since then.

We began bailing out, weighting the stern with containers full of sea water, waiting for the rainwater to drain to the stern and then scooping it out with the plastic milk bottles Tom had sawed in half. We took turns. The one who was not bailing perched on the transom to add weight to the stern. The thunderheads piled up in the blue sky like big hair. There'd be rain again before nightfall. The sky darkened to bruised gold at sunset and the clouds that had been white towers began to shed their rain elsewhere in long diagonal streaks. When the clouds arched and towered and changed like this, the whole world changed scale with them. Land shrank, water boiled up, light did strange things with distance. The line of little shacks bobbing on Houseboat Row looked small against the line of the land. Two red biplanes went over, selling rides in the sky for forty bucks a quarter-hour, pretty as butterflies. The dark rainwater drained out of our cockleshell boat, and we sat there on the teeming water of the inlet at high tide, thinking about Jimmy.

HE'D arrived at our place about a month ago. Of course, I'd no idea then that he'd have anything to do with Emily de Soto, because I'd never heard of her. The strange thing though about telling a story is that everything seems to end up fitting in to everything else. Or perhaps it's living on an island that does this. You can't go very far in any direction without ending up where you started.

I heard Tom's greeting and a tall thin man came up out of the darkness of the street into the yellow light of our porch. I saw a handsome face with bright, sideways-glancing eyes, and then I noticed the blood.

It wasn't so easy to see what it was in the yellow light, which makes everything black. But when he turned his face to the side I saw the long slash on his neck fixed with ugly stitches and the scratches and dried blood on his cheek and forehead. He had a friend with him, he said. A shorter man stepped out of the palm-leaf shadows behind him. The friend's name was Bud. We all shook hands, and Tom introduced me to Jimmy, an old buddy from way back, hadn't seen him for four years, five maybe, where'd he been all this time? They grappled with each other the way men do with old friends. Warm yet shy. The two men sat down at the little table on the porch. Suddenly the porch felt very full of men. We hadn't much room, and these two filled it. They put tobacco pouches out on the table and began rolling their own and I went for lemonade, being the woman there, and that felt strange. I set down the glasses, the pitcher, watched them smoke. Myself, I was trying to quit at the time, so I just watched, and listened to their tale.

"I know, I don't look very pretty right now," Jimmy said. He spread his hands, looked at their dirty nails.

Tom asked, "What happened?"

"Fact is, I got attacked. Guy pulled a knife on me. This ain't the worst of it. Look at this."

He pulled up his dirty white T-shirt, twisted his thin, hairless torso, skinny as a boy's, and showed us a wound just above his left hip that was still oozing blood into a wad of cotton.

"Near enough got me in the spleen, that one. Another couple of inches, could have ruptured the spleen. And this one, here, 's near enough the jugular. Guess I'm lucky to be here."

He puffed at the damp squashed remains of his cigarette and ground it out in the flowerpot we have for this.

"Hitchhiker did it. Ain't it great what happens to a guy who's just giving a helping hand? Bastard pulled a knife on me, from behind."

The smaller man, Bud, spoke for the first time. He'd been sitting hunched over his lemonade like a scared kid, bug-eyed.

"I shoved the guy out and he ran. Stepped on the gas while he was still fallin' out. Then I thought I shoulda gone back and killed him. I went back down the road a ways. Couldn't see hide nor hair of him, he was gone that fast. Man, we were outa there as fast as we could go."

Jimmy said, "Then I said, Bud, get me to a hospital, for Christ's sake man, don't worry about killing the guy, you'll have me dead on your hands first. I couldn't feel it, you see. Didn't know I'd been stabbed till I saw the blood on my hands. Funny, you can't feel it at the time. But then I freaked. I couldn't see where it was all coming from. It was just coming and coming, it was everywhere. In the hospital they said I was lucky, could've ruptured the spleen, easy, could have got the jugular, see, where these clips are."

I poured more lemonade. It was the sort my grandmother used to make, just lemons and sugar and hot water left to chill. And ice cubes. Jimmy fished out an ice cube and laid it to his cheek, like it was comfort. They just smoked and sipped the lemonade and every now and then one of them said something, a bit more of the story came out, only it was a story that was so torn in bits that it didn't make much sense.

Tom said, "Where've you come from, then?"

"Missouri."

"Where did this all happen? What state?"

"Reckon we was still in Missouri, wasn't that so, Jimmy?" Bud looked to Jimmy to corroborate everything he said. Until Jimmy agreed to it, it was only tentative, a guess at the truth. I thought then that Bud probably didn't know what truth was, he hadn't dared to speak it in so long.

"Can I use the little boys' room?" Jimmy asked me and went in through our apartment on a long stride. I wondered if they'd sleep here and how long they would stay. I asked if they wanted something to eat. They shook their heads, both of them. No, ma'am. They were nervous as stray cats, not about to take too much at once. Tom gave them twenty bucks and told them to come back later, they could sleep on our porch. They went down the steps and moved into the mottled darkness of the street where the real cats sit on car roofs and watch out for things. Much later on that night, I turned in my sleep, looking for Tom. The bed was empty beside me, just light falling in stripes across the sheet. I heard low voices outside. They were all out there on the porch smoking cigarettes and talking about whatever men talk about at three in the morning. I fetched iced water from the refrigerator and went back to bed.

So that was how Jimmy O'Dowd arrived at our place and for a short while came to stay. Jimmy stretched out on the old couch on the porch where the cat usually slept and Bud was on a papery mattress he'd laid out on the deck. Sort of like Don Quixote and Sancho Panza. One long and thin and tilting at things, the other short and squat and anxiously hurrying along one step behind. I thought of this when I saw them walking together down to the corner store. One jaunty, one scurrying. A suitable couple.

Tom said after three nights they couldn't sleep on our porch anymore, they'd have to find somewhere else. I'm not sure why. Perhaps it was out of respect for me. I didn't sleep easy with those two there. I dreamed of knifings and car chases and sometimes woke

sweating, needing iced water and Tom's firm embrace. But they were okay guys, really. It wasn't them. It was something in my dreams that I couldn't control or understand.

Then about a week later, Jimmy came back, cleaned up and his stitches and clamps all pulled out and a scar growing thicker where they had been. He sat down on the old green couch next to the visiting cat and told Tom that Bud had acted stupid and was in jail. He said that Bud had gotten stupid around rocks. I didn't know what rocks were at the time, but Tom told me later. He also said that Jimmy'd told him the car, which was Bud's, had been full of dope when the cops pulled him in, so the car was gone along with the dope, and all Jimmy's clothes and stuff in it. He went off to find Jimmy a pair of clean old shorts he'd grown out of. Jimmy was skinny, much thinner than my Tom, who's a good armful of a man, and he went off to the little boys' room as he called it, and came back looking like a little boy, or at least someone who had once been one. He looked kind of vulnerable, cleaned up and wearing Tom's clothes and with no tan yet, his long legs all white, as if they had never seen the light of day.

He had a bunch of photos on him, of his kids and the woman who was their mother, who had finally kicked him out. Bud had too, come to think of it, but his photos looked much older and more wrinkled, as if his woman had kicked him out much longer ago. I thought it was sad, how many men there were in the world just roaming about with photos in their wallets and back pockets of women and children, just as if there was a war on. Jimmy's woman had red hair. He looked at her sadly, as if from a great distance.

"Trouble is, she didn't respect me," he said.

Tom said, "To be respected, there has to be something there to respect."

Jimmy looked at him. He appealed to me. He had what it took, this guy, to get people to give him things. Yes, and perhaps to wish afterwards they hadn't.

"What are you going to do, Jimmy?"

"Try and get me a job, I guess. No way I'd have got a job looking the way I did."

He stretched out his long legs in Tom's old green shorts. They were still as white as onions.

"Really," I said.

"Guess I should get me a tan first and look like the natives. Or they'll think I'm a con, looking like this. Hey, but I look a bit prettier now than when I arrived, hunh?"

It was the truth, but I didn't know how far looking pretty would get him in this town.

"You can sleep on my boat if you want," Tom said. "Only sleep. No dope, no drugs, no booze, no bullshit. No sudden going fishing or drifting out to sea, okay?"

"Okay, boss," said Jimmy. "Thanks."

Tom took him out there the first time and showed him the dinghy and the padlock combination on the dinghy and the oars, which were still there then, and the little cabin cruiser *As You Like It*, which was his joy. He showed him where the little brass key to the cabin hung. He trusted him with everything. And Jimmy was as good as his word; he slept on the boat and came by our place in town some nights and brought sliced bread and bologna to make us sandwiches. You could say he contributed what he could. He said he was after a job. He didn't turn up for a day or two. Then he called to say he had met some wonderful people. That was the last we heard. Then he disappeared. Nobody we knew had seen him. We called the jail, checked that he wasn't there.

"Must've lit out back to Missouri," was what Tom said. "Martha, if he comes back while I'm away, don't let him in."

In the end I threw out the musty old patchwork quilt that Bud had slept under and had left on our porch, also the old torn cut-offs with bloodstains on them that had been Jimmy's jeans when he'd arrived. The only sleeper on our porch was our cat, who'd been a stray and had made this her home. The things she had in common with Jimmy were her wary independence and the fact that she

didn't come indoors or accept anything to eat from us. These arrangements, she let us know, she had made elsewhere.

Now where would a guy go who wouldn't need his Social Security card and his prescription? Tom and I finished bailing and locked up. The little brass key still fitted the cabin door. Jimmy had not broken the lock or anything. He'd simply slept there and then left.

I lay awake the night after we got back from finding Jimmy's papers. Tom said, "Leave them where they are. He'll be back for them." I wedged them under a smooth glass lump washed soapy by the sea, which we had found on a beach and keep on the dash.

At night I thought of the water out there that surrounds us and holds this island in its grip. It was another night of storm. Lightning flickered around for hours like on a stage set and then the wind came and made all the palmetto leaves vibrate and set the cat to washing her ass. We sat out on the porch and watched the first rain on the leaves, the mango and banana leaves, the sharp palms gleaming in the sunlight. Rain here is always an event. It purges and cleans everything, settles the dust, and then everything begins all over again, the build-up of heat, the mosquitoes, the clouds stacking their turrets up against the sky. I kept on seeing those people Harry had told me about, clinging to rafts in their wet rags. They were trying to get here. They were throwing themselves into the ocean and hoping to get washed up safe. And I thought of Jimmy and the way he'd brought us bologna sandwiches, and his laugh.

Tom said that he'd had nine lives already, that guy, he'd survived more crazy risks than most ever did in a lifetime. Said he guessed he'd hopped over to the bus station one day, got out of town just like that, on a sudden whim; after all, he had only himself and the clothes he stood up in.

"Tom, did you see in the paper about the Cubans?"

"Yeah, the poor suckers are coming in in boatloads. God knows how many got drowned before the Coast Guard got to them."

"That boat—"

"What, the one with 'Habana' on the back?"

"It could've been ours."

"About the same size, yeah. Why?"

"How would ours do out there in the Gulf Stream?"

"Well, I sure wouldn't want to try it in this weather."

The rain slashed at the roof again and the leaves rattled against the jalousies.

I shivered, though it wasn't cold. The fan moved over us, cooling the sweat on our bodies. He laid an arm over me as if to hold me down.

"Sleep now. There's nothing we can do."

He rolled onto his stomach, his arm still flung out across me, and shut his eyes. I've always envied his ability to fall suddenly asleep. I can't do it unless I'm exhausted or very scared. I lay there for a long time listening to the weather and thinking about Jimmy, about Harry and his heart, and Emily de Soto, and the soaked and starving Cubans out there in the water at this very moment, and it was like there were too many people in the room with us suddenly, and when I slept at last, too many people in my dreams.

It was Jake who had the next mooring up in the channel off Houseboat Row who told us about our boat. He and his girlfriend, or wife maybe she was, used to go and check out the *As You Like It* sometimes when we couldn't get out for a week or so. They even bailed it a couple of times, and Tom bought them a six-pack to say thank you. They had a nice-looking setup with a boat and a raft with a house on it and even a palm tree in a pot and a dog called Susie who used to sit submerged in the water on the hottest days, her fur looking matted like pale weed. They used to yell at us across the yards of water that separated our moorings, to see if we'd like coffee, say hi. The woman, Lou, was a tough-looking blonde with big arms from rowing a lot, back and forth, stoically pointing her rowboat towards land and then returning with it stacked with provisions and the dog jumping in the bow. She told us, a couple of days later, what she had seen. A tall man had come aboard our boat, using the dinghy she knew was ours. They'd found the dinghy

drifting back on the current towards the shore, early in the morning. The man had taken the *As You Like It* out, not using the engine but paddling to get out of the channel into the open sea. She'd shouted at him—Going all the way to Cuba like that, are you? She'd assumed, since he'd used the combination on the lock, that he was a friend of ours. Later, when the boat was out a ways, she thought she'd heard the engine start. It sounded like a two-stroke; she knew the way ours sounded when it coughed into life.

"I can't swear to it. But I think it was yours."

"Anyways," Jake said, "the boat got out of sight pretty damn fast. It was dark and you don't have lights, do you. But I don't reckon he would've gotten far just paddling like an Indian, the way he was going. Current was running strong then, too."

Lou said, "That current'd take you to Cuba if you let it, it's the way it goes. I've tried rowing against it often enough."

"So how did the boat get back?"

"Found her with her nose in the mangroves. Just over the other side. Lucky for you, eh."

Tom frowned. He lit a cigarette and said nothing for a minute, but narrowed his eyes the way he does when he's thinking. I just sat there. We were alongside their little homestead, up against their makeshift quay, in our dinghy with no oars.

Jake said, "You know, I heard tell they were taking boats, commandeering them, like, to pick people up and bring 'em in ashore here?"

"Who were?"

"People who wanted their relatives over here, not in Guantánamo or Texas, and not drowned out there...."

Jake waved an arm out towards the Atlantic in the direction of Cuba, or where he thought it was.

"What's that got to do with it?"

"They were paying," Jake said. "You said your friend was out of a job. They got money, some of those guys."

"Too far fetched," said Tom. But he still had his eyes screwed up and was looking at the horizon. He threw his cigarette butt into the water.

"Check the gas tank."

I went to look. The tanks we had left full, locked in with the engine, were empty.

Tom said, "Damn, you may be right."

"Looks like your friend could have made a little trip that night," said Jake.

"Well, where is he now? And why's the engine all wrapped up where it should be?"

"Can't tell you that, man. Where all the others are, maybe. Or maybe he was the one that got away. Your motor, I put it back myself. Only I couldn't find the key to lock the door."

Tom and I looked at each other.

Perhaps Jimmy was in one of Castro's jails by now instead of the posh new one that's been built here like a pink cake sitting on the edge of Cow Key Channel like a tarted-up version of Alcatraz, to house all the people who don't want to do what they're told. Perhaps, like so many others during these last weeks, he was just floating out there, a piece of debris in among the debris of other, unknown lives. Perhaps he'd just gone home. But our boat had been somewhere that needed two full gas tanks to get there. And where that was was anybody's guess, these days.

AT this time of the year, we lived in a mirrored world. It was what made things confusing, perhaps. The ocean, when it stopped its raging, became still as glass. The clouds grew up from it, mushrooms and castles, lions and giants, maps of the universe; and they also grew downward in the water to an equal depth. Everything had its mirror image. The island existed below the water as well as above. Ships joined their mirrored selves exactly at the water line. Herons standing in shallows joined themselves with one thin stalk of a leg. Pelicans and ibis flying close to the water's surface met their reflected selves with each slow wing-flap. Nothing was single any more. After the days of no visibility, the ocean and sky gave us this echoing calm. Everything had its drowned double, hanging upside down.

We began going back to work. Tom went down early to spend the day scraping old paint off the big gray ship, so's to paint it again. Summer was the time for work in the yards and preparing journeys. He came back each evening with tiny spots of paint all over him and on his glasses. I could tell by the color of the paint what stage he was at. I went down to clean up the *Cat* and get her shipshape just in case any tourists came by. I waited for Emily de Soto to come to the booth again, but she didn't come. I hung out with Janie in the silence around gull cries and the occasional small plane. We drank water from bottles and wiped the sweat off our faces and waited for Harry.

"Have you seen him?"

"Not for days. You?"

"Nope. I haven't seen anyone."

"He's probably with her. That was some luck, getting all those days off, hunh?"

"I wonder if she's still here?"

"Guess she might not be. Hey, look, there's another boat going in."

One more battered little Cuban boat was being towed into the harbor behind the Coast Guard. We watched it go.

Janie said, "Clinton's decided no more can come in. You didn't hear? If they catch them now they're all going to be sent back to Guantánamo."

"Jeez, no, I didn't know. Since when?"

"I dunno exactly. Since yesterday? This one just made it in time."

We stood side by side on deck, with the mop and bucket behind us and the hose snaking around everywhere, and we forgot for a moment or two what we were supposed to be doing. We watched the two boats cross between us and Christmas Tree Island and turn the corner out of sight where the shore curved round.

"What'll happen to them?"

I felt the desolation of making all that effort and then being sent back where you'd come from, like a package, Return to Sender. What was going on?

Janie said, "They're already sending some of them from the refugee center off to Texas."

"Texas? Why the hell Texas?"

"Guess there's a lot of space there."

We were silent on our overcrowded little island, thinking of Texas.

"What if they don't want to be in Texas? Most of their relatives are in Miami."

"Well, they're refugees. I guess they don't get to choose." We thought about this.

Then I said, "How's things with Sergey?" I knew she was thinking about him.

"Not wonderful. I wish to hell he'd stop drinking. But, well, I guess he's homesick, and he's frustrated about not working, and then he wants me to stay home with him. Of course I can't, or we wouldn't have anything coming in. Fact is, I must ask McCall if I can do another day. If there's the work, that is."

"If."

"It's been a bitch, huh? No one's in town. Nothing. It's dead as dogmeat."

"Here's Harry."

We watched him come biking slowly across the ruts outside the Schooner Wharf bar, slide off his bike, and chain it to the rack beside the booth. Even from where we were, he looked depressed.

"Hey, Harry!"

"Hey."

He went into the little booth and began setting up, as if there might be customers.

Janie whispered to me, "Looks like bad news." I went on shore and bravely said to him, "Hey, man, what's up?"

"Hi, Martha."

"You're not a happy man today."

"I'm not. Leave me alone, will you?"

"If you want. Or, you can tell me. No point in being miserable longer than you have to, is there?"

"Guess not."

"Well?"

"Shit, Martha, I don't know what's going on. That's the truth of it."

"With Emily?" As I said it, it sounded oddly familiar, as if I knew her well.

"Well, look, you're a woman." He looked at me as if I were from another species.

"Yeah."

"Maybe you can tell me. Why'd a woman act like she was crazy about a man and then refuse to speak to him at all? Can you tell me that?"

I thought about it. It wasn't something I'd ever done. After a minute I said, "I guess it would have to be, something else happened that wasn't anything to do with him, and she couldn't tell him, so she just had to cut off, and maybe hope he'd understand?"

"So you don't think a woman would be really crazy about a guy and then switch, and not want him at all?"

"No. I think people sometimes feel like that, but deep down, if she ever really loved you, it'd still be there."

"Oh. Really? How do you know?"

"Well, I guess I just know. We spend a lot of time thinking about these things. Women do. Guess I'm just going by what I feel myself."

I was thinking, there was something weird about Emily. Talk about blowing hot and cold. I felt sorry for Harry.

The tired down-drawn lines of his face began to lighten a little. He leaned back against the wooden side of the booth and sighed.

"Well, she won't answer my calls. When I tried going by the house, she wouldn't answer the door. I just don't get it. I mean, one day she's in my arms and the next I'm locked out."

"Try calling her."

"What, now?"

"Sure."

"What'll I say?"

"Shit, Harry, just ask her what's going on!"

"Did you get to talk to her?"

"Well, we met in Fausto's."

"In Fausto's? What was she doing in Fausto's?"

"Well. Buying stuff. What else do people do?"

"What did she say?"

"Nothing much. We just chit-chatted for a minute, you know, at the checkout. Where she came from, was all."

"Where's that?"

"Miami, she said, and before that Coral Gables and Havana."

"Havana!"

"Didn't you know?"

"Well, I guess I knew she wasn't American."

"Cuban Americans are Americans." I was touchy on this subject, being an immigrant myself.

"Yeah, I know. I guess I mean she didn't come over on the *Mayflower*, like my aristocratic family."

It was good to see him laugh again.

"Whyn't you try calling her, Harry?"

"What'll I say?"

"Shit, I don't know, just ask her what's happening!"

"No, here's an idea, you call her. Would you do that? She won't hang up on you. And you seem to have made good contact."

"Oh, yeah, standing in line at Fausto's, is that better contact than going to bed with her?"

"Could be. Nobody's who they really are in bed," was what he said.

I dialed the number he told me, leaned against the booth next to him, and waited. I was thinking how helpless men were, when it came to certain things. Harry breathed and sighed close beside me and drummed his long fingers on the counter. The phone rang and rang and then somebody picked up.

"Hello?"

"Hello, is that Emily? This is Martha, from the boat. Remember, we met in Fausto's?

"I'm calling to invite you aboard the *Cat* tonight for a free sail. We're inviting a few friends now the weather's better, for a free sunset sail. I know you used to enjoy coming, so I thought you might like a last sail, if you're leaving soon. Are you free tonight?"

I heard her draw her breath in. It was curious, being linked by a telephone line like this. People say, "It's like you're in the next room." This time, it was like her head was right next to mine, like we were joined. Maybe I was the upside-down version of her, or she of me.

"Well, that's kind of you. I'll think about it. No, I'm not doing anything else tonight. Hey, is Harry there?" I shook my head at him hard and said into the receiver, "No, he's not here right now. Can I take a message?"

"Tell him...wait a moment, tell him to call me between three and four this afternoon. Will you do that?"

"Between three and four." I nodded at Harry, who raised his eyebrows. "Sure. I'll tell him. At this same number? Right. Maybe I'll see you tonight, then. Fine. Nice talking to you. Bye."

"Martha, what's McCall going to say about taking people out for free?"

"Tell him it's good for business. It will be. Nothing like a freebie to get people's attention. And phone her between three and four, don't forget!"

"As if I would. Hey, thanks, Mart. I don't know where you get the chutzpah."

"It's easy," I said, "I'm not in love with her. Being in love, you're worse off than a refugee."

Part IV

THE boat came in just before dawn. The sky was gray and getting light and the water was still dark before the sun rose. She'd been sleeping lightly and waking from time to time. There it was, the chug of a boat engine coming in closer to shore. She pulled on a T-shirt and shorts and went down the stairs, barefoot across the polished wood floor, walked into the flip-flops that lay by the door, and opened the doors on to the terrace. The world outside was misty. There was no wind.

She stood on the wood of the dock and watched the boat come in close, a squat little cabin cruiser with no light showing. There was no sound except for the engine putter as the man at the helm slowed it to idle. He turned the boat's bow and came in. The engine cut out. He was a tall man reaching for the post, tying up with a skimpy rope. There was another man there, in the cabin. She saw him bend and come outside and stretch himself to a standing position as if he'd been asleep. The boat rocked against the posts, down below her where slime dried slowly on them at low tide. The boat was far down and the two men stood together, one lighting a cigarette, and they were both tall and skinny so that she didn't know for a moment which one was her husband. She crouched down on the splintery wood of the dock and whispered to them, "Hi."

"Hi, ma'am. Ain't no need to whisper. No one saw us. Here, you'd better take him in, he's in bad shape."

"Just tired," said the other man in Spanish, and then, "Emilia?"

"Get on out of this boat, friend. I gotta be outa here."

"I go."

He began trying to climb the steps, barefoot.

She said, "Take care, it's slippery." Then she said it again in Spanish, sounding strange to herself.

"How'd it go?" she asked the man with the scar, who stood steadying the boat while Raúl climbed up. She could see him more

clearly now, with the sky lightening by the minute and his face tipped back to look up at her.

"No problem. I had to scout around a bit, but I found them out by the Sand Key light. Half the others wanted to come along for the ride, but I shoved off fast. You know they're being sent back now? The Coast Guard'll get those others, unless they land somewhere up the Keys. You got this guy just in time. Your husband, yeah?"

"Yes."

"Well, have a nice night." He grinned, white teeth in the dusk of dawn, a lanky wild-looking man with that scar, but friendly.

"Thank you." She leaned and handed him the bundle of notes, five hundred in fifties. He threw his cigarette in the water, took them, counted them, and put the folded wad in his back pocket.

"My pleasure. Thanks for the dough."

"You earned it. You risked your boat, too. I heard they're impounding boats these days."

"Well, no problem. It's not exactly my boat, but that's another story. Hey, I gotta get going. You take care now."

She watched him shove off from the post, drift a couple of yards, and then turn to the stern to start the outboard. It took three tries to start it and then it coughed and turned over and he swung the boat round fast and set off out to sea. The little cabin cruiser looked small out there in the dark water. She gave Raúl her arm. He was limping and heavy and held her arm hard as they walked back across the soft grass towards the house.

"It's my grandmother's house," she said to him, "*La casa de mi abuela*. Isn't that strange?"

Everything was strange. She couldn't remember now ever having longed to see him. When you plan something down to the last detail and it works, it seems that the thing you most wanted escapes you completely. She led him into the house and pushed the old green director's chair under him, for him to sit down. She didn't turn any lights on, not yet. Soon it would be light.

He hadn't moved for hours. He lay across her wide bed and she sat in the chair and looked at him and watched his quiet breathing. He was deep asleep. She looked at him while he slept, the shape of his face where it lay turned to the pillow, the hair flattened out under his head, the gray-black growth of his beard. His cheeks were sallow and his eyebrows dark and bushy and dark hairs grew from his nose. Watching him, she felt like a nurse, not a wife. His cut foot stuck out from under the sheet with blood dried on it and she dabbed it clean with antiseptic without him even moving.

When somebody slept like this in a house, the house felt different, it was weighted with this presence. The weight of a black hole, drawing everything to it. Nothing else had any meaning. She remembered reading in *Scientific American* that this phenomenon had a name, "Naked Singularity." She thought of this as she moved out of the room to pour herself some iced water from the refrigerator. It was hard to move from his bedside. Naked singularity. A man in a bed. A black hole in space, sucking in matter. A human being, locked in with his secrets, pulling everything into his silence.

Her eyes ached and her neck was sore, but she stayed awake. She couldn't lie down on that bed with him, couldn't let herself be pulled that way. This was her second night with no real rest. There'd be today, and then another night, and the next day he'd be gone. Above the island and out over the ocean the Air Force planes from the base passed endlessly. The Coast Guard's boats were out. But he'd be in the air soon and then in Miami. And here, at least, he was safe. There'd be no camp, no detention center, no forcible repatriation, no Guantánamo, no Texas.

Emily made coffee for herself and sat smoking at the little table in the kitchen. She felt nauseous with fatigue and tension, but determined to stay awake. It was morning. Sun was burning off the early morning grayness outside and poking in between the shutters. She'd done it. Perhaps she'd done enough. Perhaps rescuing one man was all anyone was expected to do, whether or not he was her husband. It was like giving birth.

The night she had planned for had gone past, with its tides and

currents and fading stars. Today was new. But she felt old, with the aging he'd gone through. She'd been touched by the old country now. In America you could stay young forever, not letting anything touch or undermine you; there were books and classes and diets to tell you how. But Cuba was old, and she couldn't avoid its oldness any more. It was why Raúl was old, in a way no American of any age ever grew old. She stubbed out her cigarette in the ashtray made of an oyster shell. She drank her last cooled mouthful of coffee.

Late that morning she made him coffee, strong and milky as he used to like it, a real good *café con leche*. She carried it to him in the bedroom. She was still dressed, and felt stiff and tired after her night in the chair. When they'd had the coffee, she would take a shower and dress in something clean.

"*Mmmm, café, qué bueno.*" She saw his eagerness as he took the cup and saucer from her. His black eyes had looked last night like holes in his face. At last, after hours of sleep, he was beginning to remind her of who he was. "Milk, coffee, a cup with a saucer. We haven't had any of them for so long. You know, you can forget what a simple cup of coffee with milk is like? The memory of it seems to disappear. You can't even remember how you used to feel about it. It's like something somebody told you about. But now, I can remember every cup of coffee I ever had. It's like finding my way back into all memories. I suppose that is what Proust meant. Except he never had to go without his madeleine, so how would he know? No, really, the whole of *Á La Recherche du Temps Perdu* should be rewritten, by somebody who has not tasted good coffee for years."

She remembered how he talked. Raúl had been her teacher, and that was how it had continued, even after they were married. He told her what to read, he connected up ideas for her in long lines, each one linking into the others. Now, all this time later, after escaping from possible death, he talked to her about Proust at breakfast.

"And you, *mi amor*. You are better than the coffee. I want to

touch you and I dare not. But the sight of you reminds me. How can any man write about women unless he has been separated from the one he loves for fourteen years? *Ay, Emilia,* maybe we have something to thank this Gulf Stream for."

He sipped his coffee and she handed him a cigarette, because he'd looked around him and she knew what that glance was looking for.

"Here."

"American cigarettes. These you can get in Cuba if you have dollars. It is the prostitutes who get them, to sell. Can you imagine, prostitutes in our country?" He breathed in deeply and lay propped on one elbow, looking at her.

"I want to ask you something. Why did you leave? After all?"

"For you."

"Just for me?"

"I am forty-nine years old. Next year, fifty. I see my country go down and down. I am without my wife. I have nothing now. I am not even teaching any more. I worked as a nurse lately in a hospital, or more like an orderly. Two dollars a month. The price of these cigarettes. All this I would do. For the revolution, maybe this is necessary. But to live all the rest of my life without you, no."

"You still believe in the revolution?"

"Of course. It is only this stupid embargo that makes things impossible. Before the Russians left, it was different. But no country is an island any more, and we are forced to live as an island. Nobody can live without neighbors."

"Why now? Was it just that the boats were leaving?"

"Oh, why now." He tipped ash carefully off the end of the cigarette. "Well, let me tell you something. There is an instinct to flight. Birds have it. Birds know when to leave. There is not a decision exactly, but a movement. They gather together. Who knows who makes the first movement, the first wing beat? Who gives the signal? But once the movement is happening, it is impossible for an individual bird not to go. They may have a sore foot, tired wings, whatever, but they have to go."

"But some fall in the water, and they drown."

"Let me tell you, there are hundreds out there who have drowned. Just this week. Nobody will ever know how many. Just so many uncounted graves. Like a suicide, really."

"But you weren't like that."

"No, I do not want death. But what I try to explain is this. Death is nothing. If you cannot risk death, you cannot have life. There are many in Cuba who will not risk now, even though they may starve, they may lose their honor, they may become slaves again, they may lose everything the revolution gave them. They will not move, they will adapt. To whatever. To Batista's heirs. To American imperialism. To working for whoever comes along. To become prostitutes. To become nothing. They will stay because they prefer all this to risking death. What is death? Only what happens to everyone. So how can you avoid it? You avoid it for a little time. You make a few more pesos. You do demeaning work. You say to your children, sorry, once there was food, now no more. You say to your wife, you cannot have treatment in the hospital, drugs are all for tourists. You are already dead! So, *Emilia, mi amor*, the choice is easy. I said it was for you. But really, it was for me. Next year I am fifty, soon an old man, soon maybe you will not want me. What if I wait for the revolution again, and I am eighty when at last I can make a free choice? You will say, who is this old man, what has he to do with me? No?"

He grinned at her and finished up the coffee. "Life, that is what I came for. Not the United States of America. Not Bill Clinton and company. Not McDonald and Mickey and TV dinners. Not even good coffee with milk. Just to live the rest of my life, with you, not without? Okay? Okay? Does that sound American? I want to pursue happiness! That is what we are not allowed to do."

He placed the cup and saucer on the bedside table and stretched his arms, very dark against the white of the sheets. She smiled at him.

"*Querida*, that is the first time I see you smile. Oh, my God, the smile of your wife in the morning! You see, we will be happy. I am content with so very little. I will be in ecstasy. A coffee, a smile. What is it, what are you thinking?"

"Well, I think you preferred Cuba to me, Raúl. Otherwise you

would have come when I came. I never knew, was it on purpose? I know it's old history now, but I want to know."

"Yes, it was on purpose."

"Why?"

"Because I wanted to stay, to work, to be for *El Líder*, to be effective."

"Then why did you let me go?"

"Because your parents wanted you to come here. Because they wanted for you to have the opportunity you would have here. I said, in Cuba she will have the opportunity too, opportunity to be useful. But they said, no, they wanted you to have American education, to see the world, travel, have money, all that. You were young. You were maybe too young to be a wife. So I thought you should go. I thought then, you see, there could be travel between here and Cuba, that soon I would come here, that our life would go on. But no. It was not to be. It was there or here, no being between the two. No living in the middle of the Gulf Stream, eh?"

"So you pretended you wanted to go to Mariel."

"Well, you know what it was like. The soldiers told people who will go. They got people out of the prisons. The boats were full. It was not so difficult to not go. I thought, you would not go, if I did not pretend. I was right, maybe? We were in love. You were stubborn, as a girl in love is. I had maybe to act for us both."

"Oh, my God, Raúl." You didn't say, would never tell him now, what it had been like to wait for him endlessly, miss him continually, those first years. To be on that endless boat trip knowing he was not there.

"What is it, *mi amor*?"

"You changed my whole life without even consulting me."

He gazed steadily back. She remembered that once she would have done anything he said.

He said, "Because I love you. Just because. I know, it is not the American way. American women don't want this kind of love. Maybe you are an American woman now."

"Well, you made damn sure I became one, didn't you? What the hell am I supposed to say?"

She had decided that whatever happened, she would not cry. But now she began accusing him, tears choking her until she sobbed with rage. Raúl just stayed there in the bed, watching her. Then he put out a hand to her. She took it and held it hard, and let the tears come like hard rain.

When the doorbell rang, they both jumped. She stopped crying and pulled her hand away. The bell rang again. Then there was silence. Someone was outside the house, waiting outside the door, listening. Then footsteps sounded on the gravel outside and a car door slammed. An engine started and the car pulled away. Emily looked at Raúl and saw his fear.

"It's all right. Whoever it was, they're gone."

She felt irritable as hell. She wanted him to go now, so that she could breathe freely and be alone. If she'd known how it would be, she would have booked the plane a day early and just gotten him out of here.

"Who was it?"

"How should I know?"

"What time is it?"

"Just after five."

"Why don't you get some more sleep?"

"It is not safe."

"Of course it's safe. Nobody's going to know you're there."

God, but he was thin. He seemed to have been hollowed out, both face and body. He looked like an old tree.

"You have the tickets, *querida*?"

"I have a ticket. One ticket. You fly tomorrow afternoon."

"I thought you would come with me."

"I will come later. It's safer not to travel together. Don't question everything I've arranged. Mamá will meet you at the airport and take you home. I will come in a few days. I have to finish things here."

"Things?"

"Take the house keys back. All that."

"All right, *mi amor. Emilia?*"

"What?" She answered him in English.

"I want you to hold me. It has been such a long time, we are like strangers. I know it is strange. But I have thought so much of this moment."

"So have I. I guess it'll take time," she said, and leaned forward to hug him anyway. He felt stiff and bony in her arms. She held him and felt nothing give, in him or in her. *Ah, God, can I do this? It was like being halfway across a river, no going back. Or halfway across the Straits of Florida, midstream. If you could divorce a whole country, surely you could divorce a man?*

"Fourteen years, *mi amor*, my God, it is not right."

He murmured with his chin above her head, gaunt and clumsy in his tenderness; to her he was half alive. He stroked her hair as if it were the first time he'd touched her. She felt herself putting up with it. Then the phone began ringing again, over and over, and they stayed listening to it without moving, he stiff as an ironing board in her arms. Then he moved back and looked at her. He smiled and pulled a face, mocking hopelessness.

"Not very romantic, eh? Thank you for doing your best, anyway. Things can only improve. Where is my hot husband, you are thinking, where is the old Raúl?"

There were only hours now, before he had to leave. Suddenly she thought, *it is too soon.* These crucial hours might be all they would have. Whatever would happen now, this time would be a turning point. She saw him coming back to life before her eyes. She made herself think, deliberately, of the sailor.

"What are you thinking, *corazón?*"

"That this time is so short."

"*Es verdad.* But we will have more time. A lifetime, soon. That's true, isn't it, Emilia? You will come to me soon?"

"Soon, yes."

"You know, I don't ask. I don't ask if you have been faithful to me. It isn't important. I don't want us to ask about this."

"I've had boyfriends," she said quickly.

"Boyfriends, what does this mean, lovers? Say it, lovers, if that

is what you mean. Boyfriends, girlfriends, that sounds like children. We are not children, Emilia. No, I don't want to know, really. But if there is somebody now, if you have another life, if there is a man, you should tell me, and I will not continue to hope."

She kept a steady voice, and looked straight at him. "No, Raúl, there is nobody."

She showered and washed her hair and put on a light black-and-white print sleeveless dress. In the bathroom mirror she looked to herself tired, but not ugly. The ugliness might come, in time. Like death, she thought. Like what Raúl said about death. After all, you can't spend your life avoiding things. Nor should you even try.

When she came out, he said, "You are beautiful. Now it is my turn. Who wants to be married to an old wreck come out of the sea with a long gray beard and smelling like a raccoon?"

She heard him whistling in the shower in little short bursts, and once she heard him laugh. He was probably just enjoying the fact that there was soap. She didn't go into the bathroom, even when he called her name, but waited for him outside, quite formally. She heard him in there, whistling and laughing, so happy just because of soap, and coffee with milk.

Who would dislodge her from her indecision now? Raúl, whistling away in there, or the sailor who waited for her tonight and wouldn't talk to her of Proust or know anything about politics, but who saw her as she was now, not as she might have been?

IT had been a strange week. Rob drove his car through the deep lakes that had formed in the night across streets and the water swished right up the doors and across the windshield. Nobody had been into the office to pay rent, so he'd decided to go out and do some collecting before everything fell in arrears. It was a nuisance, how nobody here did anything when it rained; the whole town just stopped, people stayed indoors and behaved as if they weren't there. The power flickered on and off according to the wind and rain and all the electric clocks said weird times and nobody knew what time it was for real. Still, some people had to go on with business, whatever. The hotels, he'd heard, were in big trouble, because of the weather and the media reports of hordes of Cubans rampaging through the streets. It was TV that did that, and the idiot reporters down from the north who couldn't think of anything better to do than make up lies. The whole country was waiting to hear what Clinton would decide to do and meanwhile nobody wanted to spend a vacation in the pouring rain with thousands of Castro's rejects roaming the streets.

The reality was, nobody was roaming the streets at all. He'd seen some of the boats towed in, poor bastards. He'd been up the Keys only yesterday, and passed the lines of people down from Miami in their buses, just waiting to hear if their cousin or son or in-laws had arrived. There'd been people out there in the rain, just hugging and sobbing and hugging each other some more, right in the middle of the street, up on Stock Island where the refugee center was. It made you want to cry, too. So much emotion. Un-American, he supposed. But quite a sight for sore eyes, looked at another way.

He drove down South Street and glimpsed the gray line of the ocean down the side streets; debris, palms in the wind. A wrecked playground. No wonder there was no one around. He parked in the street outside the house so's not to disturb her. Light warm rain fell

on him but it hardly mattered. He felt his shirt and hair damp, his face moistened. He went down the side of the house and rang the bell. Between the house and the beach, the soft grass was flattened and the sand soaked and dark. The leaves of the seagrapes clattered in the wind and the palms leaned steeply. Out on the water, there was one small boat. He wondered if it was one of them. The Coast Guard had been out there day and night bringing them in. How could you be so crazy as to risk your life, he wondered, in a cockle-shell boat, on a goddamn inner tube even, just to get here? It must be as bad over there as they said. He couldn't imagine wanting to escape anything that much, to risk being thrown about on that ocean for days and nights, and probably be drowned too. He wasn't a sailor, himself. Couldn't see the attraction. A nice cruise on some-thing big and safe, yes, perhaps, with all comforts on board. Otherwise, no.

The bell rang inside the house and nobody came to answer. Damn. He should have called her first. He'd been so sure she'd be home. Where else could she be, on a day like this? In bed, taking a nap, but it was a funny time to take a nap, five in the afternoon. He'd come after the office closed, on his way home. He'd imagined her opening the door, pleased to see him on a rainy day, inviting him in. Maybe she'd have given him a cocktail, or a cup of coffee. The rent would have been the least of it. She must have forgotten the rest of it was due. Well, he'd call her tomorrow, try again.

He was just turning to go when he heard something inside the house. The house was not empty, and there was more than one person inside. He caught a movement, a quick back-and-forth across a crack between shutters. Just a flicker, dark against light. He knew houses, their atmospheres, their emptiness or fullness. He moved across the window and stood where he could not be seen. In a heartbeat he knew he'd been seen from inside. He didn't mean to spy, it wasn't his nature. He never did any-thing like this. In his line of business, he was straight, straight as a die. But he stood flat against the house wall, between the door and the shuttered window, with the fine rain sprinkling his san-daled feet and he heard the murmur of voices. There were two

people in there, a man and a woman, and they had heard the bell and had not come to open the door.

Well, it was not his business if she had company. She must be entertaining, and hadn't wanted to be interrupted. He'd go now, and they'd hear his careful footsteps, and even hear him start the car engine. They'd know he had stood here trying to be invisible, spying on them, for no reason at all that he could name.

He left, wet-footed, stepping across puddles. He still felt someone from inside the house was watching him go. A comment was being made. He was noticed. He'd been seen, doing something pointless; that made him already ashamed. Tomorrow, he'd tell her that he'd just sheltered for a minute from the rain. It had suddenly rained harder as he'd stood outside her door. Or, he wouldn't mention it at all. He'd let it fall among all the other unexplained acts that fogged his life, ones which if nobody mentioned them didn't exist. He reached the car and sat in it for a minute without starting the engine, maybe so's they'd have a chance to forget him. He felt it deeply, that he'd interrupted something, done a dishonorable deed, and been found out. Barb always used to say he was too sensitive. She used to mock him for feeling guilty about so many things. Other people, she said, hardly even noticed. She was so busy getting rid of guilt from her own life and giving herself top marks for doing it that she hadn't been able to stand his own obsession. But wouldn't anyone feel it, he argued back in his mind, after spying outside someone else's house? No, said Barb in his head. Only you.

The trouble was, he didn't even know why he'd done it. Unless there'd been something going on in there that shouldn't. Unless he'd picked that up like a dog on a scent and now knew something he shouldn't, or didn't want to know.

I TOOK my bike and wobbled down between the pools of water towards the house at the Southernmost Point. Before, I hadn't even known this house was there, it was so well screened from the street by a row of casuarina that dripped on me now as I locked my bicycle to the gate. I walked towards the house and the ocean.

That was when I heard the music of the tango. Somehow it made my standing out on the step feel more dramatic. Two palm trees bent back against the pale strip of the ocean as if they were dancers. Da dum da da da. Someone was in there, moving about. I heard footsteps and saw movement, dark against light from the windows. But for the longest time nobody came to the door. I went forward and knocked with my knuckles on the wood. A man came out of the house onto the deck. He looked shocked to see me. He was dark, and very thin, but what struck me most were his eyes. I stared at him. You don't often see eyes like that, so full of the person, as if that was the only way he could show himself. He stared back at me too. Dark eyes, narrowed against the light, or against invasion. Round here, men only stare at you if they think you're sexy, and then it's in a certain way. This man wasn't looking at me like that.

He held out his hand and I took it. We shook hands there on the deck. Or rather he was on the deck and I was on the sandy grass. The music went on, spilling out of the house.

"Good day, madam."

"Hello. I'm Martha. I came to see Emily. I mean, she was expecting me. We spoke on the phone. Hey, I'm sorry if I'm disturbing you."

"*De nada.* Not at all. My name is Raúl Aguilera. Good morning. How are you? Won't you please come in? Emilia is out, but not for long. I am sure she will soon be back. Come in, please. You will have some coffee?"

He stood aside and let me go before him into the dark interior

of the house. I stood in the room and turned, uncertain of where to go. I looked at him. His shirttails were hanging outside his pants and his feet were bare, bony, long-toed. His face and hands were tanned. He was thin, the clothes hanging on him.

"Go on. Sit down. I will make some coffee first. Or, you can come into the kitchen."

He stood in the kitchen and tipped Cuban coffee from the pack into a jug. He filled a pan and set water to boil. I stood there, not wanting to sit on my own and be waited on.

I said, "Why don't you use that kettle?" There was an electric kettle on the work top. It wasn't my business, but I can't easily just stand and watch people do things the hard way.

"Ah, yes. I had forgotten it." He tipped the water into the kettle. "You are Emilia's friend, yes?"

"I guess. I'm a deck hand, on the *Black Cat*. It's a schooner. A boat, you know. It's where I first met her."

"Ah, a schooner. And you are, you say, deck hand? That means, sailor? You have woman sailors, here?"

"Sure."

"I had not thought so, not in America."

I said, "So, are you a friend of Emilia, Emily, too?"

"Me, I am her husband."

"Her husband?"

"Yes. You did not know, eh?"

"No, I didn't."

"You like *con leche*? With milk?"

"Sure. Yeah, we have *con leche* here too."

He laughed. "So much of Cuba you have here, I think."

"You're from Cuba?"

"*Sí*. You never saw a real Cuban before?" He made a face, hands waving like claws. "We are monsters, for American people, no?"

"No, lots of Cubans live here. But I mean, you just came from Cuba?"

"Yes. I am what they call *balsero*. I come in a boat. This is a secret, you don't tell anybody? Emilia says now I am here they can do nothing, I am safe, but I am not sure. We sit down with our

coffee, yes? We are civilized human beings. We don't stand in the kitchen."

He smiled at me and gestured to me to go first again. He followed, with two cups on a tray. It smelled like all the best *café con leche*. We perched on two dark chairs and beyond the French doors to the deck, the ocean winked at us, coming and going in little gleams behind the bent trees.

"So, you are Marta. Pretty name." He gave me a friendly grin. I started to like this man. "Tell me about you."

"Well, I live with my fiancé, his name is Tom. We live in a little apartment, with trees all round it. We have a boat, we like going out in that."

He pulled a face again. "Ha, I have enough for now of boats. But this place, is it all boats, sailors? What else do you do? You like music, dancing? You like poetry? You read? You like pretty clothes, not just—" he gestured to my shorts.

I thought. None of these things seemed to have come my way during the last couple of years.

But I said, "I like dancing, yes. And music."

"You like this?" He rewound the tape on the tape deck and the Argentinian tango began again.

"Sure."

"You like to dance?"

"Dance?"

"*Sí.* Come. I show you?"

So then I was dancing the tango, in the middle of the morning, in a strange house, with Raúl Aguilera, who was Emily's husband. He was a good dancer. He held me firmly, my right hand lightly in his. We paced and strutted and rucked up the carpet. Then he stopped and rolled the carpet to one side, so we had a dance floor on the bare Dade County pine. De-dum-dadada, de-dum-dadada. Back and forth, me in my shorts and boat sandals, he barefoot, a scarecrow of a man, his bony shoulder under my hand, his flapping shirttails lifted by the movement of the fan above us and his eyes looking straight down at me whenever I glanced at him.

"Good! You are good! Now, shall we finish our coffee?"

How could I ever explain to Tom why I'd danced the tango with Emily de Soto's husband that morning? I probably wouldn't even try. Dancing? In the morning?

He sat down again, humming the tune. "You think I am a little crazy, no?"

"No."

"It is just—I am happy. I am happy to be here, to drink coffee, to be with you, to talk, to dance. It is good to be on this side of that—" and he gestured with one hand, towards the ocean.

"You only just came over?"

"Only just?"

"I mean, you came—yesterday? When?"

"Not many days. After Clinton say, no more come. You see? I do not want to go to Guantánamo. No. I had enough Guantánamo, enough labor camp, I tell you. I am a free man now. That is why I dance, you understand?"

"You dance well."

"You too, Marta. Some day we dance again, no?"

I didn't answer. I began wishing Emily would come back, so that I wouldn't feel so strange. Key West is a place where strange things happen, but not usually dancing the tango with a Cuban *balsero* before you've even had coffee.

We both sipped in silence for a moment. I was putting all this information together in my head. Emily de Soto had a husband, and this was him. This was what Harry was up against. I felt confused. What was Emily up to? Was she just playing Harry like a big fish she didn't intend to land, to while away the time till her husband arrived?

Raúl said, "You have much to think about?"

"I guess."

"I too. People say, lucky to escape from Cuba, no? But I leave many things behind. It is for Emilia that I come here now. You understand?"

"Yes, I think so." I didn't, not yet. "What's it like in Cuba? Why was Emily here and you there? Why didn't you come before?"

"So many questions! But, good questions. I will tell you. You

know, Marta, you are pretty woman, you should wear your hair—
so." He lifted my hair in a bunch in one hand, like a hairdresser. I
looked at myself and him in a pitted gilt-edged mirror that swung
against the wall. When I'm sailing, I wear my hair in a bunch at the
back, a sort of ponytail. But he had it right up on top of my head.
It made my face look less round and my eyes bigger. But I shook
away his hand, embarrassed.

"Excuse me. I do not want to interfere, believe me. But you see?"

"Yes, I do. But tell me about Cuba."

"You want to be here the whole day?"

I had all day, until I was due on the boat an hour before we
sailed. A day with this man could probably tell me a whole lot of
things I wanted to know.

"Well, not exactly all day. Perhaps till Emily comes?"

"*Bueno.* Where to begin? You want more coffee? I take a ciga-
rette. That way it is easier to talk with you, Marta, you know that?
So. When I was young. You want to know this? I am young, I am
excited, because there is Fidel in the mountains, in the Sierra
Maestra, with his few men. Imagine this. I am a boy, I hear of this
man who is so strong, so intelligent, nobody can stop him. I am in
love with this idea, no? Fidel—well, you have to see him to under-
stand. It is like love, yes. For many years, this man is like a lover to
me. I do not talk about sex. But love, devotion. He make you feel
this. He look at you, and—like this." He paused and looked at me.
His dark eyes in their little nests of fine lines gazed into mine. I
don't know about Castro's eyes, but this man's were quite enough.

"Yes," I said, "I see."

"It was my—not my real father, my mother's husband—"

"Stepfather."

"Stepfather. Who was with Castro. Later he marry my mother.
He told me how it was. He told me many stories. You want to hear
one story?"

"Sure."

"Okay. Is in 1957 I think. My stepfather is with Fidel and Ché
Guevara, they leave a place called La Emajagua and they are go-
ing to Mount Caracas, a big mountain more than three thousand

feet high. A beautiful place. Many honeybees and birds, that sing in the night."

"Nightingales?" I remembered, suddenly, a summer night in England, when it hardly got dark. A naked trilling sound, almost like water.

"*Claro*. They are very tired, very hungry. Ché had asthma, you know that?"

"No, I didn't."

"They have to leave him. It rains heavy. Roads are very muddy. They reach a cabin. There is a farmer, who offers coffee, and chicken with rice. They are going to eat the chicken when a shout comes from the lookout—Fidel, the guards! They have to leave, without eating. My stepfather is very hungry, all are very hungry. They still smell the chicken and rice. Rain still falling. Very tired, very dirty and wet. They pull in belts. They are twelve men, together. Towards night they come to thick streams, then valley, then another cabin. They rest an hour. Then Fidel says, go look for food. Men must eat, cannot walk forever without food. They set one guard, others sleep. In the night my stepfather says, he hears Fidel humming. This is very amazing to him. He gets up. Fidel says, come, we go again to search for food. They go through thorn bushes, on and on, and find old cabin, and two chickens there. They shut all doors to the cabin to shut chickens inside. They chase chickens while another man goes to meet the peasant who gives beans to him. They kill chickens, they make a herb tea with a plant called *canasanta* which in English I don't know. They find leaves of *culantro*, you know?"

"Yes, we call that cilantro. Go on."

"They cook beans, herbs, and chickens, they make a soup. It is better than in the best restaurant each man has ever known. They eat soup, go to eat chickens, but Fidel says, no. You leave chickens till tomorrow."

"So did they?"

"Of course. They do what he says, but each man protests, Fidel, we are still hungry, we want to eat now, who knows what will happen tomorrow? They remember the smell of the chicken and rice

they had to leave before. But in reality, their stomachs are full. They can sleep. The next morning, Fidel gets up first. He says, those chickens, are they ready? The chickens are cooked so well they are like pâté. The meat falls from the bone. They all eat the chickens, then they go on their way to Caracas, they can march for two days."

"So, the message was, to have your cake and eat it too?"

"The message is, you keep something for tomorrow. You know when you have just enough. You do not act like a greedy man, eat all at once. This my stepfather told me very often. When I was young. Always, you must wait. Soup today, chicken will come. But, what people think now is, chicken is coming too late. They wait too long. Every day is soup. When will there be chicken? You see?"

"I see."

Then we heard a car pull up outside. Footsteps on the gravel of the driveway.

"Taxi," he said. "I think this is Emilia."

So Fidel Castro's eyes and the business of how long to wait for your chicken would have to wait till another time.

THAT night we sailed on a glassy sea. The boat sat on the mirror surface between two worlds, hardly moving. Above and below us the piled clouds towered. We had to motor out of the harbor to catch the slightest breath of wind. McCall turned and turned the wheel, hoping for a sudden puff, and Harry held the staysail right out over the side to starboard. We only had a few on board. This summer was a lean time still. There was a bunch of old friends of McCall's from up Cocoa Beach way, people who had sailed this boat with him before. So it wasn't hard to convince him that Emily too could come as a guest. Then there was a young couple who were getting married. The bride wore tiny white shorts and an off-the-shoulder frilly white Mexican blouse and her pale shoulders were reddened in patches by the sun. The husband wore white shorts too, and a striped T-shirt and had his hair in a ponytail. They were already drinking champagne and kissing sexily in the stern as we made our way with difficulty out into the channel.

Emily was there. She looked almost ordinary tonight, without make-up, so that her lips were the same color as the rest of her face. Her black hair hung straight to her shoulders. She was in shorts and a T-shirt, and she perched amidships on one of the life-vest containers, because the kissing couple were up in the stern. She smiled at me as I offered her a drink.

"It was nice of you all to invite me. Are we wedding guests today?"

"Sort of. I mean, yes, they're getting married. Nobody else knows them, so they'll need some witnesses. So I guess we are their guests too."

"Do people often get married on the boat?"

"Oh, yes. They like it. It's romantic, being married on a schooner by a sea captain. It's something to remember."

McCall was wearing his whites and had his gray hair tied back

beneath his captain's hat. When we were clear of the channel markers and just moseying along with our nose turned southwest and the boat in irons in spite of Harry's efforts, we had the wedding.

McCall said, "Take the wheel, Martha, just in case we go anywhere." I did. I longed to put one foot up and steer with that, the way Captain Sharon did, but I didn't quite dare. As it was, steering this boat was always a charge, even if, as McCall said, we weren't going anywhere.

The young couple stood together at the lifelines with their backs to the setting sun. McCall began the ceremony. It felt grand and somehow archaic. I thought of burials at sea. That would be a way to go.

But the bride and groom were far from thinking of burials. McCall made a joke about the captain having the right of the first night, then said, "You may kiss the bride, as long as I get to kiss her next."

The bride blushed to match her shoulders. She kissed her new husband, long and enthusiastically, with Mo, our musician, strumming excitedly on his guitar and the guys from Cocoa Beach whooping and growling. Then she kissed McCall. All this kissing was making me feel strange. I looked at Emily de Soto and she smiled back. Harry was a little ways away, pretending to have to set the staysail on the port side, although nobody had told him to. He was still trying to do something about the wind. Next he went up into the bow to shake out the jib. Emily held her glass of champagne and said to the bride, "Congratulations."

"Gee, thanks. Isn't this great? I never thought I'd be married on a real boat."

"Have you two known each other long?" McCall asked, and took the wheel back from me as there was a brief ripple of wind across the mainsail.

"Just a week," she giggled.

"Hey, that's sudden."

"I know. But you only live once."

"Marry in haste, repent at leisure," said her new husband,

grabbing her round the waist where an inch of skin showed between her top and her shorts. He kissed her hard, again. We all watched. "Anyways," he said, "nothing ventured, nothing gained."

I was wondering if the two of them had been reared entirely on clichés, when a shudder of wind turned the boat halfway around. Everybody staggered and clutched for the rigging.

"Looks like we've got a wind at last," McCall said, steadying her with the wheel. "Good work, Mr. Mate. You're the only one thinking about sailing around here."

Harry came down aft and Emily was briefly in his way. Before she sat down on the life-vest box again. I saw his face, and it was taut and set as if he were in pain.

"Harry..."

"Get the cannon up, will you, Martha? I don't think I can, right now."

"Sure." I went below and lugged the little cannon out and hauled it up the companionway in my arms. Then I went for the gunpowder and paper towels we use. I propped it on the deck and poured in the slaty trickle of gunpowder, then rammed in the torn-up pieces of paper towel.

McCall shouted, "Can't have a wedding without a send-off, pirate fashion! Stand back, cover your ears! Fire in the hole!"

I took the lighted cigarette he passed me, set it to the end of the fuse, and stepped back. The explosion made everybody jump and scream, as usual. McCall clapped the new husband on the shoulder and said, "I hope you can match that tonight, boy!" He enjoyed weddings, and being expected to be as salty and rambunctious as he liked.

"Ready to go about? Let's use this wind!"

"Aye, captain."

"Ready about!"

We swung and scuttled to our places, and the boat went about. A slight new wind was coming in unusually from the west now. The new couple went up into the stern with their filled glasses of champagne. I stopped by Emily to see if she wanted more.

"Just one week?" she said to me.

"Yeah, crazy, isn't it. What people do."

"Are you married, Martha?"

"No, I'm not married, but I live with somebody. We might marry someday. But I don't think there's any point in marrying somebody unless you feel you're married to them already. Right? That make any sense to you?" It was weird, I thought, that she should bring up the subject of marriage right now.

"You mean, you have a sort of inner marriage? Then you get the outer one?"

"Yes."

"That makes sense to me."

"Does it? I think, if you do just the outer one, it doesn't get you anywhere. You have to know who you are married to, in your heart."

I didn't really want to be giving her a lecture on the subject. Luckily Harry called me then. "Listen up there, Martha! Captain said trim the main. Just a little, okay?"

When we'd trimmed the main by an inch or two, I went back to her. I was guessing she didn't know I'd called on Raúl yesterday, unless he'd told her. I'd scooted out the door when we'd heard the car, only the car wasn't her. It was a dark red Oldsmobile, not a taxi, after all.

"Martha," she said, "have you ever been to Cuba?"

"No. I'd love to go, though."

"You should go, if you get the chance. It is very like here, and very unlike. It is like the opposite."

"The flip side?"

"Yes. Or the mirror. But you know, for centuries these two islands were very close. This water"—she gestured back in the direction of the open water of the Florida Straits, beyond the reef—"this water was just a corridor. A connection, not a separation. Very different, but close. Maybe like a marriage. Tell me. Do you think a marriage is forever? Or can it have an end?"

"Why're you asking me? I've never been married, not officially, that is." I refilled her glass for her. It felt like I was caught in some web that was nothing to do with me. What was she getting at?

"But you feel you are married."

"Yes. Yes I do."

"What does he do, your man? What's he like?"

"He's a sailor."

"Like Harry. A very unsure job."

"Well, he's not much like Harry. I guess it depends which way you look at it. It's not exactly a safe job and it sure isn't a well-paid one, but at least the ocean's always there. I mean, someone's always needed to sail on it. So at least it's a job that'll always exist."

"But what about marriage?"

"Oh, yeah, I forgot what you asked me. I can't imagine what would make it end, myself. Because it's a decision, isn't it? You just decide what your life is about and you live it. That's how it seems to me. I guess death might end it. Hey excuse me, I've got to work. Maybe we could talk later."

I never did figure out exactly why she wanted to talk to me about marriage that night. Was she trying to get me to tell her to go back to Raúl? Who was supposed to have my allegiance after all, Raúl or Harry? Was it really anything to do with me at all? It felt like there was something she wanted to know, quite urgently, and like she thought I could tell her. I just told her what I knew according to me. It was all I could do.

I had to scoot after that and get back to sailing the boat in. We do get time to talk to customers when we're serving their drinks, but you can't overdo it. We'd sailed in okay so far, but as we passed Fort Zachary Taylor the wind died again. So I went starboard and Harry to port, to man the main and foresail halyards and hold them on their pins before hauling the sails down.

"Ready on the peak?"

"Ready on the throat?"

"Ready!"

"Haul away."

McCall wanted to motor back in. We hauled and the huge sails billowed down on to us like clouds falling from a still blue sky. The clouds, white thunderheads cleaner than our canvas, piled higher

and higher, tinged with sunset, and the whole world seemed to hold still. I went up to take the bow watch, crouched up high by the furled jib. Harry watched from the starboard side. McCall, at the wheel, centered his far-sighted gaze. We were all on watch. But later I thought, no amount of staring into the distance can ever tell you what's coming, not really, not so's you can make any difference.

I WOKE at five and heard the rain beginning again. It pattered on the roof and rustled on the mango leaves outside our window. It was gentle rain, dawn rain. I lay next to Tom, who was asleep. We had a single sheet halfway over our bodies. The ceiling fan turned above us, giving us air. I heard the rooster next door crow again. The roosters sounded through our dreams these days, shouting slogans. Tom said that one always shouted "Oklahoma!" I knew there was one that yelled out "I hate you!" and another that said, "I want to go home!" They roosted in the avocado tree in the yard next door, and their hens laid in among the wheels of the old rusted truck that lived permanently between the two houses, with weeds growing up around it. In the beginning their cries had maddened us and we'd paced round the apartment in the small hours, cursing. But now we'd been here so long, we hardly heard them any more. They were dream voices, clues at the edge of sleep.

One more crow and Tom turned and pulled the sheet with him, maybe dreaming of Oklahoma. I curled against his cooled damp naked back, under the fan. The room filled with gray light and the outside world was very close, with the wet leaves crowding up against our jalousie windows and the rain creeping in to my thoughts.

I was thinking about Emily de Soto, and about love. I'd woken after dreaming about her, I remembered it now, and this morning she was urgently in my mind.

Why should I dream of her? Outside, a rooster shouted, "Help me now! Help me!" I watched Tom's breathing and the way he slept, absorbed, his hands tucked between his thighs. In sleep we go back to babyhood and beyond. I saw Emily's black wing of hair. I'd been dreaming of weddings, hers and mine. She was an old-fashioned bride in white lace and there were men all around her in black hats, perhaps in Mexico. "Help me!" her glance said. She was a sacrifice, an offering. She was marrying a stranger.

I was looking all through the congregation, to find Tom. There he was. Ah, I didn't have to be afraid.

I lay on my back under the fan, feeling its breeze on my breasts and stomach, and tried to remember more of my dreams. There had been somebody speaking in Spanish and I'd been trying to understand. Emily de Soto gave me something, a gift, a folded paper. Who was the bride in this dream, was it her or me? There was a procession, and it could have been a wedding or a funeral, only everybody was dancing, twirling around. Then, I was giving birth. Except the roosters or the rain woke me before the ending came.

Tom flung out an arm to hold me close. Where was his own dream taking him? Did he want me with him, wherever he was? I felt the strength of his hold and lay within it, watching the fan and listening to the rain. It was like we were all going down into a watery world these days, one made of rain and floodwater and rising seas. I waited for day to begin, with coffee and going to work and moving across this island, back and forth, the way we did, like so many ants not knowing why or where but only what the day's task was. I thought about love, the kind Tom and I had, and the kind Harry and Emily de Soto had, and the kind she might have had with Raúl. The love which tends towards safety and the love which tends towards danger. Perhaps the two are needed, I thought, so that some kind of balance can be reached in this precarious life we have, floating between water and sky. Like high tide and low tide. Like storm and calm.

While Tom was making coffee an hour later, I still lay tangled in the single green sheet. I wanted to tell him that something was going on out there that involved us, but I didn't know how.

I said, "You know I told you about the woman Harry's fallen in love with?"

"Uh-huh?"

The coffee perked on our little stove and he poured it thick and brown and hot from our old yellow coffee pot. We had a good brew of Bustelo coffee in the mornings, not the watery stuff most

Americans drink north of here. He handed me a mug and I sat up wrapped in the sheet.

"Aren't you getting up?"

"Yeah, I am. I was just thinking. I had some weird dreams. About getting married. And about her. I had a feeling I should help her in some way. D'you know, I found out she's married?"

"Well, didn't somebody say that everybody in a dream is really you? D'you want to get married, Martha?"

"I feel as if I am married. But it didn't feel like this was about me. But this wasn't in the dream. She's married for real."

"I've been wondering if we should." He wasn't interested in Emily de Soto the way I was. He was talking about us. I decided to go along with him. After all, which mattered most to me, her life or mine?

"Have you?"

I looked at him. He was pouring sugar into his coffee mug and stirring it in. It was always a pleasure, watching him do things, quite ordinary things. He had a deliberateness about him that made them look different, not ordinary at all.

"D'you want to get married?" I asked him.

"I think so. But right now I have to go to work."

So it was that our talk of marriage began, out of a dream in which Emily de Soto and I had been like one person, or two interchangeable ones. I got up to kiss Tom at the door of the apartment and the taste of the coffee, toothpaste, and tobacco on his breath. Then I went back in to shower and dress. I thought, I'll call her. I'll talk to her. Maybe she'll come out on the boat again and I'll have a chance there. Maybe this is all nonsense. Maybe dreams are best kept to yourself. Maybe I made this all up. Maybe I shouldn't have danced the tango with Raúl and kept it to myself.

"Help me!" a late, flustered rooster called out from next door, "Help me now!"

I went down the rickety white-painted steps from our apartment, down between the wet shining leaves and into the steaming morning.

The rain was slowing, gentle and soft. As I went, the lines of a poem I had learned in school came to me.

Western wind, when will thou blow,
The small rain down can rain?
Christ, if my love were in my arms,
And I in my bed again.

Here was the west wind and here was the small rain. And though we'd lived together for a couple of years already, close as a hand in a pocket, I felt suddenly that I couldn't bear to wait till tonight to see Tom again. I decided to bike down to the dock where he was working and just say hi, on my way to work. Had we just moved on, made some large leap forward, without even realizing it? It was like the moment when wind suddenly fills a sail, there's movement on, and you're sailing. Fear and pleasure all in there together, because you never know where the wind's coming from or what it may do.

I unlocked my bike and wheeled it out. The street was flooded again. Wet birds clung to the avocado tree and the truck was rusty red. Someone went by on a bike, wobbling between puddles, holding a *café con leche* in a styrofoam cup in one hand. The old guy next door had turned on his TV already and was standing on his front step smoking and coughing and looking at the rain. One of the women who lives below us was already out on her porch, tugging wrecked-looking house plants out to be rained on. It was all very much as usual, our street. So I weaved my way down it the wrong way, through the puddles and down to the lake at the bottom. As I was turning the corner by the cemetery, I saw Jimmy O'Dowd's little sidekick, Bud, coming down towards me, but I didn't stop.

WE were in the Southernmost Pharmacy, on the corner of Simonton and United, drinking sodas. Emily sat across from me at the narrow table and the vinyl of the bench seats was sticking to our thighs.

"Emily," I said, "I wanted to see you. Harry asked me to find out why you won't see him. So. I've come clean with you, at least. I can't tell him, can I? I mean, that you're married? What am I supposed to do?"

I was in way over my head, I knew that. I'd have to tell Harry something when I went back to work that night.

She sipped through her straw and looked at me. "You won't tell him, will you?"

"Not if you don't want me to. But aren't you going to have to tell him sometime?"

"Sometime, yes. D'you think I'm bad, Martha? Do you disapprove?"

"No. But I don't know what to do, or why I'm suddenly in the middle, taking messages."

"It's because you're easy to talk to. People trust you."

"Oh." I thought, I guess they must.

"I'm sorry, I didn't want this to happen. You see, I thought Raúl was going to Miami yesterday, but he won't go."

"And that would have solved it, you mean?"

"Well, only temporarily, I know."

"The thing is," I said, "which one do you love?"

It was for myself that I wanted to know. There had to be an answer to that, didn't there?

She blew down the straw into her empty glass, like a kid. She raised her neat black-wing eyebrows and drew down the corners of her mouth in a grimace. She still looked beautiful. I thought, what's the use of looking like that? It just makes life more difficult, if you don't have any clear thinking to balance it.

"I hadn't seen Raúl for fourteen years when he showed up the other day. Can you imagine that? Think of not seeing your boyfriend for fourteen years. Can anyone stay in love all that time? I came down here to organize his arrival because it was expected of me, I'm still his wife. We never separated, we never talked about divorce, he just put me on a boat to this country and said he was coming too, and never did. He really let me down. I was a kid when I came here. I'd been married such a short time. Of course, I was nuts about him. But it was so damn painful. I just had to give up, after a while. Give up thinking about him, I mean, have other boyfriends, behave like a normal person. Our marriage was over, because he'd decided to stay in Cuba. I'm not saying I didn't love him or he didn't love me. But what's the good, when the fucking ocean lies between you, you're in two different countries not even speaking the same language?" I shook my head. "I'm thirty-four now, not twenty. That's a hell of a big gap. When he contacted my family to say he was going to try and come across, not even they really expected us to go on being married. I just came because we're married, it was going to be a whole lot easier for him from the point of view of immigration and everything if he could say he was married to a U.S. citizen. He has no idea what I've been through since I've been here. Major depression, first, then therapy, just a horrible time. And now I'm out of it. Or I thought I was. It's just not as simple as you seem to think."

I listened to her, and she sounded real to me for the first time. I'd wanted her to be human, and she was.

"Go on."

"What about? Harry? Well, after I realized Raúl probably wasn't going to come, I had a whole bunch of boyfriends, one after the other. Lovers, should I say. Then I realized they were all pale copies of Raúl, whether they were Cuban or not. Then I had a period of no men at all. I was trying to get free of something. I went into therapy. I started my own business, focused on that, or tried to. I really haven't fallen in love with anybody since Raúl. Sex, yes, but not love. He was a hard act to follow. So I guess I stopped trying to follow him. When I met Harry, he was just something else entirely.

He's not anything like Raúl. But I had that same weird feeling, that I'd met him before. I haven't, of course. But it's that feeling, like, something has to come of this. Something. I don't know what. But it matters. Do you understand?"

"But how can you lie to him about something as big as being married?"

"It's just for now. I will tell him. I have to. But I'm afraid he won't understand. Men are so absolute. I don't think he'd understand that Raúl and I aren't married in the way—the way he'd think."

"And you don't think women are? Absolute, I mean."

"No, I don't. Not me, anyway. Maybe you, Martha." She looked at me across the table, then went on sucking her straw. There was nobody in the little café of the pharmacy but us and the woman who sat watching us from behind the counter. Emily said, "I know, I'm asking you to lie too, but not for long, I promise. When Raúl has gone, I will tell him."

"Why when he's gone?"

She felt in her cigarette pack for what looked like her last cigarette. The woman at the counter stared across at us and Emily put it away again. She folded her arms on the tabletop.

"Why when he's gone? Because, then I'll know something I don't know yet. Okay?"

"Okay." The woman came to ask if we wanted anything else. I paid for our drinks and we sat on, with a fly buzzing between us. Outside the afternoon was heavy as matted lint, but in here at least it was cool.

"So what will I say to Harry?"

"Just that I'm busy for a couple of days? Tell him—I'll come on the boat on the weekend."

"Busy."

"Yeah."

"But you're supposed to be madly in love with him."

"Oh, Martha," she said, "grow up. Busy isn't the end of the world. Men say that. They don't always have to explain, do they?"

"Okay, just busy. Do you send your love, or what?"

"Yes, I send my love."

I thought for a moment about not seeing Tom for fourteen years. It was hard to imagine. It was almost half as long as my life to date. We'd be in our forties. What happened to people when there were gaps made in their lives that they had not chosen, couldn't do anything about?

"How are you going to decide?" I asked her. After she'd said "grow up" like that, I felt I didn't have to tiptoe around her feelings either. "Toss the dice, do the I Ching, or what?"

"Hey, are you angry with me? I'd hate you to be angry."

"No," I lied. "It's just complicated, that's all."

She looked hard at me with those green eyes, their whites unmarked by sleeplessness or stress. I wondered again what it was like to live behind a face like that.

"Can I say something else?" She spoke abruptly.

"Well, sure." I couldn't think what else there was to say.

"It's about us. Women. I wonder if you'll understand. You see, I feel like a whore some of the time. That's what it's called, when you have more than one man in your life, isn't it? But the weird thing is, I've never felt so much myself. It's like there's more than one of me, always has been. Between the two of them, I'm kind of free. I'm not being what either of them expects. It's like, having a secret frees you. Does that make any sense to you?"

I thought about it. What she said was a long way from what I wanted to believe about myself, and yet it echoed in me, an unwelcome truth. So long as I didn't tell Tom about dancing with Raúl, I had an area of life in which I was free. It was like a no man's land, this gap between two areas of life. Yes, I knew what she meant. I didn't want to admit it, though, even to her.

"Mm-hmmm. Shall we go?"

We went out into the steaming afternoon. Rain lay in pools still on Simonton and United, and the sky promised more. When would this season end?

I unlocked my bike and set off up United to go home. She set off on foot, back to the house on South Street. As I passed her and waved, I knew I'd refused a confidence, in refusing to give one in

return. I couldn't help it, I told myself. Our upbringings were just so different. I clung on to my sickly morality that afternoon, not naming it as fear, and I let her go on alone.

Emily walked back to the house, making detours around the lakes of dark water on the street. Big drops of water fell from the trees overhanging the sidewalk. The air was still heavy with rain.

"Which one do you love?" Martha's question stayed with her, as if there were an easy answer. It was so American, she thought. This or that. Love or not. What did you call the feeling she had for Raúl, beneath the anger, beneath the sadness, way beneath all that passing time? You could say, oh that's just nostalgia left over from an old marriage. And Harry? Just the excitement of a new affair. You could describe anything like that, and make it sound shabby or ridiculous. She turned to go in through the gates of the house. The dark trees dripped all around it, but out over the sliver of sea a pale light patch was forming in the sky. She felt alone, in a world in which no one could help her.

It was not as if it were yesterday, for all her yesterdays were now American, but as if it had happened in a place where time didn't change or alter anything; only the same events went on, over and over again. Part of her would always be that student, that immature schoolgirl, caught on a sharp intake of breath in a dusty Havana classroom where the professor, Raúl Aguilera, was kissing and touching her after a history class. She was wearing a summer dress. It was close to the end of the summer semester, in her first year as a student. The dress was long, in the fashion of that year, and he pushed it up and held it so that he could touch her. She breathed in chalk and saw dust dance in the sun from the high windows and felt his fingers go inside her. He'd seduced her, and she'd been willing. She wasn't a child any more, or even a virgin. She'd been with Jaime Delgado in his parents' house and with other boys who'd kissed her while dancing and touched her to frenzy out along Havana beaches, she'd done everything she and they knew how to do. But Raúl Aguilera was another matter. He and his friends were

adults, the next generation. They knew what to do, how to say things, how to discuss them. He had chosen her, to kiss and touch that day, and to marry. She couldn't remember having chosen him, because who was she to choose? There was just the inevitable acceptance of him, the man who had appeared out of all Cuba, to love her. In his apartment in Vedado, just a few streets from the university, he had shown her again and again what this meant.

She remembered the drive out of town with him to Varadero in an old Dodge he'd borrowed somehow, the pitted road that ran along close to the shore, the smells of dung and diesel, then the burning odors of the oil fields that had made her hold her nose. She remembered standing on the Matanzas bridge, watching a hawk swoop and carry up some small struggling prey above their heads. She remembered the house in Varadero where he had taken her, that weekend. She'd been picked, chosen from among her classmates, Vera with the amazing bust, Luz who could sing like an angel, Lourdes who was the best in philosophy week after week. She remembered being that young, and that in love. She'd loved this man to pieces, simply because he had decided to love her. She went on with her studies, and he taught her everything he knew. She read Proust, his favorite, and Camus; he gave her Lucasz and Fanon, the prison diaries of Gramsci, he read her all the Cuban poets, Martí and del Casal and his favorite, Guillén; and Shakespeare in the original, Lorca and Artaud, Sappho and Virginia Woolf. And they worked for the revolution, she teaching at school, he continuing at the university. Until he had his first warning, that was, that his tastes were too catholic, his teaching too liberal, his choices suspect. He had smelled something in the wind, she knew it now, whatever he said to disclaim it. And he had gone with her to Mariel, pretending all the time that he too was going to embark for Key West, America, the enemy island only ninety miles across the water.

Fourteen years; and here she was, thirty-four years old, having made other choices, loved other men, being claimed by him as if she were her schoolgirl self, a pretty girl in a summer dress in a classroom on a hot summer afternoon, as if nothing had happened

in between. She was that girl as she was also the child who lay on the rag rug in her grandmother's house in Key West before the great storms came that blew her grandparents away. These selves were present, always would be. But what of her present self? And what could she say to Harry, who was from another place and time in both experience and geography? Long ago, I was a small girl lying on a rug in a house in Key West which would be forever home. Long ago, I was a girl in a classroom learning about the Belgian colonization of Africa, when a professor kissed me. Long ago, I was a solitary young woman on a boat crossing the ocean, believing her husband would follow in a few days. Long ago, I became two people, Cuban and American. It is too late for me to undo that now.

Raúl knew the way to her, as he knew history and philosophy and the streets of Havana. That was the trouble. He could come to her blindfolded, as he could walk from his brother's apartment to her other grandmother's in the Cayo Hueso district in old Havana, without looking to see where he went. And she knew the way to him. With Harry, she would have to find her way through to something difficult, something foreign to both of them. She would be a sailor's woman in Key West. She would really be American. Either way, it seemed to her now, her life would be exile. But at least, with Raúl, they would both know what they were missing and why.

She let herself into the house. Raúl was in the kitchen; she smelled garlic and hot oil, heard the sounds of him moving about. It irritated her that he was here all the time, so that she was never alone. He wouldn't even go out into the yard. It was no good explaining to him that he was safe; the habit of hiding had just become too strong. But she wanted him out of here; how she wanted it, just to be alone, to be free of the pressure, to have time to think. They were crowding her out, all of them, Harry with his messages, Martha with her searching questions, Raúl with his presence. She thought of being on the deck at the Pier House restaurant, just sipping a margarita and watching the schooner go past; that lost moment, when she'd still been able to choose.

One day soon, she would tell him how it really was. She could

not stand herself as a liar, not any more. She thought of Martha, and how she'd gazed at her across the table in that soda place in the middle of the afternoon, saying, "Which do you love?" Martha would not be capable of lying, any more than Harry was. She had the straight gaze of someone who had never had to pretend, to save her skin. It was a luxury, Emily knew now, an American luxury, that easy openness that came from never being threatened. Lucky Martha. Lucky Harry. However they were damaged, they wouldn't lose that.

"*Hola!*" she called, to let him know she was back. He came out of the kitchen, smiling, wiping his hands on a towel. It was like being married.

"*Hola, corazón,*" he said.

IT was my free evening. Tom was working late, and I went to call on Raúl while pretending to myself that I wanted to see Emily. I'll put it down straight like that so that at least now, there isn't any pretense.

"Hey! Marta, come in! Good to see you, *cara.*"

He stood holding the door wide for me to go in.

Tango music was on the tape deck again.

"You see, I play your music! Will you dance, madame?"

Still in my shorts and sandals, I danced the tango with him while the bugs and moths fluttered up against the screens and the ocean muttered at the dock, and the languid air of that summer came in through the open French doors. He was a good dancer, a good teacher. Da-dadada-da, dadada. Up and down, between the dresser and the table, on the narrow space of floor we had cleared. He held me firmly. He was an inch or so taller, and looked down at me, not smiling but serious.

"The *Paso Doble*, you know the *Paso Doble*?"

"No."

He changed the music and we tried a *Paso Doble*. I watched his feet, as he showed me. Then I took his hand again, and we began.

"Marta, you are good, very good!"

"Well, I'm getting better."

We danced in silence.

"I must go to the kitchen, or the rice will be burned."

"It smells great. What are you cooking?"

"*Paella*. So, we will eat, in a minute?"

"Eat? Us? I thought you were cooking for Emily."

"No, *cara*, I am cooking for you and me."

"But I shouldn't stay. How did you know I was coming?"

"Why not? You won't stay? What is wrong? You have other

obligations? I did not know you were coming. I am not, what you say, magician? But now, you are here."

"Yes." I curtsied to him as the music ended, to cover my feeling of confusion. "But I shouldn't stay. I'm engaged."

"Excuse me, but what is the connection? You will be married, you say?"

"Yeah, that's what I said."

"So you cannot have dinner with me? Because I am a man? Is that it?

"Well, Tom might not like it."

"Will he not like it that I teach you to dance?"

"Probably not."

"Then, which is worse, eat or dance?"

"Dance, I guess." I broke away from him and sat down.

"If dance is worse, and you have dance already, then why not eat? He is waiting for you?"

"No, he's at work. He eats at work."

"So you must eat alone."

"Yeah." I thought of making scrambled eggs for myself in the apartment and eating on the bed in front of the TV and its permanent snowstorm of white on black. The *paella* seemed a much better idea.

"Okay, thanks, Raúl, I'd like to eat with you."

"Good, then I open the wine."

Over dinner, he taught me words and phrases of Spanish and told me about the poetry he loved. He told me about a Black poet who wrote about a zoo in Havana. He recited a poem about a papaya in a cage. He made me say *"paella"* over and over, till I had all those strange sounds right. I squashed a juicy shrimp between my teeth and the thought went through my head, quick as a fish escaping, that if I had to choose between Raúl and Harry I'd probably choose Raúl. Harry probably wouldn't teach me anything I didn't know already, except more and better sailing. But Raúl could tell me things I knew nothing about. But of course, there was sex. That must be what was tipping Emily in Harry's direction. And sex with either of them wasn't a topic I wanted to think about.

"You were telling me about Castro, in the mountains," I said to change the subject in my head.

"Of course. First, tell me, you like this?"

"It's wonderful. Just great."

"Also, taste your wine."

I took a big mouthful and felt it go through me the way wine does when you haven't had a drink in months. I thought of a man seducing a whole country to him by the look in his eyes.

"Is he really that extraordinary?"

"Extraordinary, yes, but he is still a man. That means, he can be wrong. This he will never say. So nobody can say it, even a little, in this you are wrong, in that. So then there is silence, and lies."

I thought of Emily when he said this, and her look at me across the formica counter in the pharmacy, which said, be with me, be for me, do what I say.

"Do you think of us as your enemy, really?"

"You know what I think? There is no human enemy. Enemy is only in thought, in ideas, mistakes. We have each of us the enemy inside. It is not other people, it is ourselves. So I cannot say, Americans are enemy. Americans are people. Some bad, some good. You know?"

"Sure," I said, and took another mouthful of the rose-colored strong-tasting wine.

"You are interested in politics?"

"I don't know anything about them really. I guess I'm interested in truth."

"Ah, you are intellectual. Me too. I like to know truth. Truth and politics are not the same."

We were both silent for a moment, in among the shrimp shells and torn-up pieces of bread and fish bones and grains of yellow rice.

"You know, Emilia lies to me. Do you know why?"

I shook my head, glad to have a mouthful of *paella* which let me off having to answer.

"I don't know, either. But women lie when they are afraid. Do you lie, Marta?"

"I try not to. But you know?" I reached for my wine again. "I think she's like Fidel. You just have to go along with her. You have to be on her side, or not at all."

He looked at me and raised his eyebrows and then took a mouthful of his wine and laughed. "Emilia is like Fidel. Ha. Yes, maybe there you say something. Maybe there you are right."

"Tell me more about Cuba. What is Havana like?"

"Ah, *La Habana*. You must go, see for yourself. There are so many things. People are hungry, yes, but the city is beautiful. There is the ballet. You like the ballet? We went often, Emilia and I. Alicia Alonso. She is wonderful. In the Central Park, people sit out in the dark, these days. They don't go anywhere, do anything, there is nothing to eat, to drink, so they sit. And talk. In *La Habana* people talk in the street. You know, when you have less, you talk more? The Central Park is dark at night. And on the roof of the opera building, where is the National Ballet, there are dancers, stone dancers. Many times I have looked at them, these dancers, and I wonder, were they all once angels? Because there are two who have wings. The others do not. Did somebody take them away, the wings? I do not know. Nobody can tell me this. Perhaps, I see wings, nobody else sees wings. I cannot say. But one day, you will go to *La Habana* and you tell me. Do you see wings, Marta? Do you see two dark angels, high on that roof?"

"Didn't you ever ask anybody else if there were wings? There must be either wings, or not."

He didn't answer.

"I'd love to go. But Americans can't go there. At least, people do go from Key West, but I don't think it's legal."

Raúl grinned at me. "You want to go somewhere, you don't wait till somebody say okay, you go. Like me, you get a boat, you go. No? You must go, Marta. To understand. Many Americans go to Cuba now for sex and drink. When prohibition was in America, then Americans were in Cuba to drink. Now also. Cuba is sex and drink, is bad things, for Americans. The shadow, you can say. The other side, what is not allowed. Everything we are not allowed to like is in America. Food, cars, jobs, money. These things people want. Is

hard. We have to choose. We choose, and many drown. Always, our life is divided. Always, we want two. You, in America, you have American dream. Your revolution, what you must want. But it is not enough. Sex is not in the American dream, no?"

"I guess not," I said. I chased rice grains round my plate and felt him watch me.

"So Cuba is bad things, is shameful things, for Americans. Cuba is bad, they say. It is not Fidel. Fidel is nothing. It is you, what shames you. You understand?"

I listened hard, but felt confused. It was new to me. It was through-the-looking-glass land, and I couldn't look away.

"Raúl, I must go home soon. It's getting late."

"I do not make you angry with what I say, Marta?"

"No. No. Not at all. It's just all so unexpected."

"You think deep. You are deep person, Marta."

"Not really." But I liked the notion that he thought so.

"A few minutes. I want to ask you. What did you do before you were a sailor? What was your life?"

"I went to college. I had boyfriends. I always wanted to sail, from some idea I had as a kid. One day I just left my old life in New York State and came down here."

"So you too run from the old life."

"Like most people on this island. Except the ones who were here already, of course."

"And your life now? You marry, you go on sailing? You will have children?"

"I don't know. I guess so." He made it sound like not quite enough.

"You can do everything. Everything you want."

"You make it sound very easy."

"Easy, of course, easy. Like coming here. Like going to Cuba."

"But it must be hard for you."

"Easy, hard, is just an idea. An attitude. When Fidel puts me in jail, okay, is hard. I think, my friend, what you doing to me? I want to get out. I think he makes a mistake."

"You were in jail? What for?"

I watched him light a cigarette and shook my head when he offered me one. He smoked and rubbed pieces of stray tobacco from his lip.

"I disagree, I say something to students he does not like. You know what it is, *maricón*? No? How to say this. I have a student who does not like women, he likes men. Sex with men. This is not good in Cuba. I help this student. Fidel does not like this. So then I am in jail and when I get out, no more teaching. Here in America I think you can disagree, but nobody listens. They don't put you in jail, only if you sleep on the beach. You disagree, nobody listens, nothing happens. They ignore you. Another sort of jail, is all. *Cara*, men are in jail everywhere, jail with bars, jail of their own thoughts, does it matter?"

"And you went on following Castro even after he put you in jail?"

He shrugged. "Like I say, what is jail? And, we are relation, him and me. He is family. He is like myself. You don't stop to love somebody because they make mistake, do something bad to you."

"Don't you?" I stared at him across the debris of our feast. His dark eyes stared straight into mine. He was asking me things I'd never had to think about before. Somebody puts you in jail and you don't hate them? Somebody betrays you with another lover and you don't get angry?

"What is it, Marta?"

"You made me think of a whole lot of things. But I should go, really. Tom will be home, he'll be wondering where I am."

"I do not wish to make you late. *Cara*, this has been a pleasure. You will come again?"

"I don't know." I was wondering where Emily was. With Harry? And if she was, did Raúl know? Was she telling Harry about Raúl? I felt like a spy, with knowledge to trade to both sides.

"It is not bad, you know, to talk. Do you not say, this is free country? Do not feel guilt, Marta. We talk, that is all. We don't dance any more, if you don't want."

"It's not that," I said, standing up to go, feeling in my pocket for

my bike key. I did want, that was the trouble. But I also wanted to
go home to Tom, and be safe.

"Then what?"

"It's what we talk about. It's this feeling, that everything is so
big and important."

"Life is big, important. You will discover. Now go, *cara*, but
come again before I leave, yes?"

"Goodbye, Raúl, thanks for the wonderful dinner."

"Goodbye, girl sailor."

On the corner of Simonton and Olivia, I saw a figure I recognized
and I pulled in to the curb, propping my bike with one foot, just to
say hello.

"Hi, Wanda."

"Hi, Martha! How ya doing?"

"Good. You?"

"Real good. I been writing up a storm. Look!"

She opened the flap of the big satchel she was carrying and
showed me the stash of white paper.

"Hey! Is that all poetry?"

"Yeah. It's hot, I'm telling you. Real sensual. You'll love it. You
wanna buy one? They're only five bucks."

"Don't have five bucks on me, Wanda. Another time, okay? I
like your outfit, hey."

She was wearing a little straw hat on sideways and big dark
glasses like the ones Madonna wears and she had a black silk top
on with her tits showing and a little black skirt and big red plat-
form sandals that made her wobble as she walked. I sometimes met
her out at the Salvation Army shop on Flagler, going through the
one-dollar basket, putting the bits and pieces together that made
up the astonishing outfits she wore. She paid such attention to de-
tail, always. There was always a new hat, or fancy pair of glasses, a
yet sexier pair of shoes.

"You like this? I got it all at the Sally shop. These glasses, you

like these glasses? Italian." She took them off and waved them at me, and I saw she had a black eye.

"Someone hit you, Wanda?"

"Yeah. This guy. The one in the poems. He gets crazy sometimes. How ya doing, Martha? Good to see you. How's Tom? He likes my poems. You know, he bought three books once?"

"He's fine. We're getting married."

"You're getting married! Well, that's wonderful. Congratulations. I'm never going to get married. Did I tell you about the time I got married? You know, if I got married I'd be pregnant immediately. Out to here." She drew a vast circle in the air over her belly.

"Yeah," I said. "Well, I gotta get home. See you later, Wanda. Take care."

"Later," she said, and hitched her breasts up in the black silk, two vast globes carried before her like trophies. She'd shown me photos once, which she'd sent out to editors, in case they wanted her for a centerfold. I thought, if anyone could prize an aging body the way she did hers, good luck to them. I saw her sway on up the street, and then I accelerated past her, waving. She waved back. I thought, maybe if you're nuts enough not to notice, you don't feel lonely. And sex with strange men is like candy, and your thrift store outfits make you a queen, and sleeping on parking lots with a sheaf of five-dollar poetry for a pillow only brings you closer to the stars.

Seeing her always makes me glad I have a home to go to. But her poetry, which Tom does buy when he meets her on the street, has a sad, almost wistful strain to it, in among the fucks and the cums and streams of jism pouring down thighs. Sometimes the police take her in, and she disappears for weeks. Then she's back, walking around town, walking and walking the way homeless people have to, but not as if it's a pain to her. No, she strolls, sashays, minces, rolls, or prances, but never just walks. She is on a permanent catwalk of the imagination, high on poetry and romance. A romantic, sitting down in the gutter to rest. A woman like me, like all of us, making up her life the best she can. I dream of her, sometimes. I guess, in those dreams, she is part of me, a scary player in an unadmitted area of my life.

I biked the couple of blocks of Olivia to our house among the aurelias and spiky palms. I went up the damp outside steps to our door. The blue light of the TV shone through. The cat ran and rubbed herself, wet fur and hectic purring, against my bare legs. Tom was sprawled across the bed and put out a hand to me and went on watching the screen. I lay down beside him. I wanted his hand on me, I rubbed against him like the cat. On the screen people jumped up and down and a blizzard of white fell over them. Tom turned to kiss me briefly.

"Where you been, honey? You smell of garlic. Mmm." He kissed me again, tasting. "Wine."

"Eating Cuban at Emily's place. Tom?

"Yeah?" His hand moved up my thigh, under my shorts. His eyes were on the screen.

"Can we go dancing, sometime?"

"Dancing?"

"Yeah, dancing."

"Well, sure."

He moved over on top of me, as I lay on my stomach still watching the screen. His hands came inside my shorts, feeling their way.

"Dancing, huh?"

His hands on my hips, rocking me.

"Yeah, I'd like that. I saw Wanda on my way home. She says she's got some new poems."

"Well, honey, you have been having an exciting evening." His fingers were in me. I was wet as a swamp, and I wanted him in me, filling me up completely, leaving no room for anything else. I turned over and clasped his broad smooth back under his shirt, felt the muscles tense and his penis swell against me. The TV went on flickering above us as we rolled together across the bed, finding the familiar pathway together, coming together with a shout of joy. Raúl, Wanda, Emily, Harry were all there for me at that moment, cheering me on. I don't know who was there for him.

WHEN she came in, he was clearing away the remains of the dinner.

"You want to eat, *mi amor?* Or you have eaten already?"

"Thanks, I'm not hungry." He never asked her where she had been. She ran her hands through her damp salty hair. She'd eaten with Harry at Schooner Wharf, a plateful of meat and potatoes. It hadn't been easy to leave him and come back here.

"Who came for dinner?" She picked up the second wine glass off the counter.

"Your friend from the boat. Marta. She likes *paella.*"

"So I see. What did she want? Did you invite her?"

"She came to see you. I told her you were out. I was cooking, she was hungry, so—"

"Hmmm."

"She is interested in what happens in Cuba."

"Oh, really."

She walked away from him, across the living room, where the rug had been rolled to one side. She rolled the rug back in place.

"*Cara,*" he said, "I will not go to Miami alone. After so much time we should be together."

"But, Raúl—"

He watched her. She could feel it. He watched her discomfort. "What is it?"

"But I arranged it. And it will be safer, believe me."

"You say yourself that there is no danger now. You tell me, now I am here they can do nothing. If I am still in a boat, yes. But I am now in a house with you, my wife. We have things to talk about. We have to do this for us, Emilia. This should not wait. You telephone, cancel the booking. Or, I simply don't go. But maybe you can cancel, get some money back, I don't know. Then we can travel together."

"My mother is expecting you. Pedro and Luz will look after you."

"I don't need this, *querida*. I am not sick, nor an idiot. I do not come all the way to America to be told what to do, go here, go there, not by my own wife, not by anybody. You understand?"

She said nothing, but frowned and sighed.

He watched her. "There is something else, no? Tell me. What is it? Why do you want me to go?"

"Raúl, I don't want you to go. You're my husband." But it didn't sound right, not the way it should.

"Listen, *cara*, if you don't love me, or you feel you cannot, if too much time has gone, if you look at me and think, who is this old man the sea vomited up, that is all right. But do not lie to me. This is what I have run from, the need to lie, to be silent, to not say what I think. I cannot do this anymore. That is why I leave Cuba. Because I love my country, but she is full of lies. We must not do this, we must not tell each other lies. It is the only thing. It is all that matters. Please. Trust me. Tell me why you want me to go. Are you afraid to have me here? Do you think the *Ministerio del Interior* will come, the police? If that is it, tell me."

"Yes," she said, "I am afraid of that. That is the reason, Raúl."

"If they come, we say we are going to Miami together with papers. You are American citizen, I am your husband, I have been here long time, since before Clinton changes his mind. There is no danger, *cara*, you said this yourself. So, am I to believe you?"

"Yes, believe me." She looked calmly back at him.

She knew he didn't, but that he'd decided not to go on asking.

"So, did you have a nice dinner with Martha? Was that just a social visit?"

"She said she wanted to see you. So, we talked, she asked me about Cuba, I ask her to have dinner. We have dinner. Then she went."

"Hmmm."

"She is an interesting young woman. But, you know, no education. I do not think she knows what is in life, yet. Boats, a boyfriend, playing around in children's clothes. She does not know herself yet, I think."

Emily said, "American women are like that. It's the way they are raised."

"Emilia. You and I, we are not raised this way. You are not an American. You are my flower, my bird, my little cat, you remember?"

"Raúl." She went and stood close to him, her arm around his waist. He was so thin now. Her hand folded across his chest. He turned her to him, his arms went around her, he held her there on the deck while in the darkness outside the insects came and thumped against the glass.

"Come upstairs with me."

"Not now."

"Are you busy?"

"Yes."

"I understand."

He let her go, then. She thought, he does understand, but he is too intelligent to say.

To himself he murmured the lines of another poem of Guillén's.

Si a mí hubieran dicho
que iba a llegar el día....
if anyone had told me
that there would be a day
when we two would not be
more than simply friends,
I wouldn't have believed it....

He walked away from her, out on to the deck from where he could smell the ocean. It was just a dark space between two palm trees, calm as a pond.

Everything had changed. Nothing was the same, day to day. You had to be prepared for it, that was all. And he himself was calm as the water. He saw the upstairs light go on. She moved about upstairs in the house, back and forth. You had simply not to expect anything. Love, if anything, was laying yourself open, and that he had done.

Late that night, she went into his room where he was sleeping. He was lying across the bed, but his eyes were open in the dark. She sat down at his side. She put out a hand to touch his forearm, which felt thin and sinewy.

"Emilia?"

"*Sí*. I have to tell you something."

"We must not tell each other lies."

She saw his open eyes gleam in the dark.

"This isn't a lie, Raúl."

He chuckled in the dark.

"What is it? Why are you laughing?"

"Just thinking. You know, nothing in the end matters very much. I spent all that time waiting, working to be here. Now, I am here. It is the same as there."

"You always were such a philosopher. But philosophy doesn't work."

He propped himself on one elbow and looked at her. "Emilia, if something appears to work or not has nothing to do with its truth."

"Well, the whole world says it. It's like socialism. That's dead as a dodo. And you spent fourteen years trying to pretend it works, instead of being with me. It's like having a husband who's dead. It's like being a widow." She turned her face away. She no longer caressed his arm.

"So, I am dead for you, because I follow something I believe? Tell me, why did you rescue me from the sea? Why not let me drown, or be sent back to Guantánamo?"

"Because I am Cuban and you are my husband and my family expects it of me. You know, it was Pedro and his friends who worked for this? I am just the one who came here to wait. Because I am your wife."

He sighed deeply, reached to take her hand. "That is just philosophy, Emilia. That is just ideas, that you say do not work." But he sat up, and wrapped his arms around her. He stroked her face, her neck. She sat on, in the darkness, close to him. She felt his

resolve. His hand went to her breast, and she didn't move. It moved down the slope of her breast, and she didn't move. It moved down the slope of her breast, inside her shirt, went inside her bra, and found her nipple. He pushed the shirt down, freed the breast from the bra, and began sucking the nipple. She looked down on his dark head. There was the shape of his head and the white glow of her own naked breast. The feeling that began in her grew with such sharpness that she was afraid she might cry out. She was a young girl again, in the lecture room in Havana, with the teacher who came to embrace her and woke such a feeling in her breasts and belly that she had to sink down on the nearest desk. Raúl's tongue circled the nipple and she felt it grow. She closed her eyes, shutting out the present and its complexity, the night sky, the Florida Straits, the ocean that battered at the doors of her mind. She let him go on. He unbuttoned the shirt and took off her bra and grazed on her breasts like an animal in a pasture. Then he pushed her skirt up, felt for her panties, pulled them down to her thighs. First his hand, then his head. He pushed her gently over on the bed. She didn't have to move here, or say anything, or consent or not consent. She let him in, his searching tongue, then his fingers, then his familiar penis, which felt its way home in one movement, like someone who opens the door of his own house and just walks in.

They lay there afterwards, still half dressed, her skirt around her waist, her breasts white in the moonlight, his bony spine in knobs beneath her hand, his penis limp in its snail trail.

"You remember?" he whispered in her ear, and bit the ear lobe.

"*Sí.* Yes, I remember."

"*Mi amor*, you are beautiful, so beautiful." He bit and nuzzled and she laughed and arched to him, to feel his chest and its wiry hair upon her. He licked the nipple that was still sore and erect with his sucking.

"We could have babies. Then somebody else will suck here. Then maybe I will be jealous."

She was silent.

"You still want me to go?"

"Raúl. I want you to go. I will come to you, very soon. Will you trust me?"

"You will come not just because you are Cuban and you are my wife?"

She said, "I don't know why it will be. But I will come."

HEAVY rain had fallen again in the night and the lakes of water that sit so easily on our low-lying island were all in place, wherever there was the slightest dip in the land.

He opened the door to me.

"Marta! You are welcome. Come in."

"I wondered if Emily's home."

"No, she is not. Oh, I thought you come to see me."

I had, but I wasn't going to let him know that.

"I thought you were going to Miami."

"Soon, I go to Miami, yes. Come in, we do not have to talk outside the door, huh?"

I went into the house. The furniture was all back in place, and the rug covering the floor on which we'd danced.

"I make you coffee? Yes?"

"Okay, yes, thanks."

The strong smell of coffee, better even than the smell in the Cuban cafés in town, mixed with the smells of this room, wood, damp, floor-wax, the slightly stuffy smell of furniture that has been unused for too long. Mildew and male sweat. Tobacco and strong coffee. The smells of this place and time.

Raúl turned to speak to me. Milk frothed up in the pan.

"Your fiancé, he knows you come to see me?"

"No. But I didn't come to see you, I came to see Emily."

"Are you afraid, Marta? Why do you lie? You came to see me, I think. No?"

"Okay, I did come to see you. I guess I wanted to say goodbye. I just wanted to see you before you go."

"Why then do you lie? Of what are you afraid?"

"I don't know. I guess it just seems—wrong somehow."

"But you came."

"Well, yes."

"You are afraid of me, *cara?*"

"No."

"Then what? Here, take your cup."

We both moved back into the living room. He sat down in the green director's chair, I in the bamboo rocker. I bumped it to and fro on the wood floor.

"Well, I feel like I'm doing something I shouldn't. It isn't what you think. I mean, that isn't why I wanted to see you."

He looked at me over the edge of his cup, eyebrows raised.

"Why, then?"

"I guess I—I mean, I felt like I was learning something from you. Something I wouldn't learn from anyone else."

"Not just the tango?"

"Not just the tango. No. I want to learn what you know."

"I am a teacher. Or was." He smiled at me.

"Yes, but you have some experience that I don't."

"Of course. Marta—" He leaned forward. "You know, that is I think why I was removed from teaching. Perhaps I know too much. I teach what is not—*como se dice?* on the list."

"On the syllabus? Yes, that's just it."

I wanted to dance with him again, I wanted that whole *paella* dinner over again, with the wine and what we said and the way he looked, and that question, the big one, about to be answered. I looked at him and was close to tears.

"Marta—"

A big tear splashed on my bare knee.

"You can find out for yourself. Open your mind. Read, ask questions. You do not need me to tell you. You know, this I have to say to many students when I leave the university. Ask your own questions. I give you the desire to know, I show you how to ask, now you are alone. But this they can never take from you. It is not mine, *cara.* It is for us all. I give you this," and he reached forward and grasped my hand as if putting something in it. "Now it is yours. You will not stop asking questions. Even if it is dangerous, even if it makes you sick, or die. You will not pretend, *cara?* You will remember, there is another side to everything? Always two. Always two. This, and also that."

I nodded. I slowed the rocker and took my coffee on my lap.

"This, Marta, is how I understand my wife. She is young like you, she has to find out. I cannot tell her. She like you is a woman. You, women, you have to find it yourself. We cannot do it. Old way, old Cuban way, is men tell women everything. But then there is revolution. Not Fidel's revolution, but revolution in the heart. You understand, *cara?* Nothing is simple."

"Thank you, Raúl. You know, it's been extraordinary for me to meet you." It felt like I was making a speech.

"Extraordinary? Maybe. Listen, you are a good woman. Strong, honest. You don't have to tell a lie. You don't have to have shame. You live your whole life, you hear me, not just one small part. *Los Estados Unidos.*" He grinned. "United States, pretend there is just one world. But there is another. Very close, here. There is Cuba. Other side of this water." He gestured behind him, a thumb pointing to the whole ocean, as far as the reef, and the seas beyond it.

"I'd better go now. Thanks for everything. Goodbye, Raúl."

"Goodbye, girl sailor. You won't forget, you dance with an old Cuban *balsero* come out of the sea?"

We hugged like old friends, and I sniffed the sweat, tobacco, and skin smell of him as I buried my cheeks and he held my face between his hands.

"I love you," I said, without meaning to.

"I love you too, girl sailor," he said, and gave me a little push. "Now go!"

THE trouble about trying to tell a story is that things happen when you are not there.

The reason I wasn't around that weekend was that McCall suddenly gave us all the weekend off, on account of the weather and the few customers and the fact that he wanted to go to Vermont. So the *Cat* stayed in dock and we all went our separate ways.

Tom said immediately, "Let's go out on the boat."

"Sure, if the forecast isn't too bad."

"Should be all right on the Gulf side. We can head up into the backcountry. If we get sprinkled on, it won't hurt."

We hadn't had a weekend out in months, so it seemed like a great opportunity. We'd get a pack of frozen squid and go fishing. We'd light up our little stove out there in the wilderness and cook us up a dinner of snapper and yellowtail and feel like royalty. We'd make love with our butts scraping on the hatch cover and look up into the stars.

So that Saturday we were out on Cow Key channel by mid-afternoon, with provisions for a couple nights afloat and bailers for our water-logged boat.

Tom said, as we were bailing with our cut-out milk bottles, "Hey, guess who I saw this morning when I was at the store?"

"Can't guess. Who?"

"That little guy, Bud, the one that was with Jimmy."

"I saw him yesterday too, on Olivia."

"You know what he told me? You know we wondered where this boat had been?"

"Yeah?" I sat back, pushed back my sweaty hair, and took a mouthful of soda from the bottle.

"Bud said Jimmy told him he was paid to go pick up some Cuban guy, off a boat or raft or something. He said the woman gave him five hundred bucks to go get her husband, or boyfriend, or

whoever he was. Jimmy brought him in, dumped him on some private beach in Key West, then brought the boat back out here. He can't have anchored very well, or she wouldn't have been drifting. But my guess is that by that time he'd started in pissing away the five hundred bucks."

I thought about it. "I wonder why he left his Social Security card on board?"

"Probably just too drunk to notice. Bud's been in jail. They threw him in for a couple of weeks, he just got out. Said he saw Jimmy just before Jimmy left town. He's hightailed it back to Missouri, to try to impress his woman with the remains of the money, I guess."

Tom started up the motor and I steered out of the channel between the leaning marker posts, out to where the current would take you to Cuba. Once we were out at sea I turned the boat and we headed up towards Boca Chica. Tom wanted to swing by to see a friend, a guy named Ben who lived on a series of boats all moored up that way. The afternoon was warm and sticky and the sky was trying for patches of blue, and there didn't seem much chance of a storm. Tom sat on one of the bunks listening to the crackling weather forecast on the little radio. Seas outside the reef four to six. There wasn't any chop worth mentioning where we were now. I watched for shallows, and we slopped along over little waves. The way in and out of Boca Chica Bay is a tricky little pathway between shallows, and the tide was going down, so Tom perched up on the bow directing me and I steered with all my attention. When Ben came up alongside suddenly in his little skiff, he surprised both of us. But Ben in these waters is like a monkey in a tree, just happily swinging about. He used to be a shrimper and now is a sponger for a living. He's out in his little skiff with the ten-horse motor on the back most days, picking sponges off the bottom. Then he beats them with a bat to get the muck off, dries them, and sells them in the market. He gave me one, once, and when I wash my face with it, it's like washing with soft moss. No wonder they pay such a price for them in Europe. He just gets a dollar or two per sponge.

"Hey, stranger!" he hollered at Tom, standing there in his little boat. He's skinny as a kid, with tufts of blond-gray hair and sea-colored eyes. He reminds me of Ben Gunn in *Treasure Island*, which was one of my favorite books when I was young. That, and the name.

"Hi, Ben."

Tom scrambled down and they exchanged cigarettes and circled around each other a bit warily, the way men do.

"Looks like you could do with a bit of repair work there."

"Yeah, somebody took my boat to Cuba. Must've bumped into something on the way."

He signed to me to kill the engine and we rocked there in sudden silence. I took a mouthful from the ginger ale again, and passed it over.

"Going somewhere, Ben?"

"I was just getting going when I saw you guys, so I came across to say hi. Wanna come by the beach out there and see some sponges? I've got a bunch of them. Ever seen the patch coral out there, Tom?"

"Out where?"

"Between here and the point. Just out from the wreck. It's a pretty one. If you got snorkels on board, you can take a look."

The miniature reef was indeed a pretty one. Ben put out his red-and-white diver's flag, we both anchored, and all three of us went down. For an hour we floated, lying upon the surface of the water, looking down into the dreamworld of a coral reef. I lost sight of the others and was off into a place that is a state of mind as well as reality. It's like flying slowly above great waving forests, among fish colored like parrots, and it's silent and utterly mysterious. When the sun broke through the cloud, it sent shafts into this underworld and lit the depths. I hung there, hardly moving. Below me a school of yellowtail turned and flowed away. A pale mauve jellyfish floated, gently pulsing. The heads of coral were like the thunder-clouds, roundheaded, massive, and I floated above them like someone flying above mountains in a balloon of silence.

When I came up, spluttered a bit of sea water, and looked around for our boat, I saw Ben's finned feet waving in the air and then Tom's bare pink soles. They were both diving. The two boats bounced gently on the water. I'd forgotten everything that happened on land, or even on the surface of the water. I heaved myself into the boat for a rest. Cloud was beginning to build on the northern horizon and the breeze was up a little. The surface of the water was suddenly dark.

Ben came up with his harpoon and a fish that twitched at the end of it, a dogfish he said, and tipped it onto our deck. I picked up its hard slippery body and put it in the bucket. It had goldish stripes and pink quills on its back, and its eye was already turning white. It looked bony, but would do for a start to our dinner.

Ben was off next to get sponges, closer in to shore.

"But hey, there's one thing I want to show you before you go." He uncorked a bottle and jerked his engine into life and swirled around over the surface of the reef, scattering oil from the bottle that formed golden beads on the surface of the water.

"D'you know this one? Old sponger's trick. Look. Look at the reef now."

We circled, the engine idling, and looked. Where the water had been dark, now there was complete clarity. We looked down into the naked reef.

"It's how we see where sponges are. You want to clear the water, you just pour oil on it. Ordinary vegetable oil. It's legal, it's cheap. And there you are. Good as a glass-bottomed boat."

We said goodbye to Ben and he went off to scour the shallows closer to the long beach for sponges. I know, everyone's heard of pouring oil on troubled waters, but it was the first time I'd seen it.

"If you want to see clear, pour oil on it," Ben said. I was thinking about this as I steered our little boat on, up the Atlantic side and then through the twists and shallows that lay round the point, and into Shark Key channel. We headed towards the sun. There's a highway bridge over the water that you go under, and you're out on the other side, the Gulf side, going west. This is where the man-

grove islands and the wilderness of the backcountry lie. You have to watch the surface of the water all the time, read the ripples and the changes of color and the flatness of the water to see where the shallow places are. At low tide, the water simply pulls back into its channels and leaves whole plains of shining mud, weed, clam-banks, skid-marks where boats came to grief. It's another world, not the underwater world of the reef, not the daytime world of water surfaces and journeys; a secret, only uncovered at low tide, a place that is neither land nor water, but both. It's the earth at its most naked, most vulnerable, and you can't walk on it, or you'd sink, and if you're stuck there in a boat you just have to wait for the tide to come and unstick you. But there's a kindness to it. The water is warm and shallow, a nursery water, a tender breeding ground. It's the very edge of the Gulf of Mexico. The tides from far out just reach their fingers in here and cover it up discreetly, twice a day.

"Behind that island," Tom said. "Bear right. We'll anchor a little ways offshore, far enough from the bugs, close enough in to get some shelter if a storm blows up. I don't like the look of that cloud bank."

He dropped anchor in a quiet dark green channel that would be our boat's berth for the night. The bow turned immediately into the channel and we caught our breath in the silence after the en-gine died. There was a heron fishing at the edge of the island, walk-ing in the shallow water like a very old man. Small silver fish were jumping far out and skimming vertically along the surface. It was a quiet world.

I lay on my side to rest in the V-berth and heard the slap of the water at the boat's sides. My body was tired, after all that swim-ming. I thought about what Ben had said. "If you want to see clear, pour oil on the water."

When I went outside, Tom was setting our second anchor.
"We don't want to find ourselves in Mexico."
A thick black cloud came up behind us, from the Atlantic side. It was taking over the sky. The water began knocking against the

sides of the boat. The thin water of the backcountry was green as glass, far out beyond the islands, and close to us it was turning black and slapping up in little crests.

"It'll be worse on the Atlantic side," Tom said. "At least we have some cover here. Okay, let's eat. It's traveling at around ten knots, I'd say, so we've got time."

I opened a can of beans and he lit the stove with his lighter. We sat eating with two spoons out of the same bowl, while the storm came up out of the south and spread like spilt ink across the sky. By the time we'd finished eating, the darkness was complete.

THEY stood just inside the house, waiting for the cab to take them to the airport. If anybody saw them, it would look more normal, a woman seeing off a man to Miami, than a skinny-looking Cuban traveling alone.

"I love you. Love," Raúl said, "in the Cuban way. With respect, honor, as well as feelings. I don't know what it is, the American way of love."

She didn't answer. She simply took his hand and pressed it.

Then the taxi came, a yellow streak suddenly there in the street outside.

"Your bag!"

She had given him a bag, with a change of clothes in it, men's clothes she had bought in one of the stores in town. People didn't travel without a bag. With it, and wearing a clean shirt and jeans, he did look more normal. She'd bought him sunglasses too, so that nobody would be able to see what was in his eyes. It wasn't American, what you could see in his eyes. The ticket was in the name of Aguilera. Nobody would ask him anything at this tiny airport, and at Miami, nobody would be paying attention to a few passengers stepping off the little planes that came up from Key West. People thought Cubans were surging and rioting through the streets, not buying plane tickets.

Emily sat beside him in the back of the car, her hand still in his. She noticed a car parked a little farther down the street, as the taxi turned and headed back up South Street. The car was a dark red Oldsmobile and for some reason it was familiar. There was a man in it, but she only caught sight of him in passing, looking down as if at his knees, or at something on his knees. Oh, yes, it was the realtor who'd shown her the house. Raúl squeezed her hand, caressed it, and let it go. It lay on the seat between them. She didn't take it right away. He didn't touch her again. It was the way his life

was. He had no particular expectations, his silence was telling her. She thought of things to say, and didn't say them. It was the silence between them, after what had already been said and done, that made her free.

Rob noticed the cab turning in the street. Someone was in a hurry. He'd been looking through his papers, his briefcase open on his knee. He needed to firm up with the woman who'd rented the place if she wanted another week or not, before putting it back on the market for the owners, who were up in Massachusetts for the summer. It was weird how she never answered the phone. Perhaps he should get it checked, maybe it wasn't ringing. He was about to open the car door when the yellow cab came by so close that he'd have hit it if he'd opened his door at all. Damn cab drivers. Then he saw them pass, the de Soto woman and a man, both sitting in back. He had to look past the man to see her. The man turned his face just slightly, noticing how close the cab driver had come to the parked car. He had a thin dark face and was wearing dark glasses and a white open-necked shirt. Was he her husband? Funny, she'd never said anything about a husband. But there they were, leaving in a cab. The windows of the house weren't all closed so they must be meaning to come back. He'd have to swing by again later. He'd been going to tell her that he'd dreamed about her last night, he who never dreamed, and certainly not about his clients. What the hell did that mean, dreaming about somebody you hardly knew? Now, seeing the man with her and remembering the embarrassing hard-on he'd had that day when he was driving her around, he was glad he hadn't had the chance. What was it to do with her, anyway? She'd have thought he was crazy. And she had a husband, maybe.

Rob turned on his engine again and drove past the Southernmost Point where the sign was, CUBA 90 MILES, and headed back up Whitehead and then Angela, to get back to work. The town seemed empty. Where was everybody? Maybe it was the rain, or the Cubans, that kept them away.

The little cigar-shaped plane left the runway and rose over the saltponds. Emily turned away from the wire fence where she'd been watching it. She felt suddenly exhausted. It was done, it was over. But she also felt an ache in her throat.

He'd pulled her to him quickly and then put his bag on the conveyor belt and gone through into the little waiting room where the fans churned and people sat on hard benches waiting for their flights to be called. The Comair flight to Miami was already called. The doors were open to the hot asphalt. She'd watched the little file of passengers walk out, fanning themselves with newspapers or hats, and the first ones go up the steps into the plane. She watched him walk out there, one in a small line of passengers. Then she went out alone into the broiling humidity of the day and stood at the wire fence until the plane took off.

She felt it then, the exhaustion. She walked towards a waiting cab, a pink one this time, and got into the air-conditioned cool that turned her sweat cold.

"I'm going to South Street."

"Been somewhere nice?"

"Just seeing somebody off."

"Ah, that's why you don't have any bags. I'd make a good detective, huh? You live here? Been here long?"

"No, I'm on vacation."

"Most people come here on vacation in winter. Summer's too hot for them. The heat doesn't bother you? Some people take it better than others. I'm used to it. I've been here all my life, on and off. Yeah, I'm a Conch. This place ain't what it used to be. Then what place is? You have to have change. Life ain't life without change. You understand what I'm saying? They say the weather's gonna change. There's a front coming in again, that's what they say."

Emily answered in one-word answers and longed for the silence and welcome of her house. She wanted to take off her soaked clothes and take a long cold shower. Then she'd sit down with an iced tea. Then she'd sleep. When she was clean and refreshed, she'd think about what she was going to do tonight.

"Here, this is it."

"Right here? Great house. Rental property, is it? Guess you have a nice beach. Private, I'd guess. You don't get much privacy round here, these days. Everywhere's too goddamn full. How you go on fitting more and more people onto an island this size, that's what I want to know."

He parked outside and she gave him a ten-dollar bill and didn't wait for the change. She walked quickly away up the drive and across the thin grass. For the first time, she felt observed. But she was tired. Probably it was just that. There was nothing now to spy on, nothing to discover. But now that she was over the need for secrecy, she felt vulnerable, as if something far more dangerous than even Raúl's presence was going to be found out. She felt the cab driver watch her go into the house. He was nothing, he talked out of habit, he just asked questions for something to do. But she closed all the storm shutters and locked the front door behind her.

Inside the house, she walked around removing all signs of Raúl. She put his torn, water-stained shirt and shorts in a black plastic bag and placed it in the garage. She emptied the ashtrays and stripped the sheets from the bed and put them in the washer. She rinsed the plates they'd used and ran water into the two coffee cups in the sink. He'd come here with nothing except the clothes he wore and a pair of sandals made of old car tires. Cuban shoes, she thought, stuffing them wrapped in newspaper into the garbage.

He'd lost everything. He'd come like a newborn into the United States, a place where if a man carried no luggage and owned nothing, he was immediately suspect. Here, homeless people were not even allowed to sleep on the beaches. A person without property was hardly even a person.

She thought of Raúl, on his way. Then she thought of Harry, and remembered that she had asked him to call her this afternoon. Harry was another man who had nothing. He owned few clothes and stripped them off easily in front of her. She thought of him naked, the places his skin changed color, the smell of him, his hands.

She stood under the cooling jets of the shower, turning herself round and round, letting the water run right through her hair and plaster it to her head. Then she wrapped herself in a towel and went through the house. She made wet footprints on the dark wooden floor. She took iced tea from the refrigerator and sat in the rocker sipping it. She lit a cigarette. The room stilled around her. She was in her grandmother's house. Everything about the island and about her life had changed, yet this same chair rocked bumpily to and fro on the same wood floor, and the view out through the seagrape trees to the line of the ocean was the same. In her grandparents' time, it had been easy enough to go to and from Cuba. You simply went down to the Bight and got on a boat, having traveled there on a train from Miami. You docked in Havana. Or later, there was a little plane that went to and fro. You went to Cuba the same way you went to the Bahamas, or came here. There were even day trips. These places were simply islands in the same Caribbean sea.

When she'd gone back from Nassau to live with her other grandmother in Havana and go to school there, it had seemed like a normal thing to do. Mamacita was not well, she was an old lady alone, she would welcome having her granddaughter there to do errands, help with housework, and keep her company. It was not the end of the world, then. She would help Mamacita, go to school, perhaps go on to university. Pedro was sent to stay with cousins in Miami and go to high school there. Why? When you were young, arrangements made by parents seemed ordinary, even necessary. She'd gone through that door like a person in a fairy tale and it had closed behind her. Who had decided for her? Her parents, one government or another, who?

It's not surprising that I find it hard to make decisions, she thought. All my decisions here have been made for me, by people out of sight.

Five years in *La Habana*, at school and at university, and she had become a new person in the era when everybody, everything, was being made new. When she met Raúl, she was already in love, with a society that was the best one anywhere in the world, in which women's lives—her own, others'—would really be lived without

limits. Raúl was liberation, sex, and freedom. All her education had been leading her to him. Her cry as she lay in his arms that day in the dusty classroom, and those other days in the Vedado apartment, was one of triumph, joy that they had been right. He made her into the adult she had been longing to be.

Then there was the deception of Mariel. Her deportation, as she had come to see it. In which he and her parents had colluded to move her from there to here, never to return. The illusion of freedom and choice: what could she have done otherwise? Mamacita had died, she was alone in the Cayo Hueso apartment, when the soldiers came to the door and told her to leave. Her husband would be joining her, they said. Once again, her life had no value because it turned on a lie, it was light, light as garbage, to be blown back and forth at the whim of others. The yellow buses turned in the square, and she was on one, and then on a quayside, on a boat leaving harbor, and the people she had loved most in the world had lied to her. She was truly alone.

She would like to see Havana again, walk in the breeze at sunset up the Malecon, drink coffee out in the street as they had in the old days, and hear the salsa bands. It would all have changed; and yet the structures of places never changed, any more than the bone structure of people did. The old grand houses, the palaces, the narrow streets, that must all be there. Raúl said you couldn't get paint or anything to do house repairs, so it was all crumbling slowly, but the bones of the city were there. Like his bones, which you could now see through the flesh. Maybe muscle dropped off a man as he lost hope and direction. His classes, he'd told her, had been taken away from him and given first to a Russian, then to a much younger Party man after the Russians had gone. For the last couple of years he'd cleaned up slops in a hospital and wheeled the trolleys to and fro, carrying bodies both alive and dead.

She stubbed out her cigarette and watched the ceiling fan above her and the way it sliced the filtered light.

Then the phone rang.

"Yes," she said. "Come."

Harry was short on the phone, calling from the booth. He

sounded tired and relieved. She listened to his voice and imagined him standing there, leaning on the counter, with the ship moored behind him, moving against the dock.

"See you later."

"Later."

She dressed in shorts and a tank top and didn't put on any make-up, for once. There was time for everything now, maybe even time to be herself.

SHE opened the door to him and felt immediately afraid. But he came in smiling and only slightly hesitant and put his arms around her just inside the doors to the terrace. She was standing in her bathing suit, still wet from her swim. She stepped back from him and shook back her wet hair.

"I'm all wet!"

"Doesn't matter, you'll cool me off."

He was wearing clean khaki shorts and a white shirt and his sun-reddened blond skin was so warm under her cooled touch, and he always smelled as if he had been slightly baked, like sourdough bread. Once you have sniffed up the smell of somebody with pleasure, she thought, you've had it. It'll always be there. She wound a towel around herself.

"D'you want to swim?"

"No. I don't like it. I can't."

"Can't swim?"

"It's an old sailor's tradition."

"But isn't that dangerous?"

"Less dangerous than being able to, some say."

"Want a drink, then?"

"Sure. Just some soda pop."

"How've you been?"

He had noticed something, she saw. He was a little more wary than usual. There were lines drawn down his tanned cheeks, nose to mouth.

"Well, I missed you."

"I'm sorry. I missed you too."

"What happened? I don't get it."

"D'you think you have a right to know?"

"I don't think rights come into it. But it felt like you shut the door in my face."

She said gently, "I had something to see to. I couldn't tell you. Really. I am sorry. It wasn't anything to do with you."

Harry sat down on a green director's chair that sagged under him. He said, "Okay, forget it. What about now?"

"Now's fine. We could go out for dinner, if you want. Or stay here. Now, I'm free. For the next few days, at least."

"Then what?"

"Then I'll have to leave."

"I don't want you to leave."

"But I have to leave sometime."

"Why?"

She stood by him and tangled her fingers in his hair, but he moved his head away.

"Harry."

"Don't jerk me around. Okay?"

"I'm not, really."

"Okay, if you say so. Hey. Let's go upstairs."

He got up and she led the way. He undid her wet bikini top and held both her damp cool breasts in his hands. He pushed down the bottom and buried his face in wet moss. He turned her and pressed against the curve of her buttocks, which felt like cool uncooked mounds of dough. It was no solution, he knew, but at least if he was in her he would not feel excluded. He took off his clothes quickly, threw them away from him, pushed her down on the bed. She lay under his hot body and felt him come in and the big wave that she couldn't stop come fast and carry her with it so that she screamed into its depths. He lay heavy on her tasting the salt on her skin. He gathered himself together so that her hands felt all the strength focused in his lower spine, and he poured himself into her. As they lay together, he felt the small tremors go on shaking them. He was locked into her, her legs tight about him. He felt every little clenching muscle beneath and around him. Then he felt the pain in his chest, and gasped and pushed away from her, to be free.

"I've had an idea. Hey, I want you to come out with me."

"Out?"

"On the water. It'd be better than being here. It's great, the backcountry, the islands. I asked a friend, he said I could borrow his boat. It's in Garrison Bight Marina. We can go today."

They lay diagonally across the wide bed, with only a slight breeze coming in from the ocean, and the mosquitoes fumbling up against the screens.

"Now?" she said. "D'you mean now?"

"Sure."

"I guess we'd get more air out there."

"Have you been out boating at all? Apart from on the *Cat*, I mean."

"Yeah. But not lately." She thought of telling him that her last boat trip had been from Mariel, but decided not to. The habit of secrecy grew on you. It became easier not to tell.

"How about it?"

"Okay."

"Great. We'll do an evening run, stay out real late. You'll love it. The moon's coming up to full. At full moon you can watch the sun go down and the moon come up at the same time, did you know that?"

His hand moved over her body and he thought how human bodies were like the tides and the moon too, you watched them wax and wane, come and go, you had to be there at the right moment, pay attention to tide and current, like at sea. He'd never had sex like this before, with a woman who just effortlessly let go. It was closer to good sailing than to the kind of fumbling, pushing, and apologizing that had come his way before. He felt gratitude spread through him. He was relaxed now; the pain had gone, thank God. She seemed to have noticed nothing. He didn't want her to notice, or there'd be talk of doctors and money. It was his secret, one he lived with in the dark place in his mind which was the opposite of being with her.

Downstairs, they collected together the things they would need.

"Bring a towel. Do you have a rain cape? It might rain. We can get some provisions on the way. Or have you got some stuff here?"

"Harry," she said, "I have something I must tell you."

"Tell me on the boat. We'll have time to talk about everything we want. Right now I'm in provisioning mode, I'm being a good quartermaster, thinking about stores."

He was as busy and happy as a boy, going through the kitchen in a house that wasn't his, picking up what they might need. In the kitchen closet there were a can opener, plastic beakers, a couple of plates.

"Can we take all these?" he called back to her. "We can get some subs on the way too, and some chips."

He bent to pick up the garbage to take it out, so that the place wouldn't start to stink in their absence, and saw an unfamiliar cigarette pack, in among the coffee grounds. He picked it out. It was wet and squashed and held two bent unfiltered cigarettes made of loosely packed black tobacco. It had been ripped open at just one end, so that you could push out two cigarettes at a time at the most. It was blue and had something written on it in Spanish, and there was one word there he did understand, which was *Habana*. He put it in his pants pocket, after sniffing the wet tobacco. He didn't like the action, it felt like acting like a spy, but it seemed to be part of what was going on.

TOM and I were both naked on deck, watching the storm come. First it was thick on all horizons, the sky right above still clear. But the wind had swung round to the north and was pushing the thick blackness down on us. Lightning ran about the sky, little quick flickers, just a hint, here, there, then all around, like fire catching on straw. Tom had both anchors down, one on each side, so that we were braced in the middle, our nose to the wind. He'd rolled the big tarp we use as an awning, so that it no longer flapped. He was making the boat shipshape, tidying everything away. I went back into the cabin and tucked away everything that was loose or might break. I put on my swimsuit, as being naked in a storm makes me feel too vulnerable. Tom put on his shorts, perhaps for the same reason. We'd battened down the hatches, when the first big fork of lightning split the sky right across. Thunder followed—not the vague rumblings we'd been hearing for the last half hour or so, but the crack that sounds like the whole world's being split apart like an egg. I jumped and Tom laughed.

"Still gets to you, doesn't it?"

He says he enjoys storms, now that he's learned not to run from them but prepare for them. He stood there like a Viking with his curly hair on end, letting the first rain sluice his body. I can't help my jumping, shaking reflex; it's like the electricity has gotten inside of me and is making me jerk like a doll. I held on to the side of the boat to steady myself. Then it came again, the zigzag mapping of the sky with lightning, the blue electric bolt that rips me and the world across. The crack of thunder, nearer and louder.

Tom whispered, "Jesus, it's coming right across this time." There was no way we could have run for it anyway, we were too far from any harbor. The best thing was to hang in there, trust our anchors, and be thankful for the protection of small black mangrove islands from the churning water of the Gulf.

"Tom—"

"What is it, baby?"

"I dunno." But I wanted him to hold me. I thrust myself at his chest, to hide my head in him, and felt his arms go round me. I couldn't help it. Even after working all this time at sea, I was still afraid. I'm scared of it. Maybe that's why I go out on it night after night, I don't know. Maybe I'm just testing it all the time, to see if there's really anything to be scared of. Most of the time I'm quite a tough cookie. I don't whimper and expect men to look after me, never have. But sometimes, just sometimes, this old fear comes flooding in and gets me, and this time was one of them. There was just Tom and me out here on our small boat in all this blackness, and it felt like the whole universe was a battle scene, and darkness taking over the earth.

"It's okay, we'll be okay. We'll just wait it out. It'll pass. Have some chocolate."

He divided a soft warm Hershey bar with almonds in half, and we ate it like it was communion wafers. It can't be easy to be a guy and not be allowed that luxury, a moment's weakness, sudden tears, and being held close to somebody larger's chest. I shook my head, to get the electrical buzzing out of it.

"How long d'you think it'll be?"

"I dunno. Let's hope it's a quick one. Oh-oh. Here it comes."

There was that feeling, like going down in an elevator, that comes before the full force of a storm. The temperature drops, you can feel it. A powerful wind began slapping our little boat sideways so that she writhed between the two anchors like someone tied down by both hands. The water rose from one minute to the next. This must be what giving birth is like: there's no way out but through. Lightning ripped the sky again, a long vertical tear, and the next crack was loud overhead and only seconds in between. It was over us. The whole world was made of black water, churning above and below. It was all around us. The boat leapt and heaved.

"Let's go inside," Tom said.

We hunkered down in the little cabin. I was shivering, though it wasn't cold. It felt like the lightning had moved inside my brain

and I kept seeing it ripping down the sky even when it wasn't happening. Then we heard the hard rain on the cabin roof. Tom lit a cigarette and I wished I still smoked.

"I guess we could tell the stories of our lives again," he said.

The whole beauty and reward of the universe to me then was the fact that you didn't have to be alone in it. His big solid body, his hands and voice and jokes and even cigarette smoke came between me and it. I wasn't alone, whatever happened. Even if we drowned. I wondered then if I ever did the same thing for him, against whatever scared him most. We're all taught these days that you shouldn't expect this of anyone. We're supposed to be independent creatures. But if you live where everything gets so mixed up all the time, water and earth and sky, if you spend all your time looking at the place where two vast bodies of water meet, I think you quickly get the notion that this isn't true at all. We're not self-sufficient, not really. It's a pretense you can go for in cities, perhaps. But when the power goes and there's no drinking water or food and the structures around you start splitting like firewood, then you know. On a big boat like the *Cat*, you're crew. On land, when the chips are down, you're family. And when you're out in the middle of a whirling black universe that may put out your lights for the last time, the way Tom and I were that night, you're everything to each other, and you don't pretend.

I have a strange reflex that takes hold of me sometimes: I fall asleep when I'm scared. It seems incredible that I did it then, but Tom told me I did, I just was out of it, talking to him one minute, dead asleep the next. He sat there writing in the ship's log, he said, and every now and then went out into the storm to test the anchor lines. The boat was heroic, he said. She was battered and slapped around, and he had to bail gallons of water out of the bilge, but she held. When the sky cleared, he said, it was beautiful. The whole world had been scrubbed clean and was starting again. He told me he looked at me sleeping and half wanted to wake me, to see it. But the other half of him wanted to see it alone. He stayed awake the whole night and when dawn came, it showed him what he needed:

a world stripped of excesses and pretense, a world he could live in, and he saw it as it all really was, like when Ben poured that oil on the water. Clear, naked, visible, whole. He told me this over coffee, later on that morning of the new day. He'd dried the soaked stove and wiped away the loose wet rust, and set our little coffee pot on the fragile flame. The sound and smell of the coffee woke me. I pushed the cabin door ajar and looked out. The whole world seemed to be steaming, and the water was flat. Tom, naked again with his wet shorts hanging on the wheel, kneeled to keep the flame alight, and the dark brown coffee spurted and choked in the pot.

"Hi," I said, "I love you."

"Just because I make good coffee."

"That's only one reason."

"Then maybe we should get married."

"We are married," I said.

"You are amazing," he said. "Sleeping right through all that. How do you do it?"

"I don't know. I guess it just knocked me out. Being scared made me exhausted. But I dreamed. Can I tell you my dream?"

Dream-telling is something we do often in the mornings, but that particular morning it felt urgent to me. I wanted his help. Something was happening, or had happened, that was too big for me. I'd been somebody else, in my dream, and that somebody was in pain, and had then gone numb.

He poured the dark coffee and stirred dried milk into it and then a blob of honey. We clinked mugs, without saying what the toast was to. It was to having survived.

"Great little boat, isn't she? Going through hell and high water like that. We should drink a toast to her."

We clinked, and drank to our boat.

"Well, then, what did you dream?"

"I think I was drowning. You know that thing about your life flashing before your eyes before you drown? Well, it did. Only it wasn't my life, it was somebody else's. I was remembering a house

with a seagrape tree growing outside it, and a beach with a shaky little dock, and an old man and woman in it. A rocker, with an old woman in it. I was running in from the outside. Then I was on a boat. Not this one, but a boat with a whole bunch of other people. We were trying to get somewhere. I kept looking around me, for my husband. I was married, but it wasn't you. But it wasn't me, either. It really wasn't. I think the people around me were talking Spanish. I was very, very scared because the man I was married to wasn't there, and I was afraid that the whole boat would go down and we would drown. We were arriving somewhere, and I think it was Key West. Again, there was a whole bunch of other people. We were all waiting. I hadn't drowned. But then later in the dream, I was going down into deep water, I couldn't breathe, and I realized that all the rest was just a kind of flashback, it was my life going past in front of my eyes. I knew I was going to die. And still my husband wasn't there, he was waiting for me somewhere, and I'd never be able to get to him now. Oh, Tom."

"It was just a dream," he said. But I could tell he was thinking about it. "Who do you think you were?"

"I don't know. I was a child and then a young woman then somebody about my age, and I'd had a whole life, but I wasn't with the person I needed to be with, and I was dying before I got to him, that was what was so terrible."

I began to feel tears pressing again and sniffed into my coffee mug. "I'm sorry to be such a mess."

Normally I'm a pretty calm sort of person, with my English ancestors all urging me into sensible behavior, and he knows this. But that morning I felt like someone else, and it scared me. Yet the feeling of loss wasn't new. I had a twin sister, and she died when we were both very young, so the feeling of having lost someone has been there a long time. I remember when they told me Marie had died. She'd been a long time in the hospital, so I'd been waiting and waiting for her to come home. I was three, before I knew I was alone.

Tom said, "Well, we've got some work to do here. So when we've had coffee, you can sweep up all these mangrove twigs and

give the deck a good wash. Oh, and look, there's more bailing. I'll take a look at the motor."

He was good at insisting on reality, turning me away from the nighttime spookiness of dream. But as I swept and sponged and bailed, I still went on thinking about the woman I had been in the dream and wondered if somewhere she lived inside me and always had.

Later in the morning, when we'd cleaned up and everything was sparkling in the new sun, we sat down on deck again and broke out the plantain chips and soda.

"Your dream," Tom said, "sounds like the Mariel boatlift."

"Do you remember it? What year was that?"

"1980, wasn't it? I think so. Yeah. I remember standing down on the dock at Truman Annex, which was still a Navy base then, and watching the boats come in. There were boats chartered from all over Florida. Some of them were pulled out of the water with a crane and dumped on the dock. People stayed overnight at Truman Annex and then were taken out to the submarine base first, then bused to the detention center at Krome, in the Everglades. There was all this stuff in the paper about thousands of Cubans, invasions, floods of them overwhelming the town, but really, we hardly saw them, they were shipped out so fast."

"Like this time."

"Yeah, except then they were American boats."

"It must have felt the same to them, this time, the Cubans I mean. Just as scary. Or more so, because they were mostly in such shaky boats."

"It's kind of hard to imagine, isn't it, just leaving everything behind and getting into a leaky boat or onto a raft and just setting out. What do you think makes people do it? Can it really be that bad, what they're leaving behind? Do they do it because of the American dream shit? Do they really think it's going to be nirvana over here?"

"Maybe every now and then humans have to migrate, like birds do. I mean, everybody who's here already did that at some time. All

our ancestors, I mean. Yours and mine. Think of all those refugees coming across, from the *Mayflower* on. Seasick, hungry, scared to death. It's not surprising we dream about it still. Maybe it's part of being American. It's like dreaming about your own birth."

I felt better, having said this to him. It felt less like I'd gone crazy, more as if I'd tapped into some common experience, that night. We were all of us shit-scared of drowning, of going down, out of sight, before we ever reached the promised land. Even recent immigrants, who'd come in planes, like me.

We tugged up our two slime-covered, mud-weighted anchors after that and Tom pulled the motor into life, and we set off on our journey west, out towards the Snipe Keys, to dry everything out in that new day's sun.

"THERE'S nobody else in sight. Not a single boat, as far as I can see."

"Shit. Well, we'll just have to keep trying."

Harry stood in the stern of the boat and pulled at the engine again and again but nothing kicked it into life. Christ, he should have checked with Bob that the fucking motor was working. Goddamn Chrysler, how could they have made such an abortion? He jerked and fell back, righted himself and jerked again, and there wasn't even a cough.

"Guess I'll try cleaning the spark plugs," he muttered. If only they could drift towards the island somehow and get out of this wind.

Emily was holding her hair back from her face to stop it from whipping about in black ropes. They'd come out between the off-shore islands, out through the markers of the Southwest Channel, and were headed out through the farther Keys. The afternoon was quiet, the water almost flat calm. He'd thought to take her down to the Marquesas; it was pretty down there, and there was a circular harbor he knew of where they could anchor and be undisturbed. And when he'd tried to slow the engine, it had quit.

"Harry," she said to him, as he stood there staring at it. She stood beside him, hair blowing in the wind.

"What?" He didn't turn to look at her. All he could think of at the moment was the fucking engine. He'd better take out the plugs and clean them and then see.

She was silent for a moment, then said, "The reason I haven't been able to tell you. I'm married."

"Oh. I see."

Jesus. She sure chose her moment. There'd been something in the way every time he came near her. Her silence. Her refusal of him, even while she held him inside her. He'd thought it had to do

with class, with her being rich. How could anyone do that, pretend to give herself so completely and yet not give anything at all? He was so angry as he stood there, and yet completely helpless. He wanted to turn the boat around there and then, and go back, and never see her again. But the damn thing wouldn't move. Fucking rich bitch, he said in his head, fucking playgirl. How dare you mess with me, how dare you make me fall in love. They were drifting towards Boca Grande, and he hadn't a fucking clue why they were trying to go anywhere, it didn't make any kind of sense.

"Married, are you. Well, you sure kept that one to yourself."

"I wanted to tell you, really. But, Harry, I hadn't seen him since I came from Cuba. I didn't know him."

"So you're not only married, you're a fucking Cuban." He knew, it came out crude and ridiculous, but he had to do something with this rage. He kept on staring at the engine, to avoid looking at her.

"Yes. My family came from Cuba, and the Bahamas, and before that Spain and England. My husband is Cuban."

"Jesus." He was feeling terrible. All the love he had had for her was curdling like milk left out in the sun. He had a sour taste in his mouth and his body was shaking. "I thought you loved me. What a fucking asshole."

"Harry, I do."

"What do you mean? Hey, I'm sorry, I'm just a dumb American. I don't know what's going on."

"Listen."

"I gotta clean the plugs. The engine won't start."

"Harry, listen."

"Okay, talk if you want. I gotta clean the plugs, I said."

"I thought I didn't love him. I thought I could be with you. Oh, Jesus, I didn't know what to do. He needs me. It's more like solidarity than love. Don't be mad at me. I tried to tell you when we were in the house. There's a word in Spanish, *fidelidad*, it means trust, you know, being trustworthy. That's why."

He answered her with his back turned. He was focusing on something very small and mechanical and maybe manageable after all. "You didn't tell me. You made me fuck you. That was smart.

And I don't give a damn for what fidelity means in Spanish." He still wouldn't look at her. "Pass me that cloth? The oily one?"

Goddamn, and there were clouds coming up, they were beginning to ring the horizon, he saw. What the fuck was he doing out here with an engine that wouldn't run? The whole thing was clogged, it was a miracle it had come this far.

"Stop shouting at me and listen. I love you, I love what we have together, but I'm married to another man."

"Seems kinda late to remember that," he said. But he sat down, facing her, on the fuel tank. They rocked about on small waves, drifting slightly. He reached to take one of her cigarettes and they both smoked and looked at each other. He watched without compassion as she began to cry. He was hurting inside and didn't know what to do. It seemed that nothing had ever hurt him so much before. There was a quick memory of being slapped by somebody, slapped across the face for no reason. His mother, whom he had loved. She just slapped him hard across the face and he was too terrified, too stunned at the sudden change, to make a sound. Damn women. Damn them to hell.

"Did he screw you, then."

"Yes, once."

"Look, I have to put down the anchor. We're drifting. Then I've gotta fix this goddamn motor or we're going nowhere."

Emily said, "You have to believe I love you."

"No I don't, I don't have to believe a thing. What the fuck does that mean? What's love? I never could get my head round that. What are you talking about? Fucking? Is that it? Is that what you're talking about? Love! It'd be better for everybody if that word was dropped for good. There's more shit talked in the name of love than there is water in this ocean. Now get up and hand me that anchor. It's under where you're sitting."

She dragged it out, heavy and clanking, and passed it to him. He pulled out the anchor line, tied the anchor with a double hitch, tied the line to the cleant, and pitched the anchor over the side. The green water slapped up the side of the boat. He sat down and reached for another of her cigarettes.

"No," she said. "It's more than that. You saw who I am. I saw who you were."

"Well, we got it kinda wrong, didn't we? I didn't see you were a married Cuban housewife. You didn't know the first thing about me. I'm just a guy from the Panhandle who came down here and got a sailing job, I'm not the movie hero you made up for yourself." He leaned close to her, his face up close to hers. "Skin. That's all it was. Skin. Don't kid yourself, baby. Now let me put these plugs back and we'll see if anything works."

Emily turned and looked around her. The water was turning black, the sun was hidden, and those little clouds all around the horizon were getting bigger by the minute. A breeze rippled the water and moved her sweaty, salty hair. There was going to be a storm. She knew it because she'd been here before, out on this water in an open boat, heading for an unknown future, scared to death. Then, she had been taken safely ashore, and whatever it was she had feared would happen hadn't happened after all. The storm had passed. It just lay in wait for her, in dreams and on waking in panic in the night. Until now.

The wind was coming in from the south now so if they drifted it would blow them hard back to shore. He'd wanted to get behind those islands and out of the wind, but there was no way they'd do that now, without an engine. He paid out more anchor line, to hold them. He went back to the engine and ripped at it again, but it didn't even turn over.

It was old, this motor, and clogged with dirt. Damn, he should have checked it out before they ever left shore. After a few minutes, he just pulled the cord again and then again and heard the hopeless sound of a flooded motor, which only told you what a jerk you were.

All along the southern horizon, black clouds lay in a long line, almost like land. That was where Cuba was. The storm must be over those guys right now. Where the sun was going down, the clouds were a mass of gold, purple, and black, thick and matted like

sheep's wool. The darkness was coming down fast. At the horizon the ocean was striped a pale bright green, just for a moment, then it wasn't visible. The trailing curtains of cloud came down and visibility was shortening by the minute. Harry, watching all this, gauged the speed and progress of the storm. If they couldn't get out of it, the only thing was to batten down and prepare. Damn, if this was his boat he'd have fixed a few things. The hatch cover looked like it would slither off at the slightest heave of the boat, the cabin windows didn't shut properly, and when he checked, there were neither life vests nor flares aboard. There was just him and a woman who knew nothing about boats, and the provisions they'd brought for a romantic picnic at sea. Fuck, he was an idiot. In all his years as a sailor he'd never done anything so stupid. But you had to do your best with what you had.

He looked across at Emily, who sat just inside the cabin looking as miserable as he felt.

"Don't worry," he said. "We'll be okay."

He wasn't at all sure, but you had to reassure the crew.

"How about fixing us something to eat? There's no way we can get out of here, so we better just make the best of it."

They both watched the black curtains of cloud draw across what was left of the sky. Emily began opening the cooler with drinks and wrapped subs inside. Her hands shook.

"Hey," said Harry. "It's not as bad as that, is it?"

Her face showed it. She nodded at him.

"Look," he said, "I'm sorry I yelled at you. I was upset. It's no good either of us being upset now. Give me a sandwich, then shut the box up again and stow it in the bow. All the rest of our stuff too."

There was nothing left now. He just had to tell her what to do and figure out what to do himself. They might have been strangers, he thought. Only her fear irritated him, because he was scared himself. It was the equipment that was wrong. The fucking motor. The hatch that wouldn't close. The lack of any safety measures on this goddamn excuse for a boat. Fuck Bob and his "Sure, you can borrow my boat" and the way he'd checked nothing out before

leaving on this idiot trip. But Harry controlled himself. He'd done what he could. The bow was pointing into the oncoming wind, the anchor was set, the storm would pass over them. He thought to give the engine one last try, now it'd had time to recover from the way he had flooded it in his anger. He went aft, braced his feet on the deck and pulled. The pain went all the way up his arm into his chest and flooded him. He fell forward over the stern. It was like the engine had kicked him overboard.

He heard Emily's voice and felt her pulling at him and then all he felt was the water's warm embrace.

She caught at his shirt as the current tugged him, but overbalanced and nearly fell forward out of the boat herself. "Oh God, oh my God, help me! *Madre de Dios* —" Emily prayed out loud, shouting to God as her grandmother had done all those years ago when her grandfather fell and no help came. She rocked in the little boat, out there with the storm coming and Harry in the water. She seized a paddle out of the cabin and began paddling hard after him, trying to catch him with the flat blade of the paddle, to bring him back. But the water was too fast. The little waves began slapping up against the boat and driving him away from her. She saw his face, its shut look under a layer of water, and knew that he'd gone. She'd seen dead people before. There was no way now that she could bring him back to her. He lay just under the water for a few minutes and then began sinking gently. Emily fell on her knees beside the engine. Please, she begged, please start. God, help me. Make this engine start. Why did you save me before, if you want to kill me? God, have mercy on me. Jesús, María, please! Hot tears poured down her already wet face. She cried for Harry and for herself, and watched him disappear. One wave, and then he was there again, and then he was gone again. A constriction in her throat came out as a howl. She let the sound out and it seemed to hang strangely around her in the air. She howled again. She began to scream and sob louder than she ever had in her life before. She crouched down in

the stern of the boat and felt it take the waves and be turned this way and that, battered and shaken, whirled around, slapped by the water. The loud slap-slap on the side of the boat. The sounds that came from her. The hot water pouring down her face. All this was at once inside and outside, as if there were no skin between her and the universe and the drowning was herself and it had been going on forever. There was Harry, but there was also herself, leaving Mariel, a scared young woman facing north as if she didn't dare look back. She cried for that frightened girl and for her arrival on a strange shore; and for the lines of people who stood waiting and waiting for news and food and transporation; and for the ones who went down, who drowned in that summer of 1980 and in this summer that was still going on; and for Raúl, and his thinness; and for Harry and herself, and the way they had loved each other on that bed only hours ago; and for the future, its loneliness, its lack of hope. She cried and beat against her thighs until they were sore, she let the great groans of her anguish come and rock her, as the ocean rocked the boat, and she didn't care now what happened, just for a moment she really didn't care. She could drown too, it would be so easy just to slip into that water and let it carry her. She could float out with Harry and be found on some other shore, days from now, by people who didn't know her. She could be just a drowned woman washed up on a beach, another drowned Cuban, one among many, with no papers and no possessions. Just black hair swirling like weed in water, attached to bone and skin. A part of everything that was inanimate: stone, coral, driftwood. Washed up, smoothed out, made unrecognizable by the sea. She could cease to exist, as Harry had. One day, there, one minute, here, alive and wet and shivering, crouched in the bottom of a boat; the next, a thing, a number. Lost at sea. The graveyards full of them. The legacy of all islands. Fishermen: brothers, sons, husbands. Women who drowned rather than go on. Who lay down in the water and gave up. Who could not be blamed. Who left this world blameless, uncounted, not responsible. She could. But all at once, she stopped crying and the thought came, I have already survived. The choice had been made, long ago. She had not drowned, but been carried to safety. Those men had

come to find her and carry her safely into the next part of her life. It was too late for her to drown. It was too late to give up. That other time, she had been unable to speak, the whole way across. And she had not drowned, though others had. Did she owe them, then, her decision to stay alive? Was it on account of all of them that she had to fight now, stay thinking, get that engine going? Yes, and the little girl seeing her grandfather there at the bottom of the stairs. The face of her grandmother, her dear *abuelita*. A face on which the struggle showed, to live or die. Her grandmother who picked herself up and sold the house and moved to Miami, to spend her last years in a retirement home and never again speak of the storm that had wrecked her house and life. All these people. Her brother Pedro, who had come all the way to fetch her and bring her to the boats. Raúl, who had come through these same Florida straits in a small boat at night, risking death by drowning, because of her?

She braced herself, tugged at the engine as she'd seen him tug, like someone starting a grass cutter, and to her astonishment heard it cough. She pushed the choke in gently—don't let it stop, don't let it stop—and stood in the stern with the tiller in her hands. Harry was twenty yards away now, underwater. She could go after him, try to pull his body back on board, or she could head back to port, trying to keep ahead of the storm. She pulled the anchor up. The tiller swung the boat in a tight circle. So, if you pushed it one way, the boat went the other. She pushed it gently away from her. Harry's body was out of sight now. God, could she be doing this? She had to survive, she knew that about herself now. It had been there forever, since that first command—Live! You prayed to God, but it was your own effort that counted. She turned the boat away from where Harry had been, and headed for the last patch of light. The boat jumped the waves. It was like driving a car, only with the controls going the other way. She kept making mistakes with that, pushing the tiller to the left and turning right, risking the massive slap of the wave upon the flank of the boat. You had to remember to do the opposite of the instinctive. That was all. Go against that, keep your eye on the horizon, and you were all right. Her hair whipped her face and she leaned to peer into the cloud and spray.

Black mangrove islands passed, one at a time. The island of Key West was just visible, a ghost city in weird tunnels of light from the sky. Slap, slap, the black waves followed her. She would not drown. She would not let it happen. Her face wet with tears and spray, she crouched with the tiller in her hand, and every now and then half-stood to peer ahead to where she was going. She felt alert and strong, running the boat into the surge of current. It was working for her. And the punishment of rain and spray only seemed to encourage her now, to keep going, to get back home.

Then she was aware of something moving up on her right side and the sound of a close engine. There was another boat. It came up alongside. There was a man in uniform, signaling her to stop. He waved his arm in a white sleeve. She looked over her shoulder. She signaled, "I can't!" Once she let this engine stop, she'd be helpless. He waved hard back at her, cutting in close. She was swerving all over the place as she turned to signal back to him. There were two men, in a fast boat. They were overtaking, insisting that she stop. She stood, her hair blowing all over her face, swinging the tiller to get away from them. But this was absurd, she'd only make them chase her harder. She turned and pulled a couple of the knobs on the engine, the little boat swerving and ducking. Finally the engine died, and immediately the man who'd been waving threw a line aboard and clambered in. The other one slowed the engine in the fast boat. The wind battered them all, flattening their white shirts, tearing at their hair.

"Excuse me, ma'am!" the first one shouted. "Are you in control of this boat? What's going on here?"

"I'm trying to get back before the storm. My friend's in the water. I was going to look for help. I can't get him out of the water. I think he's dead. He couldn't start the engine. Oh, go back for him, will you, please!"

"Where did you say he was?" the man asked carefully, steadying himself with one hand on the cabin roof.

"Back there. Over there. The other side of the island. Oh, look, maybe you'll get him, if you hurry. I couldn't get near enough to

pull him on board. Look, over there, I think!" and she pointed, but couldn't be sure which way the boat was turning now.

"You're trying to get back to Key West?"

"*Sí, sí.* I mean, yes."

The man spoke into a little radio he carried and then switched it off again. There was the crackle of static. Then he said, "Ma'am, where have you come from?"

"From Key West, today. We just went out, for a trip. To see the islands. Then the storm blew up."

"And your friend—he just fell overboard?"

"As if he was in pain, yeah. Sudden. He tried to jerk-start the engine and he fell in the water, but he looked as if he'd had a sudden pain or something. I mean, he didn't just fall. I don't know what happened. I just—when I saw him floating, then sinking, I thought he was dead."

The man signaled with one hand to the other at the wheel of the other boat.

"You said you came out from Key West today?"

"Yes, yes."

"Is this your boat?"

"No, it belongs to a friend, a friend of—his. My friend."

"Seems to be a bunch of friends involved here," the man said. "You're sure you didn't come from Havana now?"

"No, this is a Key West boat. You can check. My friend's American. I'm American."

"Well, we can check that, easy. This baby looks more like the tubs that have been coming across from Cuba. You any idea how many people drowned out here before we could pick them up? It was like the whole bunch of them was bent on committing suicide, if you ask me. Crazy. Never seen anything so crazy in my whole life. Okay, you get in here, ma'am. I'm going to take your boat in. You'll never get back before this thing hits, otherwise. We'll go look out for your friend, but if you say he's dead you may be right. It's damn near impossible to find anything in a sea like that."

He went and helped her across into the other boat. She was shivering now, her teeth chattering.

"Are you cold? Here, take a blanket."

"Not cold, only —"

"It's shock. Here, take a drink of this and don't tell anyone I gave it to you, it's the oldest tranquilizer in the world. You know, I thought you were one of those crazy Cubans when I saw you going around in circles out here. Didn't think anyone else would be dumb enough to be out here having a picnic in this weather. Joe, you set? I'll steer this baby." He pulled the engine into life again. "Hmm, starts all right. You said he had trouble starting it?"

"It seemed like it was dead. Then I tried it and it started."

"Hmm. It's old, but it seems to run okay. These Chryslers flood easy. Coulda been that."

Emily pulled the blanket around her and perched behind him, the taste of rum in her mouth. It had happened, what hadn't happened fourteen years ago. But it had happened to Harry, and not to her.

The Coast Guard boat cut through the waves, circled all around where she had seen Harry go down. The sliding surface of the ocean showed them nothing.

"Okay, we better get the hell back now. We ain't going to find him like this. Guess the ocean'll bring him in in its own sweet time."

He turned the wheel and accelerated. The huge engine at the back of the boat lifted the bow clear out of the water. Bam! Bam! It hit the flying waves, but the boat was in control now, not the ocean. Enough power, that was all it took. Emily sat down behind the man, and cried some more for Harry, and herself, and the way it had all turned out. It was like getting to the bottom of some deep place she'd never dared to go before. It was dredging that very bottom. She cried the healing tears there in the dark of the oncoming storm.

The rain was slicing down hard as they came in past the island, and all the buildings of Key West were invisible in thick darkness. The power must be out. There were only a few lights where generators burned, and they were like solitary lighthouses across the yards of

boiling water. Emily sat, her wet hair stuck to her head, crouched in the console.

"We're going in to Fleming Key," the man at the wheel shouted back to her. "I have to check that boat out. You have any ID on you, or the boat's papers?"

"No!" she shouted back. "We were out for a trip, I told you. I don't even know the guy whose boat this is."

The boat swung as he turned the wheel. He slowed to pass moored boats that rocked about on the dark water, their lights tipping like shooting stars. The pounding of water on the bow grew less. They were heading across between the close islands, Tank and Christmas Tree, and the shore. Emily didn't care where he was taking her now. She sat, just waiting to see what would happen next.

The boat engine cut out suddenly and they were approaching a long pier. The man threw a line ashore.

"Look," he said, "we'll have to search this tub of yours for the usual, drugs, faulty equipment, missing paperwork, that sort of thing. You know the owner's name?"

"I forget. Johnny, Billy someone?"

"Oh, yeah, a Johnny or a Billy, that really helps. It's okay, we can find the records, it has a Florida registration, doesn't it? I have to ask you a bunch of questions. Would you come ashore for a few minutes? Then I'll take you back to Key West: you look as if you could use a rest. There'll probably be an autopsy if they find your guy. They may put a detective on your tail. That is, if we don't rule out any possibility of foul play."

"Foul play?"

"Yeah. Like, you pushed him over. Something like that. That's what they call it."

"I pushed him over?"

"Well," he said, a little embarrassed, "people do."

AFTER the storm, the long rainy summer was at an end. The days dawned bright and quiet and the sky was luminous with the changed light that promised the fall. People say there aren't seasons here in southern Florida, but they're wrong. When you live here you see and feel the subtle changes that mark time having moved on. It's like when you live with somebody and feel their change of mood. A look, a smell, a different movement—you wake with them one morning and know that the change has occurred, and that there'll be more of them, one season endlessly becoming the next.

The first I heard of Harry's death was on the front page of the *Citizen*, which Tom brought in with the two styrofoam cups of *café con leche* he'd brought from the corner store. I heard his step creak on the wet wood of our outside staircase and smelled the coffee as he came in. He sat down and unfolded the paper and after a couple of minutes, handed it to me with a look but no word. I sat up in our tumbled bed and read what he showed me.

"Oh, God, I don't believe it."

A Key West man, native of Pensacola, Florida. Drowned in the freak storm, off Boca Grande. Surviving companion brought in by the Coast Guard. Foul play not suspected. Body found on Woman Key, yesterday morning. Inquest to be held.

"Drowned?"

A rhyme I'd learned as a kid played in my head:

Adam and Eve and Pinch-me
Went down to the river to bathe
Adam and Eve were drowned
And who do you think was saved?

It was as weird as that. Who do you think was saved? There was

Emily's name, Ms. Emily de Soto, of Miami. A tourist. Said that the deceased man had simply fallen into the water off the boat. I read it over and over, as if in this sparse piece of journalism I was going to find out the truth.

"He couldn't swim. And he had something wrong with his heart."

"He did?"

"He told me and Janie," I said. "I wonder if she knew?"

"Doesn't make any kind of sense otherwise," Tom said. "He was a sailor. He must have known what he was doing out there."

"Jesus." My dream from that first night at sea came back to me, the drowning, the searching, the fear. Only it hadn't been Harry. Who do you think was saved? In my dream, it had been the other way round.

Tom took the paper from me. "Says here it was a borrowed boat. They took it in to Fleming Key. That's where they took the Cuban boats in, and the ones they impounded for going to help them."

"But what were they doing out there?"

"Joy-riding, I guess. I don't imagine they were going to Cuba. Taking a trip on the water. Same as we were, only they wouldn't have had any protection from that wind."

"I gotta get down to the boat." I swung out of bed and put my feet to the floor. It was still dotted with leaves that had blown in during the storm. Mango leaves and pieces of twig. Luckily the rain hadn't reached our bed. Our house is just a flimsy shelter, same as the boat is. Nothing here was built to last, but last they do, somehow, through freak storms and even hurricanes. These frail wooden houses stay standing, because most of them were built by seamen who knew how to make joints in wood that would see a boat through a storm.

I wriggled into my clothes. I wanted to get down there and talk to somebody who knew Harry, who had worked with him, who'd be feeling the way I was, shocked and unbelieving, in the state that comes before grief.

Tom said an odd thing then. He said, "That's what comes of fooling around."

"What? What are you talking about?" I buttoned my shorts and felt under the bed for my sandals.

"Retribution."

"You can't believe that."

"Something in me wants to," he said. "You play around with people's emotions, and something comes to get you. In this case, the ocean."

"Harry wasn't playing around," I said, furious.

"No? He must have known she was married."

"No. She didn't tell him. She told me not to. And I didn't."

"You might have saved him, if you had. Had you thought of that?"

"Jesus, Tom. Shut up, will you? Will you please just shut up?"

And I was out of there, as quick as I could, taking my coffee with me. Tom didn't say anything, but went on reading the paper. I unlocked my bike, shook water off the seat, and wheeled it out between the dripping aurelias. The street was empty and quiet. The sky was greenish, pure with coming sunlight. I biked, my coffee in one hand. The puddles at the end of the street were shrinking back as if the tide had turned. There was only an inch or so of water left, and I churned right through it, splashing my feet, carving a long furrow that spread waves to the sidewalk. Harry was dead. Tom thought it was divine retribution. The Coast Guard thought there might have been "foul play." Did that mean they thought Emily had pushed him over? Surely not. Were Janie and I the only ones who knew he was sick? What would the inquest discover? Was it Emily's fault? And what were they doing out there, in the worst storm of that summer, in the open sea, where so many people had already drowned?

We mourned on board the *Cat* that morning. I've never seen McCall up so early. He came down the parking lot with a coffee in one hand and his face was long and gray beneath his cap. He reached and hugged me. It was strange to be held even briefly to his chest. He smelled strongly of stale tobacco and was about the same size as Raúl.

"So you heard."

"Yeah."

"God, the things that happen. I've been sailing down here twenty-five years and I never get used to it. You go out there and ninety-nine times out of a hundred you're okay, you come back safe and sound, and the hundredth, something like this happens. You realize you're playing with death the whole damn time. Look at it," he waved an arm towards the harbor bight and the islands beyond that floated like mirages on the pearly water. "Looks so innocent, doesn't it. But you can go down in it just like that." He snapped his fingers. "Even a sailor, like Harry. That guy knew what he was doing."

The *Cat* rocked gently beside us, tethered by long lines to the shore. Everything on her, the deck, sail covers, hatch covers, still carried water. But the sun would dry it up in minutes, once it was over us. McCall and I sipped from our coffee containers and Janie wobbled down to the dock towards us on her red bike. She had tears running down her face already. She and I hugged, and McCall lit a stump of a cigar and stared out to sea.

"We go out and back, out and back," he was saying, "and every time I have to ask my crew, are you willing to put the passengers' safety before your own? And everyone always says yes. Guess that's what Harry was doing, too."

"You do?" I turned round and looked at him.

"Sure. It was that de Soto woman, wasn't it? The one that used to come out with us. The looker."

Janie said, "He was nuts about her."

I said, "I don't think she knew about his heart."

"Heart?" McCall said. "What about his heart?"

Janie and I looked at each other.

"He had a heart problem," Janie said. "He told us. He went to the doctor, oh, about a couple of weeks ago. She told him to relax and he said he couldn't, he had to work."

"Jesus," said McCall, "he never told me."

"Guess he was scared he might lose his job."

"Jesus," said McCall again. "Jesus Mary and Joseph. What a mess. Fuck the man, he should have said."

I said, "He didn't have insurance."

Nobody said anything.

McCall said, "Jesus. This system. It sucks. I wish he'd told me, though. You shouldn't have to keep a thing like that to yourself. He told you two, though, right?"

"We got it out of him. After he went to the doctor."

I remembered it so clearly, standing on the foredeck, swabbing, while Harry talked and the water sloshed up in the gap between us. What he said about Emily, too.

McCall said, "I hear the woman was married."

I nodded.

"You knew that, too?"

"Uh-huh."

"Seems like you two were the only ones who knew anything. I'd no idea all this was going on. I knew he liked the look of her, but not that they were having a full-blown affair."

Janie and I looked at each other. She smiled, as if to reassure me. For I was the only one around who knew all the parts of the story, though I couldn't ever know the whole. Raúl, Emily, Harry had all told me their versions. But what, I wondered now, was my own? What did it have to do with me? And what was I supposed to do now?

McCall said abruptly, "We've got a charter tonight, so I'll need you both. I'll be taking on a couple more hands, so you girls don't work your hands to the bone. But tonight, you're all I've got. Okay? Martha, will you clean up on deck? Janie, I'll have you in the booth this afternoon. Now, crew, no malingering. Just don't let it get you down."

He went, looking suddenly old, his shoulders bent and hunched up around his neck. I guess when you're captain and one of your crew drowns, you feel it like family, even though it wasn't your fault.

That night, when I went back home after the charter, the palm trees were lined up black against a cloudless apple-green sky at the edge of the cemetery and the light was on in our window, high up

in darkness. It was like nothing had happened, like one more evening homecoming from before this strange summer. I slowed my pedaling and followed the yellow light, my own personal lighthouse. Tom would be there, reading, cooking, or watching TV. But what was the difference between a person really being there and them just being there in your imagination? Was he there and waiting for me, the way Emily had waited for Raúl? Or was it an illusion, and the yellow light all that told me of a harbor that might not really exist? I swung a curved path between small puddles and parked cars on Margaret Street and turned to ride up Olivia. My familiar homecoming path, the way I always came, as the *Cat* always came back inside the safe marked channel to its mooring. Home. My own particular mooring, the one I'd chosen and knew I needed. This man, this room, this way back. There were many other ways to go, yes, and a whole world of options. But I was a person who needed not to float about in them, because my work was out there on the water and my heart needed a home. I guess Harry felt this way, too. Only he chose a port that couldn't possibly stay open to him. He went down for the last time, trying to get back in. And sure as wreckers' false lights that took ships onto the flats and rocks to be splintered, she'd led him there.

FOR one last time, I slowed my bike to a stop outside the house on South Street. I balanced there on the saddle, both feet on the ground, and looked into the yard. I thought, she's gone. It was the way the house looked, as if something had been removed from it. There was a dark red Oldsmobile parked there, the one that had come by the morning I was with Raúl. Beyond it, the hard blue glitter of the ocean in this new season. It stretched a pure line between the two palm trees. The door of the house was open. I wheeled my bike in and leaned it against the end of the porch. Somebody was moving about inside; I could see a shadow against the light that came in from the seaward side. I knocked on the outer door. A dark young man came out, wearing a neat shirt, pale tan pants, and deck shoes with white socks. His was the kind of face you see around Key West these days, fattish, innocent, well-shaved. I could smell the expensive aftershave from where I stood.

"Hi. Excuse me. I was looking for Emily de Soto."

"She's gone. My name's Rob. I'm the realtor. Haven't we met somewhere before? Don't I know you?"

"My name's Martha. I work on the schooner *Black Cat*. I'm a friend of the people who rented this house."

"Oh, yeah? People? It was a woman rented it. I'm just here to clean up, as it happens. She left all sorts of stuff in the kitchen. I haven't been upstairs yet."

"When did she go?"

"I don't know. I thought she'd be here. She paid up, first and last. Seems like she's taken off without her deposit. You know there was a tragedy, a guy was drowned? I'll need to get a cleaner in here. Look at this." He picked up an ashtray with stubs in it, and ran a finger over the dust on the table, leaving a trail. Then he looked at his finger. I began to laugh.

"What's funny?"

"Just the way you did that. Like you're inspecting something."

"Well, I am. It's my job."

"You're not a detective, are you. Or you wouldn't stir up the dust, you'd study it, for clues."

"Clues?"

"I'm sorry, I'm just kidding. Do you know where she went?"

"Miami, I guess. That's where she came from."

"Do you have an address?"

"No. There's a letter here, and I don't know where to send it. I found it in the mailbox. It must've been there a day or so."

He showed it to me. It was flimsy and a little damp and addressed to Emily, and the name at the top left-hand corner was Raúl's. Raúl had written to her, from Miami. I turned it round in my hand, trying to read the date.

"So you know what happened."

"Oh, the accident, yeah. But your friend was okay, wasn't she?"

"The guy was a guy I work with. Or used to."

"Gee, I'm sorry. That's bad. He died of a heart attack, they said. Dead probably before he even hit the water. So that let her out."

"Yeah."

"They said it wasn't her fault. It was in the paper. So, what should I do with this? Will you deal with it? I've a stack of things to see to today."

"Okay." I put Raúl's letter in my shorts pocket. The real estate man, Rob or whatever his name was, and I stood there for a moment, with nothing more to say. Then he said, "I saw a guy with her. I wasn't spying or anything, but was that her husband? They said he was a Cuban."

"Yes," I said.

I turned and looked out to the blinding ocean, the thin stretch of it that showed taut like a washing line stretched between the two leaning palm trees. The music of the tango, that was what I missed today.

"Hey," he said, "is anything the matter?"

"No."

I could see him thinking I was pretty weird. I was pretty weird,

too. I was looking across at that harmless-looking diamond-sparkling blue pretty ocean and thinking about going to Cuba. I would go to Cuba one day, and smell this ocean from the other side, and see. I would look for the twin dark angels, with their un-broken wings, that fly above Havana.

I put the letter in my pocket. I guessed that Emily would be with Raúl again by now, and that I would never see either of them again. Perhaps I would struggle with the Spanish to read what he had had to say to her, before he knew that the ocean had given her back to him. Perhaps not.

EMILY poured the liquid out of the little plastic container into another even smaller container that had a round eye in it, like a dial. She watched it for a minute. Like the sky changing color after a storm, it gradually turned blue. There was a clear stripe across it, a plane trail, a wake in water.

She'd been wondering, for the last couple days. People said you could tell at once, that you felt different. But was that from surviving the storm, or was it from someone surviving the storm in her? What had happened on the outside had its echo on the inside. She had not saved Harry. But she had, it seemed, saved somebody else.

That person wouldn't talk to her yet, and wouldn't tell her. One day, in the far future, she might look at him or her and catch a certain expression, a flash of eye color, the way hair grew, the shape of hands, that would tell her. Or the person might be entirely his or her own self, inscrutable. Or, an echo of her. The tiny swimmer in rough waters, the captain of that buoyant little boat, her womb. Growing in there, becoming, whatever happened now on the outside.

All through those days, when she had been unable to choose, this person had been choosing. A microscopic explorer had set out, swimming determined and undeterred up the waters of herself. A salmon leaping upstream. One among thousands. One at the right time. Timing was everything. Tides and currents told you what to do. The moon, which had come up to full and begun to wane, dragged time after it like a long net, and everything was caught in it, and you thought you were making decisions, while all the time decisions were making you.

She watched the little blue dial for a few minutes longer. It only told her what she knew already. But it didn't, wouldn't tell her

more. What she asked it, and tried to figure out of dates, times, occasions, would remain hidden. When at last she threw it in the bathroom wastebasket, she wasn't asking that question anymore. A genetic imperative had moved into her. An inheritance was being built, becoming more complex and intricate day by day. Everything in her own inheritance had gone to meet it: Cuba, America, the Bahamas; islands, isthmuses; channels in deep waters, straits and landing places; poems and history; the dry places of land and the wet places of the seashore. Everything that was in her was working to make an easy place for this new person to grow, the person who had chosen her and a man to grow from, and whom she had been awaiting all this time, without even knowing.

 35

HE walked between children on the sidewalk, but he was walking on his own feet in new flip-flops, and the children, tall fattish near-adolescents, were weaving behind and before him on skateboards. At the very edge of the sidewalk they flipped the end of a skateboard up and skidded to a stop. They leapt the edge, crashed in the street, zigzagged away between automobiles in pastel colors with drivers in dark glasses. The buildings at the edge of the sidewalk were pink, green, orange, purple. Glass caught the light from the sun and dazzled the eye. The ocean was a street away, glittering, a line of cobalt. It looked as if it had no other shore.

The children were his brother-in-law's, they were American children with Cuban eyes but the curved girlish silhouettes of American boys. He didn't know them. They said they'd take him out and show him stuff, and they zoomed away on their skateboards and then returned, panting, their hair hanging in their eyes. A young woman passed him close by, wearing a bikini and rollerblades on pink boots. Her buttocks trembled, separated by a string. The street was all hard glitter, with no shadows. The strip of white beach gave nothing away.

He thought, I am at last in a city with no reflection. Where I have no shadow. But this is where she will come to me, if she comes. This is where I will wait, my life quite emptied out, and believe in a future. He wondered how long it would take.